ADVANCE PRAISE FOR *FAKE*

"Walton reveals the lunatic world of art speculation
on eBay with a gripping tale of his own dizzying
fall from grace. Insightful and darkly humorous,
Fake is better than most thrillers, and more thrilling
than any memoir I've read in years."
—Dylan Schaffer, author of *I Right the Wrongs*

"Smooth, fast-paced tale of eBay chicanery. Highly
recommended, read with confidence!!! (Probably
wouldn't buy a painting from him, though.)"
—Greg Beato

"Kenneth Walton's *Fake* really opens your eyes to the often
unethical price-raising methods used by some sellers on
eBay. Drop your mouse and read this book before you
make one more bid!"
—Doug Noble, *Mountain Democrat*

FAKE
FORGERY, LIES, & eBAY

Kenneth Walton

SIMON SPOTLIGHT ENTERTAINMENT
New York London Toronto Sydney

SIMON SPOTLIGHT ENTERTAINMENT

An imprint of Simon & Schuster

1230 Avenue of the Americas, New York, New York 10020

Text copyright © 2006 by Kenneth A. Walton

All rights reserved, including the right of reproduction in whole or in part in any form.

SIMON SPOTLIGHT ENTERTAINMENT and related logo are trademarks of

Simon & Schuster, Inc.

Manufactured in the United States of America

First Edition 10 9 8 7 6 5 4 3 2 1

Library of Congress Cataloging-in-Publication Data

Walton, Kenneth, 1967–

Fake / by Kenneth Walton.— 1st ed.

p. cm.

ISBN-13: 978-1-4169-0711-4

ISBN-10: 1-4169-0711-4

1. Internet fraud—United States—Case studies. 2. Arts—Forgeries—United States—
Case studies. 3. Internet auctions—Corrupt practices—United States—Case studies.
4. Walton, Kenneth, 1967–. 5. Fetterman, Kenneth. I. Title.

HV6698.Z9W34 2006

364.16'3—dc22

2005035098

This happened.

THE FIRST PART. On a clear day, from my twenty-eighth-floor office, I could see the Sacramento River slithering down the valley in slow motion. Below me, tiny pedestrians made their way up and down Capitol Mall like diligent insects. When I first started this job, and felt like a big shot, I lured dates up here at night to impress them with this view. But now, a year later, the office and the view seemed much less enchanting, and on this November day of 1998, all I could see out the window was a murky autumn fog. But as I did every other day, I sat and stared out, trying to summon the will to work.

A knock on my door startled me, and I scrambled to close the web browser windows open on my computer. My secretary poked her head into my office and said, "Bob called. He needs that memo."

"Thanks. I'll call him." My chest tightened. The project was due at the end of the day and I'd spent most of the morning on the Internet, reading basketball box scores and looking at pictures of some guy's trip to Nepal. And staring out the window at fog.

I worked as an associate attorney at Kronick, Moskovitz, Tiedemann & Girard, the third largest law firm in Sacramento. My specialty, if I could claim to have one, was municipal law. I represented cities and counties. I felt lucky to have landed this job, but a year of drudgery had left me bored and miserable, and it showed. I spent as much time taking trips to the coffee-pot as I did working. I didn't finish things on time. I rarely exercised, and could feel flanks of fat pushing into the sides of my pants. At age thirty-one, I could imagine my once lean body expanding into a pear-shaped blob, and feared that within five years I would look like every other middle-aged attorney who worked here.

My secretary closed the door and sealed me inside my office. I faced my computer, took a deep breath, and silently begged myself to get started. Then my phone lit up, and when I saw that it was an outside line, I answered on the first ring, all too eager for a distraction. It was Ken Fetterman. "Hey man, Lane and I are gonna be down in Sacramento tonight, and thought we'd stop by."

Fetterman.

I knew him from my days in the army, and although I'd made little effort to maintain our friendship, we'd somehow remained in touch, thanks to his persistence. He'd call every so often and I'd usually come up with some excuse, but this time he caught me off guard and I found myself saying, "Sure. Kris and I will be at my place around seven." I closed my eyes and winced as I

realized what I was getting myself into. "Um, we can't stay up too late. She gets up early for work."

"Hey, so do we. See you tonight."

I leaned back in my chair and let my chest collapse into a heavy sigh. I looked out my window and could just make out the building where Kris worked—the federal courthouse for the Eastern District of California—four blocks away. She was a clerk for a federal judge, a coveted position for a young lawyer. We'd been dating for five months, and I knew her well enough to know that she wouldn't like Fetterman. She was refined and well mannered; he was crass and boorish.

I probably would never have become friends with Fetterman had we not been in the army together. We came from different worlds. I'd been raised in a middle-class suburb of Sacramento. My own family struggled financially, but I was surrounded by wealthier friends whose bourgeois habits and aspirations rubbed off on me. Fetterman, on the other hand, had grown up in a very poor neighborhood in Camden, New Jersey. His dad owned a bar. The two of them lived upstairs from the bar, and Fetterman spent his youth lugging kegs of beer up from the basement and washing glasses.

We were stationed together at Fort Lewis, Washington, just south of Tacoma, and were initially drawn together by our similar taste in music. We used to go to shows in Seattle and take weekend road trips up to Vancouver, where the drinking age was nineteen. I guess I liked hanging out with him because he was fearless. I was still a shy teenager, and Fetterman, despite his lack of social grace, wasn't afraid to approach any girl. I stood back and enjoyed the fruits of his favorite pickup line: "Hey, have you met my friend Ken?"

His pickup tactics often included elaborate storytelling. When we met girls at clubs, he made up fake names for himself

and lied about what he did for a living. He usually didn't admit that he was in the army. He sometimes claimed to know (or be) someone famous. It was as if he saw these lies as intrinsic to the art of seduction.

He fibbed about other things, too, even when there was nothing to gain, and seemed to enjoy lying for its own sake. Once, when he was caught swilling beer in the barracks, he was required to attend eight AA meetings, part of the army's standard punishment for anyone busted for underage drinking. On a Friday evening when we were on our way to see a band in Seattle, Fetterman dragged me to one of these meetings. All he had to do was sit through it and get a paper signed, but this wasn't enough for him. When the time came for him to say "My name's Ken, and I'm an alcoholic," he launched into an absurd story about how he'd started drinking when he was twelve years old, how alcohol had ruined his life, and how AA had saved him from certain death. With tears in his eyes, he chanted like a street preacher, revealing details about crashing cars, abusing women, losing jobs, and spending nights on the street. He thought he had everyone fooled, but I noticed people rolling their eyes in disbelief. This nineteen-year-old punk made a mockery of their meeting and then laughed about it the whole way to Seattle.

I got out of the army when Fetterman had a year left on his enlistment, and I later heard that he was arrested for possession of LSD at Fort Lewis. He was sentenced to a term in military prison, and I assumed I would never hear from him again. Five years later he tracked me down in Sacramento and told me he was moving there. He said he'd been living in Seattle and just needed a change of scenery.

We went out for a beer and he explained what he'd been doing. After his release from prison, he'd moved into a Seattle

boardinghouse, bought a Ford Pinto for his pizza delivery job, and coached high school girls' volleyball part-time. Struggling to make ends meet, he began buying things from garage sales to resell to antique dealers, earning just a few dollars at a time.

As he told it, one day he stumbled across a painting in someone's front yard, bought it for five dollars, and had an antique dealer offer him eighty dollars for it. He decided he was onto something and spent the next year in the library reading about art. He turned it into a career and made his living buying and selling paintings.

I was getting ready to leave for law school when Fetterman moved to Sacramento, and we didn't see much of each other. We seemed to have even less in common than when I knew him in the army. It was as if he hadn't changed, other than the fact that he had a lot of money. I was sharing a house with two other people, living pretty much as I had in college, and he had his own three-bedroom place filled with art and nice furniture.

I moved to San Francisco in the fall of 1994 to attend the University of California's Hastings College of the Law. It seemed like a logical step at the time. I had an analytical mind and I liked to write and argue. But within weeks I was already bored with the subjects and had no appetite for competition with my smart, driven peers. I stayed and put in little effort, as I had done in college, but with less to show for it in the end.

While I languished at Hastings, the Internet revolution exploded around me. Law school brought me to San Francisco at an exciting time—from 1994 through 1997—the early days of the dot-com boom. San Francisco was the home of CNET, ZDNet, HotBot, *Wired* magazine, and countless now-forgotten Internet start-ups. The old brick warehouses south of Market Street were filling up with eager, bright, ambitious entrepreneurs. Just down

the freeway was Silicon Valley, a cluster of low-slung suburbs around San Jose and the home of Yahoo!, AltaVista, Netscape, and Stanford University, where two graduate students were dreaming up what would later become Google. In a condominium in San Jose, a software engineer named Pierre Odimyar was building an online auction site he would call AuctionWeb, which would later become known as eBay. As I sat in cafés reading my law texts, I overheard people discussing their brilliant website ideas, each of which was going to be "the next big thing," and I ached to be a part of it all somehow. But I was an outsider, a bored law student. A revolution was unfolding around me, and I couldn't participate because I'd committed myself to something else, like an East German border guard who could only stand by and watch as gleeful students chipped away at the Berlin Wall.

As I wasted three years in law school, my younger brothers Matt and Keith were back home building careers they loved. They both dropped out of high school at seventeen and spent a few aimless years at low-wage jobs until they stumbled across computer programming. Entirely self-taught, they worked their way up the ladder quickly and became sought-after software architects hired by large companies and state agencies to plan and oversee enormous projects. When I heard them talk about their jobs, I longed to be doing something that inspired my passion in a way I feared my chosen profession never would.

Since I'd returned to Sacramento, I'd only seen Fetterman twice. Even though I no longer enjoyed his company, I felt a sense of loyalty to him. He'd known me in the army—an institution we'd both loathed—and was the only link to that part of my life, a time when I was isolated from my friends and family. If I needed a favor, he'd be there for me in a second. When I was in law school, he drove to San Francisco to help me move. Part

of me also admired the way he'd survived a difficult upbringing and made something of himself. Fetterman and I were, in this way, similar, and different from most of my other friends, who'd been raised in relative comfort.

I looked over Fetterman's shoulder and squinted at the web page on my laptop. Across the hall, our girlfriends sat in the living room and fished for topics of conversation.

"You need to get a mouse for this damn thing," he said, dragging a thick, freckled finger across the touchpad. The cursor crept around the screen, obeying his clumsy prompts.

"You get used to it."

"A mouse is way easier."

We'd retreated to my bedroom when Fetterman offered to show me his eBay auctions. I'd never used eBay, but like everyone, I'd been reading about it. I stood behind him, arms crossed, and watched as the cursor meandered around the screen like a beetle, finally hovering over the Bid Now button. Fetterman pushed out the tip of his tongue, lifted his finger with a flourish, and poked the left-click button. The web browser blinked and displayed a new page. Fetterman pecked out a username and password.

"Are you bidding on your own item with a different user ID?" I asked. "Can you do that?"

"Just helping it along a little."

"What happens if you win your own auction?"

He did not reply. As I watched, he placed another bid on another of his own eBay auctions using yet another user ID. I smirked and snorted a quiet laugh. This seemed like just the type of thing Fetterman would do. But I assumed it was probably pretty common on eBay.

"This eBay, man—I'm telling you, it's fucking amazing. In the real world I've got to find good paintings to resell—*really* good ones—and you don't come across them every day. I could go to ten estate sales in a weekend and only find one decent painting worth buying for resale. But eBay changes everything."

I thought it was about time for him to spit. When he got excited, Fetterman had a tendency to fling bits of saliva from his mouth. He was aware of this habit and would sometimes apologize for it, but he did not seem to work at changing it. "Sorry, did I spit?" he would ask if I flinched and blinked while he was talking in my face. Then he would continue and do it again.

"Now I can go to a thrift store or some shitty little antique shop and buy crappy paintings for five or ten bucks, put them up on eBay, and *bam*, they sell for two or three hundred! Apiece!" Just as he uttered the *P* in "apiece," a tiny droplet of spittle flew out of his mouth and soared onto my monitor. I scowled at the tiny shimmering globe as it clung to my screen, already growing tired of his company.

Fetterman looked up at me and lowered his voice, as if he were letting me in on a secret. "Sometimes more. Easy money, man. Easy money." His breath smelled like beer.

When he was clean shaven, standing up straight, and wearing a pressed shirt, Fetterman could almost have passed for patrician. He was six foot three, muscular, and had light blond hair that went vertical with no coaxing. Some might have described his blue eyes and chiseled facial features as handsome. Or formerly handsome, like a WASP-y Calvin Klein model who'd seen some rough years and let himself go.

Fetterman was rarely clean shaven, usually slouched, and

typically showed up in a stained white undershirt. His dense New Jersey accent, untempered by years of living on the West Coast, spewed forth as strongly as it did when I met him. He struggled with grammar. "Lane's been trying to get me to stop using double negatives," he once said. "Do you ever have a problem with them?"

He was also plagued with body tics. When excited, the thin-skinned balloon of nervous energy he carried inside himself would burst and send him into spasms. He arched his shoulders, stiffened his arms, clenched his fists and bent them away from his body, shaking them back and forth out of control. He would look at me with widened eyes, curl his lips into a toothy smile, and nod his head rhythmically, as if to say, *Is this good, or what?* Sometimes he actually did say, "Is this good, or what?"

This restlessness was part of what made people think he was shifty. He squinted and was unable to look a person directly in the eye when he spoke. He often talked out the side of his mouth, his eyes darting left and right beneath his blond eyelashes, his lids slung low.

"Remember Beach?" he said. "He's on eBay now. He's making good money."

"Who?"

"Beach. Scott Beach. You know—the guy who lived in San Francisco with his girlfriend Molly."

Scott was a friend of Fetterman's. I'd met him only once, years earlier, and hadn't heard anything about him since then.

"What's he doing now?" I asked.

"He and Molly got married. She got her MBA and got a job in Denver. Some kind of consultant. I don't really know what she does. They bought a house in Colorado Springs, and she's pregnant." Fetterman cocked his head back toward me. Out of the

side of his mouth, he said with a smirk, "Molly hates it that Scott sells stuff on eBay. She doesn't think it's respectable enough and wants him to get a job. She fucking runs his life, man."

"He sells art?"

"Yup." Fetterman turned his chair to face me. "Well, art and board games and books. I don't know why he bothers with that other shit. I mean, board games?" He snorted. "You sell someone a board game and it's missing one piece and they want a refund. What a waste of time. There's no money in that stuff."

"I can see why Molly wants Scott to get a real job," I said. "They're having a kid. She probably just wants some stability."

Fetterman's face twisted into a crooked smile. He looked up at me, crossed his arms, and said, "You don't think selling art is a real job?"

"No, man. Listen, I didn't mean it that way. You're obviously doing fine with it. It's just that Scott is—"

He interrupted. "How much are they paying you over at the law firm, Ken?"

I looked out my bedroom door into the living room at Kris, sitting on the grubby white love seat I'd been given by an old roommate. "That's generally considered an impolite question," I said.

"Hey, if you don't want to talk about it, that's fine," he said. "But you're the one who thinks Beach should get a real job, and if you're talking about what a real job is, how much money you make has got something to do with it."

"I make fifty-two thousand dollars a year."

I looked down. I'd spent three years at Hastings, passed the bar on the first try, and had a job with a good firm, but I was just getting by on my salary. My friends at big firms in the Bay Area made twice as much, or more. My brothers Matt and Keith made

quite a bit more than I did. It might not have been so bad if I weren't saddled with more than eighty thousand dollars of student loans and credit card debt. Just a week earlier I'd had to borrow five hundred dollars from Keith when I accidentally overdrew my checking account.

"Fifty-two?" He paused. "That's not bad," he said, frowning in a show of false sincerity. "Sounds like Lane's job."

"Well, it's not that great," I said, "but if I can get a job down in San Francisco . . ."

"I'll tell you this," Fetterman said, his voice pitched and lilting. "Selling art, I've made that much in a month." He was nodding, his white eyebrows arched, mouth transforming from frown to smile.

I felt blood filling my face and I wasn't sure why. It was not embarrassment. I wasn't ashamed of what I did or my modest salary. And I wasn't angry, either. I wasn't bothered by Fetterman's derisiveness; I didn't value his opinion enough to be disturbed by it.

Maybe it was excitement, although it didn't feel like that at the time. Perhaps I sensed some sort of opportunity in this eBay thing. Maybe some good would come out of Fetterman's visit after all.

In late 1998 there was a lot of money to be made on eBay. The site was growing at a reckless pace. Its expansion was so natural, so effortless, that some eBay executives would later become fond of saying, "A monkey could drive this train." It was more than just "the world's largest flea market," as it was sometimes described in the press. It was a revolutionary new way of doing business that changed the lives of millions of people. A coin dealer in a small town in Minnesota could find a new customer in New York City.

A Persian rug dealer in Los Angeles could sell his exotic, hand-woven carpets to buyers in small towns that didn't have rug shops. Stay-at-home parents could make real money on their computers while caring for their children. Mom-and-pop retail businesses that couldn't compete with Wal-Mart found, in eBay, a new way to stay afloat. It was a place where a normal person— without the aid of an MBA, marketing expertise, or venture capital—could make money on the Internet.

That night at my apartment, Fetterman spent five minutes showing me how to sell things on eBay. It was easy. He took photographs, used a scanner to convert them to digital images, and filled out a form on the eBay website. That was it. Fetterman had very basic computer skills and ran his auctions from an ancient little Macintosh perched on a cluttered desk in the room in his house that otherwise belonged to his dogs.

Auctions on eBay lack the sensual experience of traditional auctions. The Internet cannot provide the staccato-voiced auctioneer, the bobbing paddles raised and lowered by competing bidders, the shouts of "Going once! Going twice!" There is no thwack of the hammer when an item sells. Perhaps most important, an eBay bidder cannot see, smell, or touch the item he's bidding on, a limitation that inspired the eBay motto: "It's all based on trust."

Still, eBay does provide many of the thrills of a real auction. A bidder hunts for the perfect item. He finds it. He places a bid. He might have to compete with other bidders. If he has the highest bid at the end of the auction, he hasn't just bought the item; he has won it.

But the excitement isn't just for bidders. EBay sellers experience a rush of anticipation when they post their auctions. They get a thrill each time a new bid comes in. When their auctions

are about to end, they sit in front of their computers and obsessively refresh their browsers, hoping for last-minute bids that sometimes send prices soaring beyond expectations. Selling an item on eBay and watching the bidding unfold is much more fun than just sending it off to a regular auction house, and worth the extra effort.

One innovation developed by eBay is "proxy bidding." In a live auction, a shopper must bid and then keep raising his paddle to place higher and higher bids, until everyone else drops out or the price exceeds what he's willing to pay. This process is made much simpler on eBay: A bidder can name his limit, and then eBay will place bids for him as others come along.

When a shopper places the highest bid on an eBay auction, eBay sets it at an amount that is just enough to surpass the next-highest bid. As other bids come in, eBay increases the high bidder's bid and keeps him on top, until someone else places a bid that exceeds his maximum. Bidders love this system, as it saves them the trouble of returning to the site repeatedly to place bids.

Unfortunately, proxy bidding also encourages sellers to place bids on their own items, like Fetterman did when he introduced me to eBay. If a seller knows his customer's actual bid may be much higher than what is shown in an auction, the seller may be tempted to bid on the item to push up the price. In doing so, the seller risks outbidding the customer and ending up on top of his own auction. But this may be a risk the seller can endure, especially if the high bid on the item is less than the seller is hoping to earn.

Shill bidding, as this practice is known, did not originate in the eBay universe. Historically, it has always occurred in auction houses. Sometimes the owner of an item up for auction bids on it himself. More commonly, an auction house places "shills"

in the audience to bid on different items throughout an auction.

While generally considered wrong, shill bidding has never carried severe penalties. In many states there is no specific law prohibiting it. In the states where it is illegal, it is either a minor misdemeanor or just an infraction, no more serious than a parking ticket. Getting caught for shill bidding generally involves a modest fine.

Although shill bidding did not arise on eBay, the site did, in its early days, make it very easy. Shill bidding online didn't require a cadre of well-trained shills sitting on the floor of an auction house, communicating with nods and secret hand gestures. All it took was a crafty seller with an extra user ID, which could be created in five minutes.

Shill bidding has always been against the rules of eBay, but eBay hasn't always done a good job of communicating this to sellers. Indeed, when I first signed onto the site, eBay allowed a seller to place a bid on his own item, with his own user ID, as a way of making sure the item did not sell for too little. This was likely confusing to a lot of sellers. If a seller could bid on his own item with his own user ID, why couldn't he place a bid with a second user ID? This early policy, which was later repealed by eBay, undoubtedly contributed to shill bidding being so widespread in the early days of the site.

This, and the fact that eBay was largely unpoliced. In 1998 it had no effective mechanism to detect shill bidding or determine if a single person was registering many different user IDs. EBay considered itself a neutral platform and let its users do pretty much as they pleased, perhaps fearing that if it became too involved in policing its site it would someday be legally bound to do so. Except when abuses were reported by users and easily verified, it looked the other way. EBay was, after all, "all based on trust."

• • •

After Fetterman showed me around eBay, he navigated back to his page of auctions and checked for more bids. "You want to try it out?" he asked. "There's an auction ending in a few minutes for a painting I *know* I can resell for more. The guy took crappy photos and didn't advertise it right. It's sitting at six hundred bucks right now. I know I can get at least twice that much for it."

"I don't have six hundred dollars."

"I'm not gonna let you buy it yourself. I figured I'd let you go in half on it, just so you can see what it's all about." He navigated to the auction and showed me a photo of a landscape painting surrounded by a gold frame. It didn't look like anything special, but what did I know? "This guy's a listed artist. His work sells for thousands. This should be going for a lot more. I'd be willing to pay up to nine hundred for it."

I hesitated. It didn't feel right to be entering into a business transaction with Fetterman. "I don't know. It seems risky."

"Hey, it's always a risk," he said. "There ain't no guarantees. But I'll tell you—I make money on ninety-five percent of these things. I'm what you call a conservative investor." He looked up at me and flashed a confident grin.

"So you'd be selling it?"

"Yup. I'll sell it and we'll split the profits. The auction's about to end, man. You in?"

I stared at the painting. Half the purchase price was still a lot for me to be throwing at something I knew nothing about, but something told me to trust Fetterman's expertise. He'd bought his huge house in the foothills with money he'd made selling art. "Okay," I said. "I'm in."

Fetterman waited until the final seconds of the auction to place a bid, and he got the painting for eight hundred dollars. He

turned to me and smiled. "We're gonna make some money on this one. I can feel it."

"Can I cut you a check?" I asked.

"No, cash is better. You can get it to me later."

Lane appeared at my bedroom door.

"Are you boys going to ignore us all night?" She spoke in a honeyed North Carolina drawl.

I turned to her and smiled. "Sorry, Lane."

"Yeah, just a sec," Fetterman said. His eyes remained fixed on the computer.

Lane sighed. "Ken, we should probably get going. We've still got to drive back up the hill and walk the dogs."

Fetterman ignored her for a moment longer and then finally stood, tilted his beer high over his head, and gulped it down. Kris and I walked them to the door and said good-bye. We stood on the second-story front porch of my building and watched them drive away. I put my arm around Kris and wondered how I would explain to her that I'd just invested four hundred dollars in a painting I'd seen on the Internet.

"I'm going to try this eBay thing," I said. "It looks easy enough. I think I can make some extra money, maybe chip away at my credit card debt."

"You should." She rested her head on my shoulder. "I just hope it doesn't mean we have to hang out with that guy much."

THE SECOND PART.

Fetterman posted the auction for the painting the next day. A week later it sold for $1,600. With no effort, I doubled my investment, and I couldn't stop thinking that I could do what Fetterman was doing. I didn't have his encyclopedic knowledge of art, but I didn't need that to sell thrift-store paintings. And so, on a Saturday in December 1998, Kris and I went hunting for art. We woke up early, made a list of nearby thrift stores, and drove off with aluminum coffee cups resting between our legs.

Our first stop was the Purple Heart store on Folsom Boulevard, a warehouse of castoffs and odds and ends bathing in the smell of musty wool and Lysol, cigarette smoke and moth balls, body odor and air freshener. The store was busy. Hunched old Russian women, heads wrapped in scarves, flipped through racks of polyester blouses. Two Goth girls in black clothes and white

makeup held up clunky shoes for each other and made faces of disgust. A man with a long gray beard and a nicotine-yellowed mustache held up a nine-iron golf club and gave it a long, careful look, closing one eye as he brought it close to his face.

There was plenty of art to choose from. Dozens of framed paintings hung on the walls. Or so it appeared. As we walked around the store, I discovered that most of them were posters of famous paintings in flimsy frames. Others were reproductions of paintings printed on cardboard with a texture meant to resemble paintbrush strokes. For every real painting there were a dozen posters and look-alikes.

I would come to learn, in the ensuing months, that what we found at the Purple Heart was typical of the inventory of most thrift stores. The paintings that were real, rather than reproductions, generally fell into one of two categories: the amateur art-class paintings and the "starving artist" mall paintings. The amateur paintings were unwanted high school class projects, relics of Grandmother's nursing-home hobby, and forgotten canvases dashed out by weekend painters who followed along with a fuzzy-headed art instructor on public television. These paintings all followed the same general pattern of migration: They were created by nonprofessional artists for fun, given as gifts, displayed in guest bedrooms, stored in closets, moved to garages, and eventually donated to thrift stores.

Starving artist mall paintings were a bit better, in that they were at least done by professional artists. These were paintings sold (or "liquidated at rock bottom prices!") at malls, convention centers, and discount furniture stores in what were often called "Starving Artist" sales. They were mass-produced in Asian countries (Vietnam was responsible for a lot of them) and shipped to the United States in cargo containers. Artists painted them on

assembly lines in art factories. The sky specialist painted the sky. The water guy filled in the lake. The tree person painted some evergreens and passed the painting to the mountain lady. While the artists were competent, the paintings looked dashed-out, uninspired, and cheap. Vendors placed them in inexpensive but ornate gold frames and sold them at bargain prices. Eventually, many of them ended up in thrift stores.

Sometimes these paintings were good enough to sell on eBay. Some amateurs had talent, some factory paintings looked better than others, and every now and then a gallery-quality painting by a professional artist could be found at a thrift store. But Kris and I found nothing of the sort. Everything we saw looked bad, and at the time, I had no idea what to look for in a painting. I didn't know what would and wouldn't sell on eBay.

"These are all pretty ugly," said Kris.

"Jesus, look at that one." A huge Don Quixote loomed before us, drawn in shiny black paint on an olive green background.

Kris put her hands on her hips and squinted at the painting through her tiny European glasses. "That's *atrocious*," she concurred.

"The thing is, I don't think they have to be very good. Fetterman says he makes a profit on really crummy little paintings." I turned away from Don Quixote. "I'm not buying that one, though. I don't think it would even fit in my trunk."

Then we found a little painting of a bouquet of flowers. It wasn't nearly as bad as the Don Quixote, and although I would never have hung it on my own wall, I could almost picture it hanging on someone else's. "What do you think?" I asked.

"I don't know." Kris wrinkled her nose.

"It's only twelve bucks. I'm gonna buy it."

I chose two other paintings at the Purple Heart, stacked

them in the trunk of my car, and continued on to the next shop on our list. We visited the Deseret, a clean, brightly lit place on Auburn Boulevard run by the Mormon Church. With its electronic cash registers, organized aisles, shopping carts, and PA system, it seemed more like a discount department store than a thrift shop. We went to the Salvation Army, a place downtown favored by hipsters looking for ironic T-shirts and ill-fitting jeans. We stopped at the grimy Goodwill store in Oak Park, a poor, run-down neighborhood in the southeast part of the city. By the time we decided to call it a day, we'd collected seven paintings. I brought them home and leaned them against the walls of my dining room, eager to put them on eBay.

Fetterman, excited by my interest in his vocation, drove down the next afternoon to see what I had collected. We walked into the dining room and he stopped suddenly, the soles of his running shoes squeaking on the hardwood floor.

"Oh, man!" he said as he glanced at the large painting of an orange sunset. He grimaced in exaggerated disgust, curling his upper lip away from his teeth. "Dude, that one's bad. *Really* bad." He huffed and shook his head. "Man, where'd you find that?"

"Purple Heart. You really think it's that bad?"

"It looks kind of familiar. I think it's been hanging in there for a couple of years." He chuckled. "Yeah, dude, it's bad. Trust me. *Bad*."

Fetterman circled around my dining room table, his arms crossed over his motorcycle jacket, and gave each painting a quick look. He turned to me and said, "Ken, I hate to tell you this, man, but you've got a terrible eye. You can't sell these on eBay. These are really, really, *really* bad paintings." He twisted his face into a deeper scowl.

I considered this for a moment. "You said they didn't have to be very good."

"Yeah, but these are awful. I'm telling you, you might not have an eye for this business. Not everyone does."

We sat in the living room, and I shifted the conversation away from art. I tried to forget about the hundred dollars I'd just wasted on worthless paintings. I thought about giving up on them, perhaps donating them back to the thrift stores, but decided I should at least try to recoup my investment by putting them up on eBay.

Later that afternoon I brought the paintings out to my sunlit back porch and took several photographs of each canvas. Following Fetterman's example, I took close-ups of the signatures on the ones that were signed. That night I stayed up late and scanned the photos into digital images. I opened each image in Photoshop and cropped out the background. I didn't want to cheapen the paintings by showing my customers the rotting deck behind my apartment or my neighbor's satellite dish in the distance. I'd been watching eBay carefully and noticed that many sellers made mistakes like this. It was common to see a beautiful treasure photographed on a patch of crabgrass, or on a living room floor next to a carpet stain, or, in an attempt to be cute, next to a dog or a child. In a well-known eBay photo that was passed around by e-mail, the reflection of the fat and completely naked photographer could be seen in the mirrorlike surface of the teakettle he was selling. I knew right from the beginning to be careful with my photographs.

After editing the photos, I planned to follow Fetterman's example and list them as "featured in category" auctions on eBay. Art sellers typically only sprung for the $9.99 fee to feature an auction on the first page of the art category when they were selling valuable paintings by well-known artists. Fetterman claimed to be the first eBay art dealer to feature thrift-store paintings. "It makes

them look more valuable," he said, and I couldn't argue with his logic.

EBay extended the privilege of featuring auctions only to sellers with a "feedback" rating of ten or more. The feedback system was the backbone of eBay's "based on trust" policy. It allowed users to make short comments about each other and build reputations. As users collected more comments, their feedback scores increased. I needed to build a feedback record quickly in order to unload the paintings I'd bought.

As soon as Fetterman showed me his auctions, I signed up for an eBay account (I called myself *advice*) and began collecting feedback by buying cheap paintings I thought I might be able to resell. I received my first positive comment on December 16, 1998, from the user *ninecaroline*, who wrote, "Excellent transaction: Good communication with rapid payment. A Pleasure AA++." After this a number appeared next to my user ID on eBay in parentheses, showing my feedback score: *advice* (1). I needed nine more comments, but the feedback came in slowly. Not all sellers left feedback. Some took their time leaving it. By mid-January my score was still just 2.

Having watched Fetterman bid on his own items with other IDs he had created, I decided to create some of my own to help myself build up my feedback rating. I created three user IDs and had each of them leave feedback for my main ID, *advice*. "Great communication, prompt response. Great to do business with!" I wrote with one of them.

Before I pressed the Leave Feedback button for the first time, I paused for a moment. I knew I was bending the rules and manipulating a system that was easy to abuse, but I told myself there was no real harm in it. I just wanted to sell my paintings in featured auctions, and the ten-comment minimum seemed arbitrary. EBay

would make more money from me if I paid for featured auctions, wouldn't it?

I was sure others were doing it. And indeed they were, because in early 1999 it was easy to leave spurious feedback on eBay. Any user could leave feedback for any other user for any reason, or for no reason at all. EBay later tightened the rules and allowed feedback to be exchanged only between users who had completed a transaction.

On February 18, 1999, I received my tenth feedback comment from *yankeedoodleantiques*, who wrote, "Wonderful Customer! Great communications, quick payment, Recommended!!!" Three of my first ten comments were fake, but I didn't let this keep me up at night. I was ready to sell.

I analyzed Fetterman's selling strategies and followed his lead. In addition to listing all his paintings in featured auctions, he also set his opening bids at one cent and did not use hidden minimum "reserve prices." This was another technique Fetterman claimed to be the first eBay art seller to use, and it worked. People were shocked to see featured paintings offered for a mere penny, and the possibility of being able to buy one for an absurdly low price excited them and prompted them to bid. These early bids begat more bids, and eventually, the items were priced at respectable levels. Fetterman usually made good profits on his art and almost always made enough to cover his costs. I watched him start the bidding at a penny on a painting for which he'd paid five hundred dollars. It sold for nine hundred dollars. He believed in his methods and was willing to take risks.

Or was he? In theory, one of these paintings could have sold for a cent, and Fetterman would have lost money. But he had a secret weapon that prevented this from ever happening: shill bidding. If not enough early bids were coming in, he could place

some himself to "get things rolling." If, near the end of an auction, the price was not high enough yet, he could place a "safety bid" to ensure that he wouldn't lose money. His strategy, while seemingly bold, actually involved very little risk. I would come to adopt it myself. The only change I made was to start my items out at ninety-nine cents, rather than a penny, to distinguish myself from Fetterman. "You don't want people thinking we're the same person," he said.

Indeed.

Shortly after collecting the required amount of feedback, I posted my first batch of auctions. I described the little floral painting, the one I bought for twelve dollars at Purple Heart, as follows:

Beautiful Floral Impressionist Oil

This lovely impressionist oil painting is one of several estate paintings I am selling this week, each of which has an opening bid of 99 cents, with no reserve. Please check my other auctions to find other quality paintings.

[Photo of the painting]

This lovely piece is done in oil on canvas and depicts a bright, beautiful bouquet of flowers hovering in a richly hued background. The artist, clearly a skilled practitioner, used confident brushwork and left a thick impasto. The painting has a wonderful texture to it. It does have some age to it, as can be seen in this photo of the back of the canvas:

[Photo of the back of the painting]

This painting measures 20 inches by 12 inches and is housed in a simple wooden frame that is a perfectly subtle complement to the artwork.

It is signed in the lower right corner. I'm not certain,
but the name appears to be "plumb." I'll leave it up to you
to decide:

[Close-up photo of the signature]

Calling the piece an "estate painting" was Fetterman's idea. It was
a way of making the painting seem more important, as if it had come
from the distinguished collection of a wealthy, recently deceased art
collector. "It's not a lie," he said. "All 'estate' means is the stuff some-
one owns. It doesn't mean they died. You've got an estate. I've got an
estate. Every painting comes out of someone's estate." I consulted my
law dictionary and realized he was right, so I added this term to my
sales pitch and used it for most of the paintings I sold. It lent an air
of respectability to a painting of otherwise dubious origin.

I displayed a close-up photo of the signature because this
was what sellers seemed to do on eBay. I didn't think "plumb"
was anyone important. For all I knew, it could have been the
pseudonym-of-the-day chosen by the floor manager of a paint-
ing factory in Hanoi. I figured the mere fact that the painting was
signed boosted its value. It wasn't just an original oil painting. It
was an original *signed* oil painting.

The description for this particular painting wasn't much dif-
ferent from the ones I drafted for the others, but something about
it launched a last-minute bidding war. I watched in astonishment
as my auctions ended, and called Kris as the last one closed.

"Did you see that?" I asked. I'm not sure why I thought she'd
know what I was talking about. It was the middle of the day, and
she was working, which is what I should have been doing. I was
supposed to be writing a letter to a client about California pub-
lic disclosure law, but instead I was refreshing my eBay auctions
every ten minutes.

"See what?"

"The auctions ended."

"Auctions? Oh, the eBay auctions . . . are you rich?"

"Kris, I made, like, six or seven hundred dollars in profit. That ugly little flower one sold for four hundred fifty!"

"Wow!" she said, her voice now pitched with genuine excitement. "Wait—which one?"

"The little one of a bouquet of flowers," I said. "We got it at the Purple Heart. Really colorful, kind of ugly—thick globs of paint scattered like vomit all over the canvas. It looks like something you'd find in your grandmother's house. Three people were bidding on it in the last minute and the price just soared. I thought I was going to have a heart attack."

"You need to start going to the gym."

"Very funny."

Kris offered to make me dinner to celebrate, but I begged off. Packing these paintings would take a while, and I didn't feel like doing anything else. A few minutes later, I received an e-mail message from the high bidder:

Hello,

I was the high bidder on the Beautiful Impressionist Floral Oil you sold on eBay. Please send me your mailing address so I can send a money order to you. By the way, in case you were wondering, this painting is by the French artist Andre Klumb, who is listed in *Davenport's Art Reference & Price Guide.*

John Metropolous
Grass Valley, California

Andre Klumb? I opened the auction page on eBay and scrolled down to the photo of the signature. The first letter, which had looked like a lowercase cursive *p*, could also have been read as a *k*. Maybe it was "klumb."

I called Fetterman.

"Yeah, I saw them," he said as he answered the phone, forgoing formalities. "Beginner's luck. Those paintings sucked."

I ignored his dismissive attitude and didn't care if my success could be attributed to luck. "Hey, that one that sold for four-fifty—the high bidder says it's by an artist named Andre Klumb. He's in a book called . . . *Davenport's* . . . *Davenport's Art Reference and Price Guide*. Have you heard of it?"

"Dude, yeah, I've heard of *Davenport's*," he said. "Everyone's got that book. I've got one right here. But trust me, that painting is not by a listed artist. That thing is a piece of shit."

"Look him up. K-L-U-M-B."

Fetterman sighed, the static of his breath tickling the receiver. "Jesus, man, I'm telling you that painting is not good enough to be by a listed artist."

"Just look him up. You've got the book right there!"

"Hold on, hold on. I'll find him." I heard him flipping pages. "Here he is: Andre Klumb. Born 1925. French. It says he painted landscapes and flowers. In 1990 a thirty-two-by-twenty-six-inch painting by him sold at a Paris auction for $2,410. Another painting by him sold at auction in 1991, but it doesn't say how much it went for. That's all it says."

I leaned forward over the phone and my eyes widened as I took this in. "This painting is of a bouquet of flowers, and it's got his name on it," I said, glancing at the open door of my office. I lowered my voice. "Maybe it's by this guy. Maybe I could have gotten a lot more for it—"

"Dude, you don't know if it's by him. Based on the quality, I *seriously* doubt it. People on eBay do this all the time. They see a painting with a name on it. They look up the name in *Davenport's*. If it's there, they jump to conclusions and think it's by a listed artist. But they don't know. They're just taking a chance. How can anyone know if this painting is by the same Klumb? Do you think there's an art expert who specializes in authenticating paintings by Andre Klumb?" He snorted into the phone. "It's not like he's some major artist—he just got his name in this book."

"I never said it was by the guy in the book. I didn't even know about the book."

"The guy who bought it is a picker," he said. "Pickers are guys who sit around all day on eBay looking up names in their *Davenport's*. They get excited when they see a painting they think is by a listed artist being sold by a seller who doesn't know what he's got. They think they're stealing it from you, but you probably got more for it by *not* trying to convince them that it was by the guy in *Davenport's*."

One of Fetterman's dogs barked, and he yelled at it.

"Trust me," he said. "Even if it was by this Klumb guy—and there's no way to know—you got a good price for that thing. Make sure the check clears before you send it."

John Metropolous, the man who bought the Klumb painting, was indeed a "picker." The Picker is one of a number of archetypal eBay characters I would come to know over the ensuing months.

Pickers, who are invariably male, are on an unending hunt for art to resell at a profit. They're not strictly an eBay phenomenon. The term has been used for decades to describe people who

scavenge thrift stores, garage sales, estate liquidations, and auctions for underpriced art and antiques that can be turned into quick profits. In the art and antique world, the term "picker" is not complimentary. Pickers prefer to think of themselves as "dealers" or "consultants." Some, however, embrace the term. One eBay user who often placed bids on my items went by the moniker *onegreatpicker*.

In the eBay art world the Picker finds hundreds of unsophisticated sellers who don't know the true value of what they are selling. This is the Picker's dream. He can search through scores of paintings every day, sitting at home in his underwear, his tattered *Davenport's* at his side.

But he is not alone. Other pickers scour the site. This is the Picker's dilemma. When he finds something good he must compete with others to buy it, and the winning bid isn't always a bargain price. But the Picker does not complain if something he buys turns out to be worthless. He understands he is taking a risk.

One eBay picker I knew paid a high price for a drawing he thought might have been by the French cubist Fernand Léger. Several months later he e-mailed and told me that his local museum's curator had told him it was a fake. "That's okay," he wrote. "I'll just wait a few months and put it back up on eBay with the title: Drawing by Leger??????"

"As long as I've got the question marks," he wrote, "no one can call me on it."

Another typical customer is the Compulsive Collector. Unlike the Picker, the Compulsive Collector is not looking for underpriced art and does not want to resell what he buys. Nor is he looking for art by listed artists or paintings of exceptional quality. He just likes attractive paintings to hang on his walls, and

his compulsion to buy things keeps him coming back. You might describe him as a "shopaholic." I had one eBay customer who purchased ten separate paintings from me—all of them decent, but not particularly special—who praised each of them with equal sincerity.

The Academic, on the other hand, is a buyer with bona fide credentials. He may have some sort of degree in art or art history or may work in an institutional setting related to art—a university, museum, or large auction house. The Academic is looking for more than just something that looks good on his wall. He is looking for bargains on quality works by accomplished artists. He is savvy, and he is not fooled by cheap imitations and shoddy forgeries, but is not above playing the game of the Picker—bidding on valuable-looking paintings offered by sellers who seem not to know what they have. Unlike the Picker, though, he is uncomfortable with risk. When he buys a painting that turns out not to have the value he'd hoped, the Academic is heartbroken.

His cousin the Slummer is a real-world art-dealing professional who, for recreation, does a bit of "slumming" on eBay, both as a buyer and a seller. He may own a gallery or deal in expensive paintings, and he doesn't view eBay as a serious place to trade art, but he is amused by the wide selection and the vast array of customers. The Slummer is a skeptic and can spot the tricks in online art auctions just as he can identify charlatans in his day-to-day business, but he is not above speculating on unvetted paintings now and then.

Then there is the Wealthy Dilettante, who has plenty of money, time to surf the web, and a dabbling knowledge of art. The Wealthy Dilettante may be a retired CEO, a self-made millionaire, or someone suckling the teat of a trust fund. He sees others

gambling on eBay and relishes the adventure of buying art that may or may not be (and often isn't) authentic. He is not nearly as savvy as the Picker, the Academic, or the Slummer, but he has more money to spend, and is therefore an easy mark for unscrupulous dealers.

Although I hadn't yet come to know these eBay archetypes as I sat on my dining room floor and packed my first batch of paintings, I had already learned an important lesson: I didn't have to claim that a painting was by a listed artist for people to assume it was. In fact, being oblivious to a painting's potential value seemed to increase demand for it.

I was learning other tricks as well. I placed shill bids on each of my first seven auctions with the user IDs I'd created to leave feedback for myself. I rationalized it by telling myself it was harmless because my bids didn't affect the final prices. I was offering the items for ninety-nine cents, and surely I couldn't actually sell them for that little. The bids I placed were very low, just enough to attract attention to the items and draw in other bidders who might be interested in paying more. In placing them, I realized that I, like Fetterman, could bend the rules of eBay without repercussions.

The next day at work I surfed eBay for two hours, taking note of marketing techniques used by other sellers. I looked at Fetterman's auctions and placed a few bids on them with my alternative eBay user IDs, just to "help them along," as I'd seen him do. EBay was suddenly much more interesting than the letters, memos, and briefs I was employed to write. I was getting hooked. And like any addiction, this one would eventually exact its toll.

THE THIRD PART. "I want my

money back. You cheated me."

I stared at the e-mail message, perplexed. It was March 1999, and I'd been selling on eBay for just five weeks. My first unhappy customer, Anthony Matthews (not his real name), was complaining about the painting he'd bought, a grubby little unframed pattern of interlocking geometric shapes rendered on paper in some kind of a water-based paint and signed "BILL" in the lower right corner in capital letters.

I'd gotten it from Fetterman, who owned hundreds of paintings he claimed he didn't have time to sell. "Help me out and put these up on eBay, and I'll split the profits with you," he said. Most of them were ordinary paintings that sold for eighty to two hundred dollars, but the BILL painting—much like the Klumb a month earlier—attracted last-minute bids that drove its price to

$1,300. I was mystified. Why had it sold for so much?

"There's no accounting for the taste of these bidders," Fetterman said. "Just make sure the check clears before you ship it."

Unconvinced by this explanation, I wrote to the high bidder after the auction and asked why he'd paid so much. "Is it by someone famous?"

His response: "No, I just think it's a really cool painting. I like the way it looks."

Now he apparently liked it much less.

"This painting is not by Max Bill. You pretended you didn't know what it was, but you knew people would think it was by him. I can't afford to take a loss on this."

Max Bill? I typed the name into Google and learned that he was a Swiss artist associated with the German Bauhaus school and was known for compositions of geometric shapes. Some of his paintings resembled the one I'd sold, and I could understand why Matthews had made the connection. But as I searched further, I discovered some close-up images of Max Bill's paintings that showed his signature. It was in stylized, lowercase cursive script, rather than block capital letters. The signature on the painting I sold looked nothing like it.

"I work as an archivist," Matthews wrote. "I don't make a lot of money. You misled me."

I didn't know how to respond. I never claimed the painting was by anyone named Max Bill. I'd never heard of the artist until Matthews wrote to me. I called Fetterman.

"A refund?" he snarled. "Why?"

"He says he thought it was by an artist named Max Bill, and he couldn't get it authenticated."

"Well, that sounds like his problem, doesn't it?" he said, his voice calmer now. "You never said it was by Max Bill."

"Can you look the guy up in *Davenport's*? How much does his stuff sell for?"

"I know who Max Bill is," he said. "German guy. If that piece was by Max Bill, it would be worth four times what he paid for it, at least."

"Well, he says he's broke, and he's really pissed off."

"He's broke?" Fetterman huffed. "Well, tell me this—if he's so broke, why's he buying a thirteen-hundred-dollar painting on eBay?"

"Listen, I don't want to get in trouble. He might try to say I ripped him off."

"You didn't rip him off!"

"I know, but maybe we should just give him a refund. We're making plenty of money on paintings that people are happy with. What do you say we just cut our losses on this one?"

"Fuck that," he said. "This guy took a gamble and it didn't pan out. It happens all the time in the art business. He knew what he was getting himself into. He thought he could turn that thing around for a quick profit and it didn't work out, and now he's crying for a refund. You didn't misrepresent that painting at all."

"Yeah, but—"

"Dude, I'm keeping my share."

I thought about it and, in a way, I agreed with Fetterman. Matthews had taken a risk and hadn't properly researched the painting. If he had, he would have known that the signature on it looked nothing like Max Bill's. Another part of me wanted to return the money. This is America—isn't the customer always right? Even if I didn't agree with Matthews's reasons for wanting a refund, it seemed like good business to return the money. More important, I was afraid he might report me to eBay and somehow get me expelled from the site.

But even if I'd wanted to issue a refund, I couldn't afford to make up Fetterman's share of it. I'd earned only half the proceeds of this sale. So I wrote to Matthews, apologized, and explained that I hadn't misrepresented the painting and would not refund his money. He was furious. He threatened to file a complaint with eBay. I wrote back to him, more indignant this time, and invited him to report the facts to eBay, as I had done nothing wrong. I reminded him that when I'd asked him if he bought the painting because he thought it was by a famous artist, he told me no. "You were afraid I would back out of the sale if you told me you thought it was by Max Bill," I wrote. "You were trying to take advantage of me."

I briefly wondered whether Fetterman may have tampered with the painting, but I dismissed the idea quickly. It wasn't that I thought Fetterman was above such behavior; it just didn't seem to make sense. The painting was old, and the signature looked like it had been painted on by the artist. If Fetterman were trying to fool someone, wouldn't he have added a signature that actually resembled that of Max Bill? And why would he have let me in on half the profit? The paintings I'd gotten from him so far were ordinary and unimpressive, and I could understand why it was worth it for him to farm out the work of selling them. But this painting earned me a quick $650 that could have been his, and I could not see how he would have let this happen if he knew it would sell for so much. I attributed the signature and the painting's resemblance to the work of Max Bill to coincidence.

Fetterman and I sat on the redwood deck outside his house and watched the sun disappear behind the horizon. Lane was inside washing dishes. I'd never understood the attraction between the two of them. Lane was smart, educated, and outgoing. She'd

been raised in an affluent, conservative family in North Carolina, had earned degrees in rhetoric and agricultural economics, and had a high-profile job doing public relations for the California Department of Agriculture. They made an odd pair: the agricultural economist and the eBay seller, the polite Southern belle and the kid from the mean streets of Camden. Most women were repulsed by Fetterman's personality. He had an overeager way of approaching people, like a bullshitting used-car salesman. He bragged and told obvious lies. But Lane apparently saw none of this, or looked beyond it, and she adored him. They'd met five years earlier through a personals ad, moved in together within a few months, and later bought this five-thousand-square-foot house, perched atop a hill on a dirt road called Jackrabbit Trail. To come up with the down payment, Fetterman had filled a U-Haul with art and antiques and carted it to Los Angeles, where he rented a meeting room at a Holiday Inn, put an ad in the paper, and conducted his own auction. He raised thirty thousand dollars in one day. He also claimed to have slid an envelope stuffed with five hundred dollars across the desk at the mortgage broker, to help make sure the loan was approved.

Every wall of the house was covered with paintings. This was the first time I'd visited Fetterman since I started selling art, and I was astonished by his collection. These were his crown jewels, the art with which he would never part. High on the wall in the dog room hung an eighteenth-century museum-size painting of angels floating over an Italian city. A small watercolor by Maxfield Parrish adorned a wall in the bedroom. A tiny unsigned Dutch portrait from the seventeenth century hung in one of the bathrooms.

When I arrived, Fetterman showed me around the house, pointing out his favorite pieces. His eyes grew wide as he paused

in front of an angry red and black abstract canvas hanging in a hallway on the second floor.

"This one's a Francis Bacon," he said.

"Who's he?"

"English guy. Totally insane, and a fucking genius."

"Yeah, it's wild."

"I wanted to get my hands on one of these things for years. It was like an obsession." He bit his lower lip and shook his head, his eyes fixed on the painting. "Then I found this one on eBay, and the seller had no idea what he had. He put it in a home décor category and no one else spotted it. I got it for eight hundred bucks. I couldn't fucking believe it."

"How much is it worth?"

"At least a hundred grand, but I'm never selling it. I'm going to my grave with this thing."

"How do you know it's real?"

"Just look at it. It's so damned good. He never signed his paintings, but look at this right here." He passed his hand over some rust-colored splotches in the corner of the canvas. "That's blood. Bacon did that. I'm telling you, the guy was crazy."

He continued to stare at the painting for a moment longer, transfixed. "I love this one," he said quietly.

Although the whole house was filled with paintings, Fetterman called the loft above the bedroom the "the art room." When I ascended into this space I stared in amazement at the five hundred canvases stacked in neat rows against the walls. This was his inventory, the art he'd collected over the years to resell, and most of it was much better than anything I had stashed in my dining room.

Out on the porch, Fetterman set down his beer. "Who would have thought when we were back in the army that I'd be doing so well now?" he said.

"What do you mean?"

"You know, the house, Lane, all this money. I never thought I'd have all this. It's been a lot of work, but I feel really lucky."

I looked down. The question reminded me of how different we were. Like Fetterman, I'd grown up in relative poverty. After my father left when I was nine, my mother struggled to raise four sons on her own. But I'd gone into the army with ambitions, and was eager to get out and start college. I'd always envisioned some sort of success in my future. Fetterman, on the other hand, was an aimless kid from a bad neighborhood who had no idea what he would do with his life. He'd put this all together without a blueprint.

"Hey, I've been thinking," he said after a moment. "You and I should go hunting for art this weekend. We can head up I-5 and hit all the antique stores on the way. We'll split the cost of whatever we buy and we can each sell half of them, and split the profits. Beach and I did it once. Two guys can shop for art a lot faster."

How could I resist? I knew I could learn a lot from him in a day's shopping and would stand to make plenty of money as well. "Sounds good," I said. "What time do you want to meet?"

For Fetterman, hunting for paintings was all about speed. He sat outside my apartment in his red 1988 Ford Bronco and honked three times, impatient, ready to start driving. I descended the stairs and slid into the duct-taped passenger seat. "What took you so long?" Fetterman asked. "We need to hit the road." I yawned and said nothing. He peeled down I Street onto Interstate 5, heading north. We were going to Redding, two and a half hours away, a small city at the far northern end of the Sacramento Valley. "I haven't been up this way for a while,"

Fetterman said. "We might find some good stuff today."

Our first stop was a white barn outside Redding with the word ANTIQUES painted on the roof in enormous letters to attract people from the interstate. "Let's make this quick," Fetterman said as he wheeled the Bronco into the parking lot. "If we don't find anything, we get out and move on to the next place. Time is money."

The front door squeaked on its hinges as we entered. Fetterman said, "Howdy," in a chipper voice to the silver-haired man behind the counter.

Howdy? I shot Fetterman a skeptical glance. This was not part of his New Jersey vernacular.

"What are you looking for today?" the man asked, pushing his bifocals down his nose and looking up from his *Redding Record-Searchlight*.

"Oh, just the old and unusual," Fetterman said, straining to make his voice sound folksy. He smiled, shrugged, and stuffed his hands into his pockets. Was he trying to talk in a Southern accent? Why didn't he just ask the guy if he had any art?

I followed Fetterman around the barn. He grabbed a rusty cowbell and held it up to his face, as if he were looking at it closely, but I could see his eyes darting, scanning the store. "This is interesting," he said. I frowned. I thought we were in a hurry, and he was shuffling around like a bumpkin.

Then he sauntered over to a painting mounted high on the wall at the back of the barn, a large landscape rendered in thick strokes of dark green, yellow, gray, and silver. Its gold frame was fading, and the paint was cracked and darkened with age. Fetterman gawked up at it, his freckled Adam's apple protruding. "How much for the picture?" he asked, raising his voice so the man at the counter could hear him.

The proprietor joined us under the painting. "This is a nice one," he said. "It's five hundred dollars."

Fetterman widened his eyes and whistled. "Wow," he said, nodding. "That's a little rich for our blood. I was hoping it might be a little less."

"Well, it's the nicest painting I've had in here in a while." The man paused and looked up at it. "But I may be able to take a little off for you."

"Yeah?" Fetterman said, turning to the man. "Well, we're just college students, looking for something for our dorm. We can't afford much."

Jesus. College students? We were both thirty-one years old. Fetterman had a receding hairline, a well-fed gut pushing against his T-shirt, and creases forming around his eyes. "Would you take two hundred fifty for it?" he asked.

I looked up at the man to gauge his reaction and wondered how Fetterman had the nerve to make such a offer.

"I couldn't go that low on it," the man said, a polite smile on his face.

"Okay, well . . ." Fetterman paused and looked at the painting again for a moment, then back at the man. "Maybe we'll see you another time, then," he said, his voice friendly. He gave me a look I couldn't interpret and then began ambling toward the door.

The man glanced around his barn, empty of customers, and said, "Wait a second. I might be able to go three hundred on it."

Fetterman stopped. "Really?" He turned to me, nodded, and said, "I think we could do that," as if he were asking for my consent.

"Yeah," I agreed in a small voice, wondering if this was some sort of cue, my turn to step in and insist on an even lower price.

Fetterman slipped a thick wad of hundred-dollar bills from his front pocket and fumbled three of them into the man's hand. As we pulled out of the parking lot, I said, "Three hundred dollars? I said I'd go in half on these, but that's a lot of money."

"Are you kidding? That's an awesome painting. I'll get at least seven hundred for it on eBay, guaranteed. There's only so much you can make on those shitty thrift-store paintings. If you want to make real money, you've got to invest in decent art."

I said nothing. I felt hesitant, even though I wanted to believe in Fetterman's art-buying savvy.

"Trust me," he said. "We got a steal on that one. If you don't want to pay for your half, I'll keep it for myself. I'm doing you a favor by letting you in on it."

"All right, all right, I'm in," I said. "It just makes me nervous to spend so much."

We pulled back onto the freeway and headed into downtown Redding. "Hey, what's up with the doofus act?" I asked.

"What are you talking about?"

"Acting dumb in there. You know, 'Howdy, pahdner, nice cowbell. Gosh, this shore is a pretty pic-chur.'"

"I didn't talk like that," he said.

"Dude, you told him we were college students."

"Listen, man," he said, his voice smug, eyelids lowered. He squinted at the freeway, balled his fist, and flicked a finger skyward. "Rule number one: You can't let these guys know you're in there looking for art. Antique dealers are all alike—they don't know shit about art and they're afraid of people who do. They all think some art expert is gonna come in and buy a masterpiece from them for nothing and then go laughing all the way to the bank. If they think you know about art you'll never be able to talk them down on their prices."

"So you act like a dipshit? You were really overdoing it."

"Did you see how I bargained with that guy? It worked, didn't it?"

"Yeah, that was something," I said, my voice flat.

"Never be afraid to ask for a really low price." He hoisted a second finger. "That's rule number two."

We visited three more stores in Redding and continued north to the tiny town of Mt. Shasta, a place where rednecks and loggers clash with the more recently arrived New Age practitioners who believe energy emanates from the mountain. There we found several shops selling healing crystals, but no good art.

From Mt. Shasta we continued north past a town called Weed. "Nothing worth seeing there," Fetterman assured me. Another thirty miles up Interstate 5 we came to Yreka, a dusty little city probably best known as the last place to buy gasoline before entering Oregon. It had a compact little downtown filled with old buildings, boutiques, cafés and, most important, antique shops.

At one of these shops, Fetterman was captivated by a small watercolor painting. It measured about six by eight inches and was mounted behind glass and a mat board in a thin gold frame. It was a simple landscape—green trees, a meadow, and a mountain in the background—and it had shifted in the frame so that its upper edge was visible below the mat board. "This is a *good* one," Fetterman whispered to me, glancing at the woman who owned the shop to make sure she didn't hear. The painting didn't look very special to me, but it did look old, and I assumed this was why he liked it. We bought it for sixty dollars.

Fetterman kept up his idiot charade in every store we visited that day, but it seemed more subdued after I mentioned it. We drove the 250 miles back to Sacramento mostly in silence. We'd

spent nine hundred dollars and bought nine paintings. To me, this was a lot of money to spend with no guarantee of return. Fetterman assured me we were making sound investments. "I almost never lose money on these things," he said.

When he dropped me off, I took four of the paintings with me. "Remember to take photos of the backs of these old ones," he said. "You've got to show the age." He kept the watercolor painting we found in Yreka. "I'll fix this one," he said. "It needs to be remounted. I'll bring it back down and let you sell it."

The next evening he delivered it. The frame was polished and the glass wiped free of grime. The painting was aligned perfectly behind the mat board. It also had something else: the initials "HW" in the lower right corner. "What's this?" I asked, pointing to the letters. "Yeah," he said. "I found those when I remounted it. The initials had fallen below the edge of the mat board."

"Who's HW?"

"Who knows?" he said. "You can't look up a guy's initials in *Davenport's*. Could be anyone. Anyway, they're going to like this one on eBay. You don't find many good watercolors this old. Try to post these as soon as you can."

I pulled the painting close to my face and looked at the letters in the corner. They looked like they'd been brushed on in the same paint used for the rest of the painting; the color was a perfect match with the dark brown of the tree trunks. And they *were* near the edge—they would have been hidden from view when the painting slipped from its mounting. "I'll put them up this week," I said.

Over the next ten days, Fetterman and I auctioned the paintings we bought on our trip. The landscape we bought at the white barn in Redding for $300 sold for $900. An antique still

life we picked up in Yreka for $60 sold for $275. A painting of a barnyard we bought for $80 brought in $380. Fetterman was right—spending more to buy better paintings was the secret to making money on eBay.

Once again, though, there was a sleeper in this batch of paintings. The HW watercolor sold for $1,600 after a last-minute bidding war. The high bidder, a man named Gerald who called himself Sonny, called me from his home in Arizona right after the auction. "I would have e-mailed," he said, "but I'm a really slow typist."

He was a slow talker, too. He paused between his sentences and breathed heavily into the phone, as if exhausted by the effort of speaking, and I imagined that he was obese. "You probably didn't know this," he said, "but this watercolor may be by Winslow Homer. Most people don't know he sometimes signed his paintings 'HW,' backwards of how you would expect. I found an example in a signature book."

"A signature book?"

"Yeah," he said. "You know, the guides that show pictures of artists' signatures. You don't have one?"

"No."

"Well, you still probably wouldn't have found it. I have a bunch of signature books, and most of them don't show the HW example. It's only in one of them."

My heart pounded in my ears as I hung up the phone. I called Fetterman.

"Dude, that was amazing!" he said as he answered the phone. "We made over three grand on those things. What did I tell you? You've got to spend money to make money."

"Hey, man—tell me the truth. Did you look up 'HW' in your signature guides?"

"What?" He paused. I heard him exhale into the phone. "Yeah, I looked it up. I didn't find anything. Why?"

"'HW' was a monogram used by an artist named Winslow Homer. Do you know him?"

"What?" he said in a high-pitched growl. "Shit! I looked up 'HW' and I didn't find that. Hold on, let me look up Homer." I heard him flipping pages. "Dude, I'm looking at Winslow Homer's signatures right now and HW is not in here."

"The guy who bought it says he found it in one of his guides."

"My book's got a bunch of examples of how he signed, and that one isn't in here."

"If it's by him, how much is it worth?"

"Winslow Homer is a major artist," he said. "It would be worth a lot more than it sold for."

"Maybe we should back out of the auction," I said. I didn't trust him. I wanted to see how he would respond. "Maybe we should take the painting to Butterfield's and get it authenticated."

"Well, we could do that . . . we could," he said. "But you know, the odds are low that you'll get it authenticated. It's really hard to get an unknown painting accepted by the experts. It's really political, and they're always skeptical. I hate to say this, but we're probably better off just taking what we got for it. It's like a bird in your hand, you know? You're looking at those birds in the bush, and I know what you're thinking, but if we take it to an expert and he says it's not real, then what do we do? Then it's worth nothing. If this guy's willing to take a chance, we should let him."

My head ached beneath my temples.

"I'll tell you what," he said. "I'll leave it up to you. If you want to take it to Butterfield's, you can. But in my opinion, we should

just sell it and take what we got. It's less risky." He paused for a moment. "I'm surprised I missed those initials. Maybe I need to get a new signature guide. It's hard to keep up with this shit."

Two days later I received a cashier's check from Sonny and shipped the painting to him. "Got the Homer painting," he wrote. "Love it."

It was all so easy, and I wasn't sure how I felt about it. For a second time, I'd sold a painting for Fetterman with a mysterious signature that resembled that of a well-known artist. It seemed too coincidental. I wanted no part in passing off suspicious paintings.

On the other hand, Sonny was thrilled with the painting and seemed perfectly willing to pay me to take a chance on it. Perhaps it really was by Winslow Homer, and Sonny got an unbelievable bargain. Given what I knew about Fetterman, though, this seemed unlikely.

Flush from the sale of the Yreka paintings, I began hunting for better art, looking beyond thrift stores and visiting antique shops and auctions around Sacramento. I was learning to spot what might sell on eBay, and searching for paintings was becoming more enjoyable than almost anything else I did.

On one of my Saturday forays to an antique store in East Sacramento, I found a California coastal scene, very bright and colorful and a bit abstract for a painting that appeared to have been done in the 1930s. It was signed "Gile" in the lower right corner in crude letters, and the oddly scribbled *e* looked like it could have been an *a*. The owner of the shop told me that although the signature looked like that of the artist Selden Gile, he did not think the painting was actually by him, which was why he was selling it for only three hundred dollars. "There's

something funny about that signature," he said, "and I don't really trust the guys who sold it to me. But it's still a great price for an antique California plein air painting." I nodded and excused myself to go outside and call Fetterman.

"Selden Gile?" Fetterman said. "His work sells for thousands! You've got to buy it if there's any chance it might be real."

"Yeah, but the dealer said he doesn't think it's by Gile."

Fetterman sighed into the phone. "How many times do I have to tell you? Antique dealers don't know shit about art. This guy probably doesn't know what he has." Fetterman described Gile's work—thickly painted, colorful, abstract landscapes and town scenes—and I heard enough to take a chance on the painting.

Later that day I Googled Selden Gile, discovered that he was an influential artist who worked and taught in the San Francisco Bay Area in the 1920s and thirties, and concluded that my painting did look like some of his other works. When Fetterman saw it he disagreed. "It's horrible!" he groaned. "That is definitely not by Selden Gile. I can't believe you bought that thing."

I was disappointed with this assessment (particularly after he'd encouraged me to buy it) but decided to put the painting up on eBay anyway. I needed to recoup my investment. I knew I couldn't claim it was by Selden Gile, because it almost certainly was not. But I remembered the "Klumb" and the "BILL" and the "HW," and I knew people might assume this piece was by Gile if I posted it without mentioning his name. But would it be right to let this happen? Unlike my previous sales, when I learned why the paintings had sold for so much only after the auctions ended, this time I would only be *playing* dumb by withholding the antique dealer's warning. I would be *expecting* a last-minute bidding war.

But then again, how did I know it wasn't painted by Gile? All I had were the opinions of the antique dealer and Fetterman, neither of whom was an expert. I thought perhaps I should just let the market set the price. Maybe there was a chance it *was* by Gile. People who suspected as much would bid accordingly, and I stood to make an enviable profit.

And so I decided to give the pickers what they wanted and pass myself off as an unsophisticated seller who had unknowingly stumbled across a potentially valuable painting. Remembering Anthony Matthews, and how he'd claimed I'd tried to trick him, I interpreted the signature as "Gila," rather than "Gile," because it could have been read either way. I titled the auction "Colorful Old California Coastal Oil Signed Gila."

The strategy worked. A bidding war at the end of the auction drove the price to $3,400. The high bidder, who owned an art gallery near San Francisco, sent a money order, and I packed the painting in a huge box with Styrofoam peanuts and paid extra for insurance. When the buyer received it, he e-mailed. "What can you tell me about the provenance of this painting?" he asked. Provenance is a French word used in the art world to refer to the ownership history of a piece of art. If I told the buyer about the antique store, he might contact the owner. If I even admitted I knew the meaning of the word, I would reveal a level of sophistication belied by my auction description, and the buyer might accuse me of misleading him. So I chose to play really, *really* dumb. "I bought this painting in Sacramento. I do not know if it came from a Canadian province." The customer did not reply.

The Gile auction was my first purposeful execution of the "naive seller" strategy. Having learned firsthand that people would speculate on paintings that weren't directly attributed to

the artists whose work they resembled, I consciously decided to feign naïveté so as to encourage them. By not claiming the painting was by Selden Gile, I thought I was letting myself off the hook. I wouldn't be asked for documentation or any kind of guarantee, and I wouldn't be held responsible if the painting didn't turn out to be what the buyer had hoped. More important, I told myself that by playing dumb, I was not lying, and if I wasn't lying, I wasn't really doing anything wrong. I was no different, I thought, than the realtor who failed to mention that a house was near a noisy fire station because this disclosure wasn't required by law. Caveat emptor.

Kris watched the auction close with excitement. She knew how I'd found the painting, and how I didn't really think it was by Selden Gile. She seemed astonished, but not alarmed, by the fact that someone was willing to pay so much for it. Her acceptance of the whole thing made it seem more acceptable to me.

My brother Matt was more skeptical. "Why didn't you disclose that you didn't think it was by that guy?" he asked.

"How can I be sure?" I said. "I'm no expert."

He smirked and said nothing for a moment. "Did you bid on it yourself?"

I didn't reply. I *had* bid on it myself. I'd told Matt I sometimes placed bids on my own auctions, and he'd gotten angry about it and told me he thought it was dishonest.

By the time I sold the Gile painting, I was learning more about the art trade and had discovered that the notion of authenticity is somewhat murky. The boundary between "real" and "not real" is fuzzy, and many paintings that sell on eBay fall somewhere in this middle ground.

It is often difficult to determine whether an artist painted a particular work, especially when the artist is dead or can't be

located. We rely on "experts"—art historians or, in the case of very famous artists, committees of art historians—to authenticate the works of deceased painters. But these experts can only make educated guesses, and they are not always correct. Furthermore, there are no experts devoted to authenticating the work of most artists who are listed in reference books. It is up to appraisers or auction house employees to authenticate paintings by second-tier artists like Andre Klumb. These people have to guess also, and their guesses are less informed. As a result, many "authenticated" paintings are not real, and plenty of authentic paintings have yet to be certified.

When a seller is sure that a painting is authentic, he doesn't mince words. If a painting is by Van Gogh, the seller will describe it as "by Van Gogh." If the seller thinks the painting might be by an artist but cannot guarantee this, he can describe it as "attributed to" the artist. A painting that is probably not by an artist, but more likely by someone who worked with him, can be described as being from the "school of" the artist. A piece that is from the same period and in the same style as paintings by a particular artist is described as being "in the manner of" the artist. A painting that resembles an artist's work but might not be from the right period is described as "in the style of" the artist. These are all euphemisms for "not by the artist," and they mean that a painting is worth less than one that is "by" the artist.

Many authentic paintings are sold on eBay, but far more fall into the other categories, or dubious hybrid categories. A common trick used by eBay sellers is to say that a painting is "by" a known artist but not actually *guaranteed* to be authentic. Other sellers claim to offer a guarantee of authenticity but grant a very short refund period—a week, for instance—that does not give the buyer time to show the painting to an expert. Some sellers

offer paintings that they themselves have "authenticated" (complete with a "certificate of authenticity" they've created). And of course, eBay is replete with paintings "attributed to" famous artists.

I could have used one of these techniques to sell the Gile painting. I might have said it was "by" Gile but disclaimed any guarantee, or sold it as "attributed to" Gile. But either of these would have been an outright lie. I could have offered it as having been done "in the manner of" or as part of the "school of" Gile, but these descriptions would not have attracted bidders who were hoping to buy a painting by Selden Gile. Pickers look for clueless sellers with authentic paintings, and I determined that it was best to use the naive seller approach. The tactic worked even better than I could have hoped, and it established a dangerous precedent.

After I sold the Gile painting, I invested two hundred dollars for my own copy of *Davenport's Art Reference & Price Guide*, the field manual for every serious eBay art trader. While *Davenport's* did not provide detailed information about any individual artist (just some brief biographical data and price estimates), it included far more artists than any other guide—more than two hundred thousand. Anyone in *Davenport's* was a "listed artist," and on eBay, this was a valuable label. By this time I was shopping for art nearly every weekend and wanted to be able to research paintings as I came across them. "Just never bring that book into a store with you," Fetterman warned. So I left my *Davenport's* in the car, and if I found a painting that was by a listed artist (or could have been by a listed artist, or mistaken for something by a listed artist), I went outside to research it.

After I bought *Davenport's*, I began finding paintings by listed

artists. Usually the sellers of these paintings knew what they had and priced them accordingly, which left me no room to make a profit. Sometimes, though, I found these works in thrift stores or remote antique shops owned by people who knew nothing about art. Orphaned paintings by listed artists hid everywhere, just waiting to be discovered, liberated, and shipped to new homes. Finding pieces by these artists was always a thrill, even when they were not worth much.

The thrill of the hunt was never more exciting than on the clear Tuesday in May 1999, when Fetterman stumbled across something astonishing at a thrift store on Franklin Boulevard. He called and said, "Dude, I need you to look something up for me."

"I'm at work. I don't have my *Davenport's* here."

"Shit!" he rasped. "Can you go home?"

"I'm not going home to look up a painting for you."

"You don't understand," he said, lowering his voice to a near whisper. "Listen, I'm at the Goodwill down in South Sac. I'm using their phone. This is a *big* one, man. A really, *really* big one."

And it was. Fetterman had found a painting by Oscar Berninghaus in a glass display counter at Goodwill. Berninghaus was one of the early members of the Taos school, a celebrated group of artists who migrated to New Mexico to paint the sun-soaked desert and its inhabitants. Berninghaus paintings hung on the walls of the Smithsonian, the Art Institute of Chicago, and dozens of other museums throughout the United States. Some of his works had sold for more than half a million dollars.

The Goodwill employees knew the painting was *something*, but they weren't sure what, so they'd added it to the small collection of "possibly valuable" items up for sale in the store's weekly silent auction. These items—gaudy rings, antique watches, scarves

sewn with the names of famous designers—sat under glass for a week while the store employees recorded bids on a notepad behind the counter. Each bid had to be ten percent higher than the previous one. When Fetterman discovered the painting, the high bid was five hundred dollars, and while he knew it was worth more than this, he wasn't sure how much more.

"The auction for this thing ends today," he said. "I don't have time to go home and research it. If you help me out with this, I'll let you in on it."

I found thousands of references to Berninghaus on the Internet and saw his work selling for tens of thousands of dollars in art galleries. "Okay," I said. "I'm in. It's hard to say how much this thing could be worth, but I would pay up to three thousand for it."

As the afternoon progressed, Fetterman began to think he would get the painting for less than six hundred dollars. He called me several times to tell me he was still the high bidder. I sat in my office, took his calls, and felt trapped. I wanted to be there with him, looking at the painting in person and waiting for the auction to end. Shortly before the four p.m. deadline, as Fetterman leaned against the wall of the Goodwill store and nibbled his fingernails, a woman arrived in a large Ford pickup with her two young children and placed a bid on the painting that was ten percent higher than his. Fetterman and the woman fired bids back and forth over the next minute until the woman scowled, cursed in Spanish, and stomped out of the shop. Fetterman's high bid: $4,400. "If it hadn't been for that Mexican bitch I would have gotten it for five hundred fifty," he said. "What the hell did she want it for, anyway? I think it was a setup by Goodwill."

I snickered. "Are you accusing Goodwill of shill bidding?

Maybe she's just a Berninghaus fan." My lightheartedness was forced, an attempt to smother the frightening fact that I had just spent $2,200 for half of a painting I had never seen. This was far more than I'd ever invested in a piece of art.

The next afternoon, when I met Fetterman at Goodwill, I knew I'd made the right decision. The painting was small—six inches by nine inches—but breathtaking in its precision. It was painted around 1920 and depicted two Native American men sitting under the shade of an adobe hut, escaping the glare of the midday desert sun and smoking long wooden pipes. The frame was intricately carved and adorned with gold leaf. How could something so precious have tumbled into the collection bin of a thrift store?

"Thank you so much for your donation," the woman behind the counter said as she placed the painting into a white plastic grocery bag. I thought: No, thank *you*.

Fetterman and I discussed our next move at a nearby taqueria. "We could sell it on eBay," he said, peeking at the gold frame through the opening of the bag. "But I'm not sure if it's the best way to handle this one." He looked up from the Berninghaus and around the restaurant, scanning for anyone watching him. He pushed the painting deep inside the bag and set it next to him on the orange rubber seat.

"Why not?" I asked. I'd just sold a painting signed "Gila" on eBay for $3,400. I thought eBay was the best place to sell anything.

"It just seems too good," he said. "You don't see many paintings this good on eBay, and the ones that are don't sell for very much. I'm almost wondering if we could get more for it from a real auction house."

"Doesn't that take a long time?"

"Yeah, it can. They also charge high fees. But my gut says an auction house is the best way to go."

Fetterman consigned the piece to Coeur d'Alene Auction, which hosted a once-a-year sale of valuable Western art and had sold a lot of Berninghaus paintings. The auction was two months away when we sent off the painting, and I hesitated to wait that long to recoup my investment but deferred to Fetterman on the decision.

The wait was a small price to pay. When the hammer fell on July 31, 1999, our thrift-store Berninghaus sold for $18,700. After fees, my share was nearly $8,000. This was likely far more than we could have made on eBay.

I was with Kris, at a concert, when Fetterman called me with the news of the sale. She hugged and congratulated me as I told her how much I'd made. "I really wonder if I could make my living doing this," I said, trembling with excitement. She pulled away and gave me a skeptical look. "Well, you're probably not going to find another Berninghaus in a Goodwill store anytime soon," she said. I smiled. "Yeah, you're right." The experience made me believe, however, that valuable paintings really were out there and could be found in the most unlikely places. I knew I wouldn't stumble across them all the time, but if I just worked hard, and kept hunting, I would find more.

I was spending more time with Fetterman than I had since we were in the army. He often called early in the morning on weekends, wanting to discuss a painting or point out something on eBay, and left rambling messages on my answering machine. "Wake up, Private Walton!" he shouted, imitating the Southern accent of one of our army sergeants. "Wake up! Time to do push-ups!" He would laugh and go on for a minute until either he gave up or I answered the phone.

I viewed socializing with him as an unpleasant cost of doing business. He showed me how to make money on eBay. If this required me to have a beer with him now and then, I would do it, often to the dismay of Kris, who avoided him at all costs. When Fetterman and I were out, his behavior often made my skin crawl.

Once we attended a Sacramento Kings game and sat in cheap seats in the upper level. Fetterman gulped two beers during the first half. At halftime he ordered a third, and we decided to move down to two empty seats we'd spotted near the court. As we slid into the hundred-fifty-dollar chairs, close enough to the hardwood to hear the players curse, I felt the nearby well-heeled fans giving us *Who the hell are you?* glances.

But it didn't take Fetterman long to feel comfortable in his new surroundings. Several minutes into the third quarter, excited by being close enough to the court to be heard, he began heckling. "You're fucking blind, ref!" he shouted, placing his palm over his beer to keep it from spilling. "He's been in the paint for nine seconds! He's setting up a tent down there!" After each outburst he turned to me with his *Is this good, or what?* look, nodding his head. I was embarrassed by him, but some of his tirades were funny, especially when his observations were astute. When he said, "Aw, man, he was dancing a jig down there—you missed the traveling call!" he was right. Some people around us laughed. Others rolled their eyes. They weren't used to colorful language down in the expensive seats.

Near the end of the fourth quarter the game was tied, and our rookie point guard Jason Williams was shooting (and missing) three-point shots instead of passing the ball. Another beer had seeped into Fetterman's bloodstream, and he was feeling it. "He's throwing the fucking game!" he shouted. "You gettin' big Vegas

money for this, Jason?" He wasn't just taunting the player—he believed it. He turned to me and whispered, "I've seen this before, man. This game is fixed."

"He's not throwing the game. He's just playing like a rookie. Calm down."

Fetterman continued shouting his conspiracy theory until the woman sitting to my left reached over me and tapped him on the shoulder. "This is Jason's dad," she said, glowering, pointing to the man next to her. I closed my eyes and shook my head. "I'm sorry, sir," Fetterman said, leaning over my lap. "No offense meant." The man did not look at him.

Fetterman sat silent for a moment and then leaned into my ear, cupping his hand around his mouth, and whispered, "I still think it's a fix, man. He's getting paid off. It's all run by the Mafia."

"You're a fucking idiot," I said, staring at the court.

Fetterman said nothing.

The fourth quarter ended in a tie. In overtime, Williams made his shots, resulting in a lead and then a win. I offered to let Fetterman sleep on my couch that night, but he drove home drunk.

As I continued to sell on eBay, I tainted most of my auctions with at least one fake bid. Sometimes I bid on Fetterman's items, and as I learned to spot his fake user IDs, I saw that he often did the same for me. Beach and I also exchanged bids, even though we never talked. None of us discussed shill bidding or asked each other to place bids. There was no grand scheme, just a tacit understanding that shilling was part of how we did business. We were just "helping things along."

There were plenty of other art sellers doing the same thing. One user in New Jersey appeared to have his own small stable of

shill bidding IDs. After a while, I concluded that he was exchanging bids with a couple of other sellers. Eventually he began bidding on my items, but never for amounts that were high enough to win the auctions. I took the hint and placed similar bids on his items. Once, when I accidentally won one of his auctions, he wrote, "Did you really intend to buy the painting, or was that just a courtesy bid? You don't have to purchase it if you don't want to." I bought it anyway, but our understanding had been made clear.

By mid-1999 I had created about seven alternate user IDs. At the time, many eBay sellers were shill bidding, and most of them did it with only one user ID, which made things too obvious. If an eBay user with no feedback continually bid on a single seller's items but never won them, it was clear that the user was a shill. To avoid this transparency, I used different user IDs, and used them to bid on other sellers' items as well as my own.

I saw the shill bidding as an advertising strategy. Nothing drew a crowd like a crowd, and sometimes I needed to supply the bodies. Really, this was just rationalization. The truth was that my customers trusted me to play fair and follow the rules, hated the idea of a seller bidding on his own items, and would not have wanted to buy from me if they knew I was doing it. This is why I went to such great lengths to hide it.

Another way Fetterman, Scott, and I made our fake user IDs look more authentic was to have them leave feedback for each other. Again, we didn't do this pursuant to any elaborate scheme. For the most part, it was casual and unspoken. Every now and then I might use one of my user IDs to leave feedback for an ID I knew was Fetterman's, and he might return the favor.

Once, Beach tried a more complex scheme to exchange feed-

back. He created a new user ID called *pigroast* and used it to post an auction requesting feedback from strangers. He promised to send the board game Risk, at no charge, to the person who left the most creative comment. Beach wasn't the first person to try this. People had been running "feedback auctions" on eBay for a long time, and the site had banned them. When eBay discovered this auction, it suspended *pigroast*, but not before Fetterman and I had left feedback for it with nine of our alternate IDs.

Shortly after the auction was canceled, Kris called me at work. "Ken, your eBay games are getting out of hand," she said.

She knew I sometimes placed bids on my own auctions. I'd told her about it. While she wasn't convinced that my shill bidding was harmless, she'd never expressed alarm about it. "I found the auction," she added.

"What auction?" I honestly wasn't sure what she was talking about.

"Listen," she said. "I'm not trying to snoop around in your business, but I was looking at your paintings, and saw that you were bidding on one of them with one of your made-up IDs. I looked to see what else it was bidding on and came across this *pigroast* auction."

"Oh, that was kind of a little joke. Scott Beach set it up. I guess it's against eBay rules, so Scott's new account got suspended, but none of mine did. It's no big deal."

"Ken, it looks really bad. It ties you all together. Some of those bidders are yours and I know some of them are Fetterman's. They probably all belong to you guys. I looked at what they're bidding on, and you guys are out of control. You bid on each other's stuff all the time. It's way worse than I thought." Her voice was low and serious. "You could get caught for this. If I could find that auction, anyone could."

"It's not that big a deal," I repeated, defensive, almost plead-ing. "It's not hurting anyone. It's not illegal—just an eBay rule."

"But it's wrong, isn't it? All those fake bids?" Her voice was lowered to an almost whisper, as if she were afraid someone in her office might hear. "What if someone reported it to the Bar? It's unethical. You could lose your license."

For a moment I considered this, and then dismissed it. I was getting so much money and satisfaction from eBay that I seemed to be able to rationalize anything I did on the site. "Kris, I seriously doubt that any of my clients are going to report this to the Bar."

"Well, if you're going to keep doing this I don't want any part of it."

"Okay," I said. "I'll stop. Or I'll cut way down on it, at least."

And for a few days, I did. I told Fetterman to stop bidding on my items and quit using the user IDs Kris knew about. But this didn't last. Within a week I had created new user IDs and was back to the same old tricks. With a few clicks of a mouse, I chose shill bidding over the integrity of my relationship, and barely paused to give it a thought.

THE FOURTH PART. "Ken,

no one is buying your excuses," Ruthann said, standing in the doorway of my office, scowling over the top of her glasses. She paused for a moment to let her words penetrate. "I can't count on you to finish projects. Why do you think you're still doing research memos?"

I stared up from behind my desk, mouth hanging open, unsure what to say. "Ruthann, I—"

"I don't want to hear it. Have it on my desk by tomorrow morning." She turned and walked away.

My stomach wound itself into a knot as I turned back to my computer. In the upper left-hand corner of the screen: the familiar red-blue-yellow-green of the eBay logo.

Ruthann's opinion of me was undoubtedly shared by other partners at the firm. I was no longer reliable. I made excuses. I turned things in late.

I needed out but didn't know where to go. When I interviewed with other firms and glimpsed attorneys working in their offices, I felt genuine dread. Their eyes were hollow, their voices tired or fake. I knew the work would be just as tedious at another firm, and it would only be a matter of time before my new employer realized I was a slacker.

All I really wanted to do was sell art. Sometimes I spent up to four hours of my workday on eBay. As I proved myself to be unreliable, the partners at my firm gave me fewer assignments. This, in turn, gave me even more time to skulk online. I wasn't even close to meeting my "billable hours" requirement.

I was ashamed of my performance, but I felt helplessly unable to change my ways. EBay had shown me that I could make money doing something I enjoyed, and once I'd sunk my teeth into it I had no taste for anything else. I felt like a treasure hunter each time I grabbed my *Davenport's* and set off to look for art in out-of-the-way places. I loved finding beautiful paintings that had been dumped into thrift-store donation bins. I loved unearthing paintings by listed artists in forgotten corners of small antique shops. I loved taking photographs of the paintings I found, casting them in their best light, and capturing the beauty that others had overlooked. I loved crafting descriptions of them, writing in ornate prose that had no place in legal writing. I relished the e-mail messages from customers who were delighted with their purchases. I loved the independence of it all, how I controlled every part of what I did. And of course, I loved the money I was making.

My newfound passion made me more animated and more talkative, and I appeared happier than I'd been six months earlier. Practicing law depressed me. Selling art excited me. Friends began to notice the change and encouraged me to continue. Except for

Matt. He didn't want to hear any amusing anecdotes about my online art-dealing adventures. To him, the fact that any of my auctions included shill bidding made the whole venture wrong.

I didn't let Matt's opinion dampen my enthusiasm, though. I was growing to love art, and I spent countless hours researching it. When I found a painting by an early California impressionist, I bought books about California impressionism and grew enamored with the thick, loose brushwork of Guy Rose, Maurice Braun, and William Wendt. I spent hours gazing at photographs of Granville Redmond's poppy-strewn hillsides, Euphemia Charlton Fortune's harbor scenes, and Edgar Payne's majestic plein air paintings of the Sierra Nevadas. I dragged friends to museums to see these paintings up close, to watch the light glint off the varnished edges of the brushstrokes, to see the colors in their natural state.

When I found the "Gile" painting, I learned about the work of the Society of Six, a group of artists Selden Gile painted with in northern California in the 1920s and thirties. Like the Fauves had in Paris decades earlier, these artists worked with extravagant, otherworldly colors, freeing their art from the confines of reality, paving the way for the abstract artists who would follow. Their work was rich, gaudy, and captivating.

I grew to appreciate the brash, emotional paintings of the abstract expressionists of the 1940s and fifties, and I learned how the artists of the San Francisco school, right on the heels of the pioneering New York school, helped forge this movement. I felt an instant attraction to the work of the Bay Area figurative school, a group of northern California painters led by David Park who, in the 1950s, moved away from nonrepresentational painting and went back to painting *things*—people, buildings, landscapes—using the intense brushwork

and coloration they'd learned as abstract expressionists.

As I learned about art, I collected it. I could not afford paintings by the famous artists I admired, but found works by lesser-known painters who worked in similar styles. I filled the walls of my apartment with these paintings and continually sought more. I bought art for myself that I would not have considered selling. It seemed that most people who sold art were the same. Even those who dealt art on the fringe—pickers who scrapped for their livings at flea markets and junk shops—collected beautiful paintings. I once visited a picker who lived in a dilapidated neighborhood in Sacramento and found his apartment walls adorned by California impressionist paintings worth thousands of dollars. He could have sold them and bought a house, but he could not fathom the thought of parting with them.

At the time, all that I loved about selling art obscured anything negative I did on eBay. Despite the shill bidding, I sold a lot of good paintings at prices that were lower than what galleries would have charged. Many of my customers wrote to tell me how thrilled they were with what they bought. Each time I received a message like this, I felt like I'd changed someone's life for the better, even if in a small way. This sense of fulfillment outweighed anything I got from dispensing legal advice to municipal bureaucrats, and it made me believe that what I was doing was honorable. Or mostly honorable, anyway.

As the first half of 1999 lapsed into the second, though, my tricks continued, and the stakes grew larger. In August, Fetterman brought me another painting. It measured twenty-four by twelve inches and in the middle of it, the artist had sculpted a half-inch-thick figure out of glue or caulk. This stick figure, its long limbs akimbo, stood suspended in a flat, swirling

wash of light brownish green. Below the figure was an illegible cursive signature.

"What's this?" I asked, pointing at the scrawled name.

"Well," Fetterman said, "I'm not going to lie to you."

Oh, really?

"It does look a little bit like the signature of a Swiss guy named Alberto Giacometti," he said, "but I'm just not very sure. I think we're better off selling it on eBay and not saying it's by him. You're the better one to do that."

I pulled the painting close to my face and studied the signature. It looked original to me.

"Have you black-lighted it?" I knew by now how to spot a fake signature on a painting. Under a black light, an added signature "swam," seemed to float over the surface and fluoresce differently from the rest of the painting.

"Yeah," he said. "It looks good, but there's just no way to know. It would be nearly impossible to get a painting by this guy authenticated."

That night I bought a black light from Home Depot and scanned the surface of the painting in my windowless bathroom. The signature didn't stand out. I searched the Internet and learned that Giacometti was primarily known as a sculptor of lean figures similar to the one in the painting. So was this just another remarkable coincidence, or did Fetterman know how to add a signature in a way that couldn't be detected with a black light?

What I should have been asking myself is whether I really wanted to know, or if I even cared anymore. Six months earlier, I would have tossed and turned at night if I'd thought I might be in possession of a forged painting. Now I went to sleep thinking about the money I would make.

The auction for the stick figure painting followed a typical pattern. Within the first few days, the price rose beyond what an ugly little stick figure painting might ordinarily command. But this time, potential buyers were further encouraged by the high bidder on the painting: *p_giacometti@bluemail.ch*. One could only assume that this was a member of the artist's family, perhaps his favorite nephew. I suspected otherwise; I knew it had to be Fetterman.

"Yeah, it's one of my new bidders," he said with a snicker when I asked him about it.

"Don't you think that's a little too obvious? We're going to get a good price for this thing. Maybe you should lay off the shilling."

"Hey, I like this painting," he said. "If I end up as high bidder, I'll buy it." This is how it was with Fetterman. He always maintained the ruse, even with me, that his bids were legitimate attempts to purchase paintings, even when he was bidding on something he owned. This was probably dictated by his ever-present paranoia, so much a part of him that it influenced nearly every decision he made. When we went out for beers, he refused to bring any ID, for fear that a bouncer at a bar would memorize his address and rustle a gang of thieves to rob his house while he was at the bar. When he refused to admit to shill bidding over the phone, he probably did so because he feared that his line was tapped.

On the last day of the auction, real bidders drove the price to $10,600. As I sat in my office and watched the bidding come to a close, I realized that I would make more on this single auction than I earned in an entire month at my job. How could I focus on my work when eBay was bringing in such sums? And how could I fret about whether or not this painting was real

when someone was willing to pay me so much for it?

The person who was willing to pay so much for it was John Metropolous, who'd bought the Klumb painting from me seven months earlier. Shortly after the close of the auction he called and said he was sending an art appraiser to pick up the painting.

I told Fetterman about the appraiser. "Shit!" he said. "Tell him you don't accept pickups. That's your policy. If he doesn't like it, we'll sell it to one of the other bidders."

"He lives in Grass Valley," I said. "It's only forty-five minutes away. How can I tell him he can't come pick up a painting he's buying for ten grand?"

"Shit," he said again, almost whispering this time. "What's the art appraiser's name?"

"Rudy Curiel."

He paused. "I think I've heard of that guy. Well, do your best, man. Meet him in a neutral location—don't let him come to your house."

Rudy Curiel arrived at my office with a mousy blond woman he introduced as his attorney. He was in his mid-forties, but his mane of brown, wavy hair, smooth olive complexion, and trim build made him look younger. When he smiled from beneath his woolly mustache and stuck out his hand to shake mine, I noticed that he bore a striking resemblance to Geraldo Rivera, circa 1990. I escorted Rudy and the woman to a small, windowless conference room on the twenty-seventh floor and set the painting on the chair next to me. I cringed as I looked at the stick figure glistening under the harsh fluorescent lights. If Fetterman had faked this painting, there was no way it would get past this guy.

Rudy spoke first, his baritone voice oily and measured, like a late-night disc jockey or a seasoned telemarketer. "Well, my

friend, I'm not sure if you've heard of me, but I've been working as an art appraiser and dealer in this town for many years." He flashed his Geraldo smile and continued. "I deal in a lot of very high-end paintings, and I have an international clientele." Bigger smile. "I'm well known among my colleagues in art circles and, if my daughter weren't living in Sacramento, I would probably be working in New York or Los Angeles. I spend a lot of time in both places." Even bigger, toothy smile.

Rudy plucked a yellowed newspaper article from his leather portfolio and spread it out in front of me on the table. It curled at the corners and was held together by tape. A couple of paragraphs were underlined in ballpoint pen and highlighted in yellow. "You may have read about me in the *Sacramento Bee*," he said. I glanced at the date on the article and saw that it was six years old. "They interviewed me and asked if a painting had ever sold for more than a million dollars in Sacramento. I told them that I'd sold paintings for that much, but not in this town." He paused. I nodded. "So, as you can see, I'm well known around here."

Rudy cleared his throat and exchanged a smile with the woman. "I was delighted when my friend John Metropolous asked me to look at this painting for him. I've come across some real gems in my career, and we're hoping this may be another. So, shall we get to the matter at hand?"

"Of course." I slid the painting across the table, feeling hesitant as I did so but doing my best not to let it show.

"I'd like to take a look at it under a black light," he said. He flipped the switch by the conference-room door and scanned the surface of the painting with his eighteen-inch blue wand, explaining how it could detect changes. "If someone added this signature—and I'm not saying you would have, but

someone could have in the past—this black light would reveal it to me."

"Interesting," I said.

Rudy finished his analysis and removed his glasses. "Well, my friend, I think what you may have here is an original work by a Swiss artist named Alberto Giacometti."

"Yes, that's what John Metropolous said, but I really have no way of knowing. I just got it from an estate sale."

"Well, I think I may be able to authenticate it," he said. "And if I can help John sell it, I'll send some of the proceeds your way. I believe in taking care of the people who help me."

"That's very nice of you."

Rudy pulled a cashier's check for $10,600 from his portfolio, laid it on the table, and pushed it toward me. "Congratulations, young man. This was an astute purchase. Many people would have passed this painting up."

"Thanks. I just buy what I like."

We returned to the lobby. "I'll let you know what happens," Rudy said. He and the woman shook my hand and disappeared into the elevator.

I stood there for a moment, staring at the check, thinking about what had just transpired. He was supposed to be an expert. I just sat there, showed him the painting, and he bought it. It was all too easy.

The Giacometti was part of "the estate of Eve Mitchell," a collection of paintings Fetterman claimed to have discovered in a shop in a small town a hundred miles south of Sacramento. "I bought them for next to nothing," he said. "The guy was liquidating her estate and didn't know what he had. There's some *really* interesting stuff."

Eve Mitchell was listed in *Davenport's*:

Mitchell Evalyn (Eve) 1907–Napa, CA—$200–700—
Hughes (2)—Painter, Sculptor, Ceramics, Pupil of Boynton,
Obata, Stackpole.

She wasn't a major artist, but she was in the book, which
gave her work some value. Fetterman showed me a stack of pen-
and-ink landscape drawings signed "Eve Mitchell" and some nice
pastels. The most interesting pieces in the collection were not by
Mitchell herself, though—they were the drawings and paintings
that, like the "Giacometti," appeared to have been done by more
major artists.

In all, there were about seven or eight pieces like this that I
sold over the next few months. It was around this time that I
began to feel certain that Fetterman was altering the paintings he
was giving to me to sell, though I wasn't sure how. I knew it was
possible to find valuable paintings in unexpected places, but
what Fetterman claimed to have unearthed was too good to be
true. And I no longer cared. I didn't ask and he didn't tell. I knew
my role. I auctioned the paintings on eBay, let the buyers make
assumptions, and deposited the checks as they came in. Selling
art on eBay seemed to have changed my life so profoundly, in so
many positive ways, that it was easy to turn my back on any
ethical reservations I may have had.

I wasn't just selling paintings for Fetterman, though. He had
a stake in only a small fraction of what I sold on eBay. By this
time I was mostly independent, and I ran my eBay business with
oiled efficiency. I could write a description of a painting in five
minutes. I bought software that kept track of what I was selling,
who had paid, and how much profit I'd made. I got a $1,500 dig-
ital camera. I knew where to buy bubble wrap and Styrofoam
peanuts at wholesale and where to scavenge for used cardboard

boxes. I was on a first-name basis with the cheapest freight shipper in town.

I hunted for art nearly every weekend, sometimes traveling hundreds of miles to ferret out paintings from shops in small towns around northern California, Oregon, and Nevada. Hunting for art cut into my leisure time. When I went to Lake Tahoe for the weekend to visit friends, I bowed out early to go to a flea market. When Kris and I took what was supposed to be a romantic weekend trip to Ashland, Oregon, I dragged her to at least a dozen antique stores along the way, stopping only when she insisted. My obsession with eBay was eating away at our relationship.

As I bought more art, I developed a knack for spotting paintings I could undoubtedly resell for more. The trick? I found art in places where it wasn't wanted. I once found a striking abstract expressionist painting from the early 1960s at a thrift store in Turlock, a farming community in the San Joaquin Valley, smack dab in the center of California. The residents of Turlock, perhaps not especially fond of abstract expressionism, had let the painting languish in the store for months, but I knew I could sell it to someone in a big city where mid-century modern design had caught on. I bought it for $30 and auctioned it for $760 to a man in Los Angeles. He was thrilled with the purchase, as he would have paid more for it at a chic LA gallery. While not every painting succeeded to such a degree, this kind of performance was not uncommon, and nearly all my paintings brought in at least twice what I paid for them.

My success wasn't due solely to the fact that I picked good art. Everything about my auctions cast the paintings in the best possible light. An auction's title was particularly important. It was the bait, the one-sentence pitch that made people click. If a painting

was old, I made sure to highlight this fact in the auction title. If a painting was signed, I might call attention to this. If I was sure a painting was by a well-known listed artist, I included the artist's name. If it was by a listed artist whose work was not very valuable, I might just say it was "listed," to pique curiosity. If a painting featured a nude figure, I always included the term "nude" in the title. Any auction of a nude painting got twice as many clicks because aficionados of this style (and occasional perverts) searched by this keyword. And of course, descriptive adjectives always helped. Every painting could be described as "beautiful," "stunning," "breathtaking," "captivating," "charming," or "lovely." Putting this all together, my auction titles looked like this: "Beautiful Old Impressionist Oil—Nude—Signed, Listed Artist."

I was also careful to make sure the photographs told the right story. If a painting was old, I revealed evidence of its age. If the artist showed great skill, I posted large photos of the piece and showed close-ups of the brushwork. If a painting looked better from a distance, and revealed itself to be amateurish under close inspection, I showed a single, smaller picture of it. The same rule applied to signatures. If an artist signed with a confident, professional-looking flourish, I showed a close-up of the signature, even if the artist was not listed. If, on the other hand, the artist's signature was weak or sloppy, I left it out.

The descriptions were as important as the titles and photos. Selling on eBay introduced me to my inner advertising copywriter, and I learned to craft elaborate descriptions that made my paintings sound irresistible. To attract bids on a painting of an oak-laden hillside, I wrote, "drawing upon the tradition of the great California impressionist masters, the artist used a rich palette of pastel hues and thick, confident brushwork to render this stunning landscape." To describe a painting of a nude figure,

I might ask bidders to "notice the masterful way the artist captured the subtly sensual but dramatic effects of light and shadow on the contours of the model's body and the folds of her skin." I often compared the style of a painting to the work of a master painter. "In the tradition of Picasso and Braque, the artist of this cubist piece stripped his subject down to its raw, geometric elements." If a work did not remind me of any artist in particular, I would, at the very least, assign it to a popular style or school, and describe it, for instance, as "California impressionism" or "Hudson River school." In each description I asked the reader to "imagine this painting hanging in that special place in your home or office" and invited him or her to "place a bid now or you may regret passing up this lovely work of original art." After a while the prose became formulaic, and I could draw on a library of snippets stored in my brain, but I still strove to make each description unique.

Ornate adjectives weren't enough to sell a painting. My descriptions were more tactical than this, and in each auction I was careful to emphasize good features and minimize bad ones. If a painting was old, I would call attention to this fact, but if it was not so old, I wouldn't mention the age at all and would let the readers guess. If a painting was surrounded by a tasteful frame, I raved about it; if the frame was ugly, I simply didn't mention it. I touted the grand scale of a large painting and simply included the dimensions, in inches, of a tiny one. If a work was in excellent condition, I let the reader know in the first paragraph. Damage to a painting could be addressed near the end. "There is some flaking paint in the lower left corner that could be repaired, but that does not detract from the overall beauty of the piece and would not diminish your enjoyment of it."

Even when selling paintings that had not been tampered

with, I still sometimes crossed the line and played the naive seller, putting up something I knew might be mistaken for a better work. When I came across a painting that appeared to be by a listed artist but obviously was not, due to its age, its size, the materials used, or some information that came along with it, I was always willing to describe it in a way that would entice bidders to speculate.

Even as I was making a good income selling my own paintings, I still counted on an occasional "mystery" painting from Fetterman to fill my pockets with cash. His were the ones that brought in the most money, and I began to look forward to them. One of these paintings was a small California landscape depicting a lichen-green hillside scattered with gnarled oaks. It was signed "P. Gray" and, with its darkened canvas and oily patina, appeared to be very old. When Fetterman brought it to my house, it stank of varnish, and I asked him why. "It had a few chips of missing paint, so I did a little restoration and cleaned it," he said. "I put some varnish on top. Just store it near a window and let it sit under the sun for a while."

I looked up the name and found Percy Gray, a California artist known for painting oak-laden hillsides. Once again, the signature looked original under a black light, even though I suspected Fetterman may have added it. But what did it matter? I put the painting up for auction, played dumb, and sold it for $7,600.

The high bidder was Michael Luther, the CEO of Omaha-based Aden Enterprises, a company that funded Internet start-ups and invested in technology patents. In a telephone call after the auction he told me, with great pride, that he was a self-made multimillionaire, and he mentioned his net worth. I told him I didn't know whether the painting was by Percy Gray and could offer no guarantee, and he seemed eager to take the risk. He had

studied art, he told me, and he had a good feeling about the piece. He trusted his gut and liked to take risks. When he sent a check he wrote, "I do not care whether or not this turns out to be by Percy Gray, it has been such a great adventure to find it and buy it from you."

The thrilling adventure was soon over. Several weeks after the sale he wrote, told me an art expert had deemed the painting a fake, and demanded a refund. "I was suspicious when I received it and it smelled like varnish," he wrote. This time I didn't consult Fetterman or pause to reflect on whether it might be "good business" to accept a return. Luther had taken a risk, bought the painting knowing it might not be authentic—and also knowing that if it were authentic, it would be worth double what he paid—and was now experiencing buyer's remorse.

I had grown to have contempt for this type of customer. I viewed them as greed-driven opportunists who sought to take advantage of unknowing sellers. This helped smother the ironic fact that I was the real opportunist, driven by my own greed, taking advantage of buyers from whom I'd hidden the truth. I wasn't being honest with myself, but I had to concoct a rationalization to keep things going. I couldn't allow myself to think I was doing anything wrong.

Luther was furious when I refused his request. "I will sue you," he threatened. "This is fraud, and I will report it to the FBI." I didn't fear a lawsuit, because I knew it would cost too much to sue me over a $7,600 painting. I also scoffed at his threat to report me to the authorities. "I seriously doubt the FBI will be interested in my eBay auctions," I wrote, displaying my arrogance and an appalling lack of prescience. "You have no reason to report this, because I did not misrepresent this painting." Translation: Go fuck yourself.

I told myself buyers like Luther deserved what they got. We were playing the same game and I'd beaten him. I couldn't feel sorry for a person who had willingly participated and lost.

I consoled myself by giving a refund to a woman I thought had stepped into the game by accident and didn't belong. She paid $2,300 for one of the pieces from the estate of Eve Mitchell, a small pastel portrait of a Polynesian woman that resembled the work of Paul Gauguin and was initialed "P.G." She called after she found out it was not what she'd hoped, sobbing, and explained that she was a stay-at-home mother of two small children who'd made a big mistake, gotten in over her head, gotten swept up when she thought she'd stumbled across a treasure. I heard her husband yelling at her in the background. This was too much for me to bear. I hadn't yet given Fetterman his share of the proceeds from this sale and, over his vociferous protests, I issued a refund. Within a week, I had sold the painting to one of the other people who had placed a bid in the auction.

As I became further embroiled in the world of eBay, changes were taking place in my personal world. On our second try, Kris and I succeeded in breaking up. Things had been going sour for months, and we'd both decided that our romance was not meant to be. My eBay fixation hadn't helped. Time I could have devoted to Kris I instead spent selling art online.

I was also giving serious thought to quitting the firm. I was making nearly as much money selling art as I was at work, and my job performance was continuing to suffer as a result. I dreamed of financing my own law practice with the money I was earning as an auctioneer.

I shared eBay stories with my friends, and most of them were amazed, or at least amused, by the tales of rampant speculation

undertaken by my customers. "So you never claimed it was by the artist?" they asked. "Nope," I replied. "And they paid how much for it?" I sometimes hinted that I thought Fetterman might have tampered with some of the paintings, but few people seemed very alarmed by this when I assured them I wasn't lying in my descriptions. I was less open about the shill bidding. I didn't tell many people about it, but when I did, and explained how common it was on eBay, most of them didn't seem to think it was that big a deal.

Some of them wanted to try eBay themselves. A couple of friends in the Bay Area began buying paintings at a local flea market and reselling them on eBay with great success. To Fetterman, this was a betrayal. "Telling people about eBay is like stealing money from me," he said. "How are we going to find good art if all your friends are buying it up under our noses?" But I wasn't concerned. I knew there was plenty of art to go around.

Not everyone shared my enthusiasm for what I did on eBay. My brother Matt continued to be skeptical. He'd met Fetterman, disliked him instantly, and was sure he was using me to pass off forgeries. Matt changed the subject whenever I started talking about eBay.

My friend Dave, who had met Fetterman years earlier, had similar reservations. When I told him about some of the paintings I'd gotten from Fetterman and admitted that I thought they might not be real, he said, "Man, if you keep hanging out with Fetterman, you're going to end up in trouble someday. I'm worried about you."

Other warnings were not so friendly. I sold a landscape painting with a cryptic symbol in the lower right corner, a stylized *X* inside a circle, to a woman in nearby Davis, California, who thought it was a work by the artist Xavier Martinez. She

paid $750 and never complained. Months later, after I'd unloaded several of the paintings from the estate of Eve Mitchell, she sent me an e-mail message.

"I see what you're doing," she wrote. "You offer paintings with confusing signatures and pretend you don't know what they are. You let the greed of the buyers take over and they pay ridiculous prices. I figured it out when I saw that horrendous 'Giacometti' sell for so much. It is an interesting game you're playing. I wonder how long you can keep it up."

No refund request. No threat. No accusation of fraud. Just a message: *I'm onto you.*

She wasn't the only one watching me.

THE FIFTH PART.

I was in Peoria, Illinois. Well, it was actually Peoria Heights, a neighborhood that sits on a small hill with a view of regular old flat Peoria. I'd come here to deliver an abstract expressionist painting with "C. Still" scrawled on the back of the canvas in black ink, yet another piece from the estate of Eve Mitchell. The writing suggested the painting might have been done by Clyfford Still, a San Francisco artist whose works had sold for more than a million dollars. The winner of the auction, Don Shay, had placed a bid for $32,000, the most I'd ever gotten for anything on eBay.

The painting might have sold for more, were it not for the fact that Clyfford Still always signed his paintings with his first name only. This one was suspiciously different. Several people e-mailed during the auction to point out this anomaly, but I ignored these warnings and let the painting do its thing.

Fetterman, most likely vexed by his fumbled forgery, took matters into his own hands after the auction. "I sent the high bidder an e-mail," he said.

"What? Why are you e-mailing my bidder?"

"I wanted to make him feel comfortable with what he'd bought," he said. "I sent it from a made-up Hotmail account and told him I was an expert on Still and wanted to take a picture of the painting for the frontispiece of a book I'm writing."

"The what?"

"The frontispiece. The cover photo for a book."

"Jesus, man, don't you think that's a little over-the-top?"

"Well, that signature looks funny, and I wanted him to feel good about taking a chance on the painting. I told him Clyfford Still used the signature 'C. Still' sometimes, and not a lot of people know this. I congratulated him on his astute eye for art."

"Okay, man. Whatever. I don't want to know about it." But it was too late. I knew what he'd done, and even though it seemed recklessly dishonest, I did nothing about it.

Perhaps fueled by Fetterman's e-mail, Shay initially seemed excited about his purchase, but within a couple of days he cooled and said he did not want to buy the painting without seeing it in person.

"Do you want to back out of the sale?" I asked. I knew I could probably sell it to someone else if Shay didn't want it.

"No," he replied. "I'll buy it; I just want to see it first." I was irritated by this but could understand his trepidation—$32,000 was a lot of money to send to a stranger. So I packed the painting in a huge cardboard box, flew to Chicago, and drove 170 miles to Peoria in a rented Chevy Blazer.

Shay's sprawling old house was filled with antique oak furniture, Tiffany lamps, beautiful paintings, Persian rugs, and expensive

ceramics. When I arrived he gave me a lengthy tour, describing his treasures in great detail. After extending the requisite amount of Midwestern hospitality, Shay invited me into the living room, where his friend Peter (whom I will call Peter because I can't remember his real name), the local art expert, was waiting for us. Peter was short, in his mid-forties, prison-camp thin, and walked with a pitiable limp. He stood in the background and said little while Shay examined the painting.

"I'm not going to pay you for this," Shay said after several minutes. "I don't believe it's by Clyfford Still."

My eyes remained on the painting, a sludgy wash of blood red and black. I was too shocked to look Shay in the eye. Both of us stood there staring—I at the painting and he at me—and said nothing for the next few seconds.

"I got an e-mail from an art scholar who said he wanted to photograph the painting for a book, and I was excited," he said. I blinked twice. Fetterman's e-mail. "But then I got another message from someone who said you put things up on eBay that look like they're by listed artists and pretend you don't know what they are. He said you sold him a fake and wouldn't refund his money."

I stared down at the dark wood floor, stuffed my hands into my pockets, and sighed. I felt alone and almost afraid, and tried to keep my face free of expression.

"I'm not going to tell you who it was," Shay said. "I said I wouldn't reveal their identity."

I knew it must have been Anthony Matthews, the guy who'd bought the "BILL" from me back in March. It had to be him. He'd sent two messages since then. Months after his purchase he wrote, "I told my friends about this and they all think I deserve a refund because you deceived me." The irony was that I'd never

intended to trick him, as I really had no idea who Max Bill was when I sold him that painting. But now I was fooling people all the time, and he'd been watching me.

"I have no idea who you're talking about," I said.

"Well, he knows you, and I have no choice but to believe him. He wouldn't have any reason to make it up."

"So you had me come all the way here when you knew you weren't going to buy it?"

"I didn't know for sure I wasn't going to buy it. I wanted to look at it."

"It sounds like this was all a big waste of my time and money," I said, feeling my confusion turning to anger.

"Maybe not. I want to make you an offer." He walked to his dining room table and slid a pale pink cashier's check out of a manila folder. "I'll pay you five thousand dollars now for this painting, and if I can get it authenticated, I'll pay you the rest." He handed me the check.

I glanced at it, considered for a moment that it was made out for an amount that was probably ten times the real value of the painting, and handed it back to him.

"I think what I'm offering is more than fair, all things con-sidered," he said. "I'm willing to take a chance, but not for the full amount."

"I don't know, Don," Peter spoke up. "I was looking at that thing and I think it's real." His voice was small, with a thick Midwestern accent. "I think you should buy it."

"I appreciate your opinion, Peter, but I'm not going to pay thirty-two thousand dollars for this painting."

"I think we're done here," I said, tucking the painting under my arm. "I need to get back to the airport."

"I think you should seriously consider my offer."

"I did."

I stood in the driveway and stuffed the painting back into the
Styrofoam peanuts that had settled at the bottom of the box. I
saw Shay staring at me from his dining room window, and I
picked up a few stray peanuts that had spilled onto his driveway
before shoving the box into the back of the Blazer.

I started the engine, cupped my hands together, and blew
into them. It was so fucking cold here. Before I could yank the
truck into reverse, Peter emerged from the front door, waved a
feeble arm, and limped toward me. I lowered the window. "Can
I talk to you for a minute?" he said. "Don said it was okay."

Peter slipped into the passenger seat. "Don doesn't agree
with me, but I think the painting is real." The whoosh of the
heater was drowning him out and I reached up and turned down
the fan. "You're sitting on a gold mine. I've been hunting around
for art my whole life, and let me tell you, what you've got is
something we all dream about finding. It's a once-in-a-lifetime
opportunity. I've found some good stuff in my time, but what
you got, you just don't find out here in the Midwest."

"Well, Don doesn't want it, so what can I do?" I asked.

"That's why I asked him if I could talk to you," he said. "I can
help you authenticate it. This thing could be worth four hundred
thousand dollars. I'd buy it right now if I had the money, but I
don't. Alls I want is a share of the profits if I can get the job
done." He told me to send him high-resolution transparencies of
the painting, which would need to be done by a professional
photographer.

"Okay, I'll think about it. I appreciate it." I looked at the
clock on the dashboard. I really just wanted to go. I knew this
man would never be able to authenticate the painting, and I had
a flight to catch.

Peter paused for a moment, started to reach for the door handle, and said, "Yeah, I do this art thing to make money. But it's only until I complete my theory."

I glanced at the dining room window. Shay was gone. "Your theory?"

"Yup," he said, and sniffled.

"What kind of theory is it?"

"It involves math." He hunched forward in his seat. "When I'm done with it, it's gonna blow away anything Einstein did."

I couldn't think of anything to say. "Interesting."

"Yeah, it is, believe me," he said, looking out the windshield. "The art thing? It's just to pay the bills for now."

"Okay, well, I should get back to Chicago. I've got a flight to catch."

"Make sure to get those transparencies made as soon as you can," he said as he eased himself out and onto his good leg. I smiled faintly and nodded. I knew that after he shut the door of the truck, we would not speak again.

The strangest thing about Peter's "theory" was not the theory itself, or that he believed it would put Einstein to shame. It was that Peter was *not* the first art dealer I'd met who'd expressed such aspirations. Fetterman himself claimed to be working on a theory, and he'd described it to me in almost the same way.

"Have I told you that I'm working on a cure for cancer?" he said. We were sitting in my living room drinking beer.

I almost laughed, but he said it with such graveness that I wasn't sure he was joking. So I just smiled. "No, I don't think you've mentioned that."

"Yup." He nodded, looking down into his lap. "It has to do with sharks. Did you know sharks don't get cancer?"

Here we go, I thought. "Uh, no. I didn't know that."

"Yeah, it's strange, isn't it? I've figured out that it has to do with magnetism. Sharks have natural magnetism in their bodies, and I'm pretty sure that's what keeps them from getting cancer."

I thought for a moment, searching for a way to respond. "Some people think magnetic fields *cause* cancer. You know, power lines? Tinfoil hats?"

Fetterman issued a faint, almost patronizing smile and kept his eyes on the floor. "Those are electromagnetic fields," he said. "Totally different."

He sighed wearily, as if this cancer research was his burden, his cross to bear, the responsibility of his God-given genius. "The art thing, it's just to pay the bills for now. It's fun, but I want to get to the end of my life knowing I did something important. This research may be my true calling."

I felt embarrassed to be taking the topic seriously but sensed that I shouldn't challenge him. "Well, I wouldn't give up the art thing until you know you're really onto something," I said.

He looked up at me. "Oh, I'm onto something. Trust me. I've been talking to the Scripps Institute down in San Diego, and they're interested."

Bewildered, I tried to imagine why he would concoct such a far-fetched story. I was sure that he couldn't really believe he was closing in on a cure for the world's greatest killer. Even if he'd had the talent for such a task, he wouldn't have had the time. He spent all his waking hours on eBay. So was this an expression of his need to impress me somehow, or was it simply a symptom of pathological dishonesty?

Or was it possible that he did believe it, or wanted to at least believe it was possible? Was there something about self-taught art expertise that made self-taught art experts think they could teach themselves physics or microbiology and make earth-shattering

discoveries? Did their exposure to works of great creativity by famous artists make them strive for their own creative break-throughs? As I drove down the hill overlooking Peoria, I won-dered if I, given enough years on the same path, would adopt my own delusions of scientific grandeur, perhaps a new take on plate tectonics.

I left Peoria and crossed the Illinois River. As I sped up Interstate 55, pushing the Blazer through torrential rain, I felt regret for not having refunded Matthews's money when I had the chance. It was not because I thought I had done him any wrong, but because he was causing so much trouble now. His inability to forget about the "BILL" and move on with his life had just unraveled a monstrous sale. Or more accurately, *my* unwilling-ness to refund his money had turned him into a vigilante. As I filled the Blazer with gas at a station near O'Hare, I calculated how much the trip had cost. On the flight home, I sat in silence, bouncing in turbulence most of the way, and wondered who else might want to buy the painting.

I didn't just want to sell the painting; I *needed* to sell it. I'd just quit my job and was looking around for office space. It was the money I made on eBay, much of which came from Fetterman's questionable paintings, that gave me the courage to go out on my own, and now I would depend on eBay, at least for a while, for the bulk of my income. If I could sell the "C. Still" painting, it would cover the expenses of my fledgling law prac-tice for several months.

When I returned from Chicago I found an e-mail message about the "C. Still" auction from a man in Virginia named Kevin Moran. "I wanted to buy it, but the bidding went too high," he wrote. "If it doesn't sell for some reason, let me know." I wrote and told him it was available. We spoke on the phone several

times over the next week and he agreed to buy it for $30,000. I wanted to preempt any claim he might make if he found out the painting was not real, so I told him, several times, that I did not know if it was really by Clyfford Still. Of course, I didn't mention that I'd gotten it from a guy who I thought was forging paintings. Moran borrowed money from his 401k retirement plan to pay for the piece, and I soothed my conscience by telling myself that his portfolio must have been bloated by technology stocks, and he could afford it.

I deposited Moran's check and asked Fetterman to pick up his share of the proceeds. "Actually, since this is a lot of money, can you pay me in several installments?" he asked. "Write me checks and space them out over a few weeks."

"What, are you trying to avoid the IRS reporting requirement? It's ten thousand. I owe you about fifteen, so I'll just break it into two payments and you'll be in the clear."

"No, man. Actually, they *say* it's ten grand, but the banks *really* report anything over five thousand. Break it into four payments, at least."

"That's ridiculous."

"Hey, I've never been audited, and I've been making a lot of money for a lot of years and paying very little taxes. I know what I'm doing."

"All right, whatever."

"Make sure you make out the checks to Lane."

"You're going to get Lane in trouble some day, running all this money through her accounts. Of course *you* won't get audited if you use *her* bank accounts, but she might."

"Hey, as long as the mortgage gets paid, she doesn't ask questions. Mind your own business."

I wondered how much Lane knew about Fetterman's eBay

dealings. I suspected that Fetterman tried to keep her in the dark about the shadier aspects of what he did, and that she, like a good Mafia wife, probably ignored signs that the enterprise was not entirely legitimate.

I sent four checks to Lane through my bank's online bill payment system, bringing closure to the largest art transaction I'd yet overseen. After the initial fiasco with Don Shay, the sale to Moran seemed to have gone smoothly. Moran had not been intoxicated by the excitement of the auction. He'd made a sober decision, long after the auction ended, to buy the painting from me with no guarantees expressed or implied. He understood what he'd done and didn't feel tricked. I should have been crippled by guilt for selling it to him, but I wasn't. I was pleased with myself for having pieced it all together so masterfully and was numb to the fact that I'd let a computer programmer in Virginia raid his retirement fund to buy a piece of art that I was almost certain was fake.

At the time, a lot of sellers were getting away with deceptive practices on eBay—ranging from questionable to fraudulent—and as the media picked up on it, the public's perception of the site began to change. EBay had once been considered amusing—a giant online garage sale offering everything from Pez dispensers to Elvis Presley's dental X-rays. News stories about the site typically focused on the latest can-you-believe-it item that someone was selling. In September 1999, newspapers around the world reported that eBay canceled an auction for a human kidney after the high bid reached $5.7 million. Even obvious frauds, like a seller's attempt in May 1999 to auction what he claimed was the rubber raft on which Elian Gonzalez had sailed from Cuba to Florida, were seen as humorous.

Toward the end of 1999, however, there was growing dis-

content about eBay fraud, and the press and law enforcement agencies began paying attention. In July a man in California pled guilty to selling and never delivering $37,000 worth of digital cameras and laptops, one of several "laptop scams" to surface that year. Federal prosecutors in Seattle launched an investigation into a "laptop-and-Barbie-doll" scam in November after the operation was uncovered by the *Seattle Times*. In September the *San Francisco Chronicle* called an auction for a rare (and fake) postage stamp "the latest highly dubious item to be offered for sale" on eBay.

Seasoned eBay users grumbled most about what they perceived as the site's failure to police itself. The most common complaint was that eBay did little to stop shill bidding. Even though it should have been easy to detect shill bidding, the site seemed to have no effective mechanism for doing so, and it suspended a user for this infraction only when it was reported by other users. Even then, the site sometimes failed to act, claiming it did not have sufficient proof. Some users became shill-bidding vigilantes, spending hours of their own time researching the bidding patterns of suspected shills and reporting their findings to eBay. The media, though, focused as it was on theft and hoaxes, for the most part had yet to uncover the scourge of shill bidding.

Fetterman and I were unwittingly laying the groundwork for their eventual discovery. Starting with the paintings from the Eve Mitchell collection, the nature of our shill bidding on certain paintings began to change. Fetterman, not content to just put a few low early bids on these paintings to attract interest, started creating his own fake bidding wars, inflating prices entirely with shills.

"What the hell are you doing?" I asked him when I first noticed this. "You brought that drawing up to eight hundred

bucks on the first day. What if no one else comes along? Then I'm stuck with it."

"Don't worry," he said. "I'm trying a new strategy. I'm creating a market for it. I'm tired of waiting for these guys to come along and bid it up. If they want this thing, they're gonna have to pay for it. When they see how high it is, they'll get out their *Davenport's*, and believe me, they'll bid."

"I don't like it," I said. For one thing, the notion of "creating a market" seemed like price-fixing, which was illegal, and I still harbored the belief that my style of shill bidding was harmless. I also had faith in the eBay speculators to bid the paintings up to profitable levels on their own. Furthermore, the rampant shill bidding looked suspicious, and I was afraid that someone would connect the dots and find out how much fake bidding we were doing. But I didn't insist that Fetterman stop, and I knew he wouldn't. The paintings he was bidding on belonged to him, after all, and I was just selling them for a share of the profits. I let him do his thing and the paintings sold for their typical, absurd prices.

In January 2000, shortly after I sold the "C. Still" painting, I leased a small two-room office on the fourth floor of a building at 8th and L Streets, near the Greyhound station in downtown Sacramento. I bought a desk, a phone, a ficus tree, and a fax machine and hung a sign on the door: LAW OFFICE OF KENNETH A. WALTON. I bought business cards, expensive stationery, and a cheap ad in the Yellow Pages. My first client was the boyfriend of a friend of mine in Los Angeles who wanted to open a drive-through espresso stand and needed a nondisclosure agreement to give to people with whom he shared his idea. Most of my early clients needed assistance with small things like this—disputes

with neighbors, simple contracts, questions about protecting ideas—and I was excited to be able to help them.

I also had a new girlfriend. Katherine was two years younger than me and worked for a real estate development company, structuring financing for subsidized low-income housing projects. We met in December and, after watching 1999 pass into 2000 on a redwood deck overlooking Lake Tahoe, we started dating exclusively. She took an immediate interest in the art I sold, but I kept her at a distance from the details of how I traded. Things had gotten too dicey on eBay and I didn't want her to discover the ugly particulars.

My new dependence on eBay meant that I needed to buy more art. I wasn't always able to collect enough paintings on my weekend trips, so with few legal clients and plenty of time, I started looking around on weekdays. At first, something about hunting for art on a Tuesday morning, when most normal people were at their desks in offices, was unsettling. Just weeks earlier I'd worn suits to work and drunk free coffee and had my paychecks deposited directly into my bank account. Now I was scrounging through junky antique shops in faded jeans and a sweatshirt. By throwing away a steady job, with no means of income other than eBay, I felt like I was taking a big risk, propping myself on an unsteady foundation that could collapse at any moment.

I did, however, have the money from the "C. Still" painting, and I knew I could pay my rent for the next several months. So I took a vacation. I went to Paris for a week to visit my friend John, a law school classmate. He and I had motorcycled through eastern Europe and Turkey for two months after we took the bar exam, and when I came back to start working at Kronick, John stayed in Europe, living off credit cards and handouts from his

parents until luck (and his exchange-student French skills) handed him a job with the Paris office of a big New York law firm. He lived in a 250-year-old apartment about two blocks from Place des Vosges in Le Marais, one of the oldest parts of the city.

John was swimming in so much of what he'd hoped for during law school. He lived in France, worked for a prestigious American law firm, and dated a beautiful woman from Hungary who took the train to see him on weekends. He hadn't followed a traditional path, but his career was advancing even more rapidly than he could have hoped for if he'd stayed in California. He actually enjoyed, or had at least adapted to, working for a big law firm. But when I visited him at work in an old stone building on Boulevard de la Madeleine, a short metro ride from his apartment, I noticed that, despite the fourteen-foot ceilings, French antiques, and charming tiny elevators, his law office was as dreary as any other I'd visited. John may have been structuring a hundred-million-dollar deal for a new bridge in Cote d'Ivoire, but what he was doing wasn't much different from what I'd done when I put together a railway crossing deal for the City of West Sacramento. He worked seventy hours a week. He labored over contractual minutiae. His partners sometimes made him feel like his work was inadequate, even though he was smart, diligent, and fiercely dedicated to his job. I knew then that, despite the risks I'd taken by going out on my own, I had made the right choice. I knew I wouldn't ever want to go back to life in a big firm.

I was happier making my money selling art, and I couldn't spend a week in Paris without hunting for paintings. I'd tried to get away from eBay when I left for vacation, and I'd made sure all my auctions had ended so I had nothing to check, but I

couldn't get it out of my blood. The city was so full of art that it was on my mind as much as it was back home, and when I passed a small art gallery near John's apartment, I couldn't resist stepping inside. The shopkeeper, an attractive blond woman in her early forties, model-thin and wearing a stylish green dress, greeted me with a cool smile. Her demeanor warmed when she learned I was American and possessed a knowledge of art that identified me as a member of her trade. While I flipped through a stack of paintings leaning against a wall, scribbling names of artists on a piece of France Telecom notepaper, she lit a cigarette and began chatting. "This is a tough business for a woman," she said after a while, dropping her shoulders and blowing out smoke and a long sigh.

"Yeah? Why is that?" I asked.

"Lots of . . . eeuuu . . . sharks, you know?"

I glanced down for a moment, my mind racing through all that I'd seen and done on eBay over the previous year. "I'm sure there are."

I walked back to John's apartment, called Fetterman to ask him to look up about twenty names in *Davenport's*, and finally decided not to buy anything from the woman, as much as I wanted to go home with a souvenir. Like everything else in Paris, the paintings were just too expensive. If I'd been there longer and visited the flea market, I might have come home with an extra suitcase filled with art.

Several weeks after my return, on an unseasonably warm day in late winter, Kris called and asked if I wanted to go for a ride in her new convertible. Months had passed since our breakup, and we were lapsing, slowly and carefully, into a good platonic friendship. She wheeled up to my house in her cheesecake-colored MG, the

ragtop tucked away, and smiled at me from behind sunglasses. "I love it!" I called as I descended the stairs from my front porch. She drove south on Highway 160 as it snaked along the levy of the Sacramento River toward the San Francisco Bay delta. We stopped in Locke, population 150, settled by Chinese immigrants in the 1800s (and virtually unchanged since then). We sat at a bar in a ramshackle Victorian building and ordered beers. It was late afternoon and the place was dim and almost empty. Johnny Cash sang from the jukebox.

"How are things with your office?" Kris asked.

"It's going well," I said. "I've gotten some new clients. Did I tell you about the Russian inventor?"

She nodded, and I suddenly remembered mentioning Slava at least twice already. I was helping him borrow $150,000 from an eccentric, big-game-hunting Russian financier to fund research into the use of plasma radiation for precious metals extraction. It was the biggest and most interesting deal I'd been involved with since going solo.

"Sorry," I said. "I'm just excited about it. . . . It's weird, things are really coming together. I was afraid when I went out on my own, but now I think it's all going to work out."

"You seem pretty happy," she said. "It sounds like you made the right decision."

Kris was looking right at me, but my eyes remained forward, focused on nothing but the musty air. "I feel like I'm coming into my own," I said. "I've learned so much about art. At the museums in Paris I really just drank it all in. I knew who so many of the artists were, and how their work fit into the big scheme of things, and it was all so much more meaningful than the last time I was there. Plus, I'm learning new stuff about the law, and thinking I might actually find a way to enjoy practicing. I've got so

many different things going on in my life that I'm passionate about. I feel like a . . . like a Renaissance man."

Yes, I actually said this. I was an unaccomplished lawyer who sold thrift-store paintings on eBay and had visited the Louvre and the d'Orsay, and I called myself a "Renaissance man," as if I were some dashing man-of-many-talents, some multifaceted genius. And, in my own way, I sort of believed it. I was just so obsessed with my ability to profit by outsmarting art "experts" on eBay that I'd started to believe my illicit activities had revealed some sort of rare talent. Perhaps I wasn't so different from Peter and Fetterman, with their "theories."

Kris might have wanted to laugh, but she didn't. Instead she just smirked and said, "You mean like Jefferson or da Vinci?"

This made me smile, and realize how pompous I must have sounded. "What, did I say that out loud?"

THE SIXTH PART. Fetterman

and I soon embarked on what turned out to be our final art-buying trip together, a frenzied journey that took us from Sacramento to Las Vegas and back in three and a half days. By the time we took this last trip, we had gotten it down to a science.

Fetterman paid an early-morning visit to the Sacramento International Airport to rent a minivan. He made sure the rental contract included unlimited mileage, a provision we intended to exploit without shame. To maximize cargo space, we usually removed the backseat of the van; this created enough room to store more than a hundred paintings, if they were stacked carefully. This time the backseat was connected to the van with a bicycle lock and could not be removed, which infuriated Fetterman.

"Relax," I told him, and folded the seat forward. We still had plenty of room. I shoved about twenty flattened boxes in

the back to use as buffers between delicate paintings.

As usual, each of us left for the trip with a folded stack of hundred-dollar bills. I brought two thousand dollars. For on-the-road research, we brought a copy of *Davenport's*, Hughes's *Artists in California*, and two signature guides. Anything more only got in the way.

I was the navigator. Before the trip I spent hours poring through Internet Yellow Pages to find each antique and thrift store in our path. I used mapping software to plot a route through all the stores in each town and kept everything organized in a binder.

Fetterman appreciated this efficiency, because he was obsessed with making good time. His jerky, kinetic gestures became more pronounced on these trips and his gait quickened to an awkward race-walking pace. After buying paintings at a store, he would tuck them under his arms and fly out the door so quickly a bystander might have thought he had stolen them. If we entered a large antique shop together, he would go in one direction and I would head in the other, so we could search the place as quickly as possible. If we found two adjacent shops, he popped into one while I checked the other.

Within a few hours of our departure, my optimistic mood was turning sour. Fetterman usually felt the need to take charge when we were on the road, and this morning he went so far as to question my ability to shop for art. "You didn't find anything?" he said with slack-jawed incredulity when I left a store I had searched by myself without buying anything.

"There's nothing in there," I said.

He rushed into the store to make sure. He came out empty-handed too, but I knew if he had found something he'd have badgered me about it for the next hundred miles. Fetterman's

impatience demanded we eat only at restaurants with drive-through lanes. If he found something on sale, such as a burger for ninety-nine cents, he would buy several and save them for later, so we wouldn't have to stop again for a while.

More disturbing than his impatience was his inane chatter. His three favorite topics while on the road were eBay, the time we'd spent in the army, and large-breasted women. His sense of humor was always juvenile, and sometimes it bordered on slapstick. One gag he enjoyed was pointing his finger at my chest, as if indicating a stain on my shirt, then smacking my chin with the back of his hand when I looked down. He would giggle wildly if I ever fell for that one. Another of his favorite tricks was burping into his hand and quickly holding it up in front of my nose, expecting me to tell him the contents of his last meal. "Knock it off!" I would say, clenching my teeth as I shoved his burp-filled hand out of my face.

But here's the thing: I put up with it. No one was forcing me to be in the car with him. I didn't have to endure his childish jokes and condescending insults. I did it for one simple reason: the money I was making on eBay. I tolerated him with embarrassing passivity. There seemed to be no end to what I would endure, and do, in order to keep art and money passing through my hands.

One thing Fetterman and I did agree on was our obsession with eBay, and one of the most unpleasant things about being on the road was being separated from our favorite website. Public Internet access was not easy to find in early 2000, especially in rural areas. We might stop at a library or a Kinko's, but it was easier to call a friend or relative. "Hi, Mom? Could you check my auctions again?" I loathed making these annoying requests, and felt like a drug addict who was continually asking to borrow money from relatives to support his habit.

We made it all the way down the Central Valley in the early morning hours and visited shops in the desert cities of Lancaster and Palmdale before lunch. Just after noon, we stopped at a place called The Orbit, a grimy antique store in Pearblossom, an unfortunate cluster of buildings nestled along a barren stretch of two-lane Highway 138, outside of Palmdale. The shop was a vast depository of grotesque furniture, carpet remnants, obsolete home electronics, coffee mugs with clever sayings, and tangles of forgotten and mostly undesirable objects. A narrow path snaked through this collection of rubble. While perusing this mess I noticed a large orange and green abstract painting perched crookedly atop a stack of milk jugs behind a bicycle frame. It reminded me of something, but I wasn't sure what. I climbed over a Naugahyde sofa and a stack of board games to get to it. The canvas was covered in a viscous layer of grime that spread to my hands and shirt. The price? Eight dollars, after some haggling with the elderly proprietor. We left Pearblossom and headed up Interstate 15 toward Nevada, stopping in Victorville and Barstow and several other small towns before night fell.

On the final stretch of highway before we reached Nevada, as the sun dipped below the horizon and left behind the brilliant, sad colors unique to the desert, Fetterman leaned out the window and snapped photos with his new digital camera. Before long the sky was black. About fifty miles from Las Vegas, in the middle of an uninhabited desert, traffic on the interstate slowed to a surreal standstill. For nearly thirty minutes we sat trapped on an unlit four-lane highway along with hundreds of other people, forming a chain of cars that stretched as far as the eye could see. Then traffic started creeping again, just as inexplicably as it had stopped, and we were soon cruising at freeway speed. There was no accident being cleared, no roadwork. Just

a traffic jam in the desert. Obstacles sometimes appear where they're least expected.

As we pulled into Vegas, Fetterman spoke for the first time in nearly an hour.

"You still seeing that same chick?"

"Katherine? No, I broke up with her last week." I ended things because I had been unable to resolve my ambivalence about our relationship, the way I admired Katherine's strength of character even as I was bothered by her domesticity and all the "settling down" it carried with it. Settling down meant accepting myself for who I was, a frightening endeavor I wasn't ready to undertake despite the things I loved about Katherine. But I wasn't going to explain all of this to Fetterman. This wasn't the sort of thing we talked about.

"Too bad. She was hot, man. Maybe we can pick up some women tonight in Vegas. I hear this place is crawling with them."

In Las Vegas, Fetterman and I stayed at the Venetian, a thirty-six-story casino hotel that tried, without success, to look like the city of Venice. The next morning we set out to look for art. Most people come to Vegas hoping to win money in the casinos, but Fetterman and I found our jackpot at the city's antique stores. The place was a trove of reasonably priced art that was ideal for resale on eBay.

The abundance of art in Las Vegas was a surprise. For one thing, Vegas has relatively few antique stores for a city of its size. This is understandable, as the city had been nothing more than a fork in the road until 1941, when the first big casino was built. Anything antique in Las Vegas was brought in from somewhere else. Secondly, Las Vegas has never had a thriving local arts scene. Instead of galleries displaying quality original work by local artists, Las Vegas has high-priced art shops in the casinos that sell gaudy reproductions of famous paintings. Finally, to the extent that there is money among the local residents, it's new money,

more likely to be spent on flashy cars and stucco mansions than tasteful art collections. Vegas just isn't the type of city where I expected to find much art. It was Fetterman's idea to go there.

But I was wrong. The antique stores in Vegas were packed with good paintings. We unearthed handsome nineteenth-century land-scapes and fascinating abstract paintings from the 1950s. We came across decent paintings in all styles from all over the United States, Europe, and Latin America. We found something to buy in nearly every shop we visited, and in a single day we purchased sixty pieces.

Why so much good art? I could only guess. For one thing, Las Vegas is not just a place to gamble, it is a retirement town. The weather is warm and dry and the real estate's cheap, so it attracts people from around the country to many new develop-ments targeted at retirees. When people retire they get rid of things, including furniture and art.

Las Vegas is also a frontier town where people come from other places to seek fortunes or make new starts. Not all of them make it. Some go bankrupt, some start drinking again, some grow weary of the heat, and some reconcile with spouses left behind. For whatever reason, a lot of people leave Las Vegas not long after moving there. There's a lot of coming and going, and where there is coming and going, things fall through the cracks. People have to sell stuff quickly. Some forget to pay the rent on storage units. Good paintings trickle into the local market. One of the more memorable finds of that day was a beautiful landscape by the Florida artist Harold Newton, whose work was becoming very popular in, but rarely found outside of, his native state.

The seeming abundance of art may also have been due to the fact that we might have been the first eBay sellers to raid the place. We were able to pick through a huge assortment of paint-ings that had been sitting around for a while.

There were many thrilling discoveries during the day, but my mood was always undermined by nagging reminders of the trickery that was part of what we did. I had been working with Fetterman long enough to know that he was not just looking for good paintings to resell at a profit; he was looking for art that would fool people. I was sure he scanned each painting we bought to see if he might be able to alter it in some way.

Sadly, my mind was now working like his. I no longer relied on him to hatch every crafty scheme. I had yet to actually commit an act of forgery (although I'd entertained the idea more than once), but I had gotten very good at deception. "This is a tricky one," I said to him when we found a seascape painting that looked old and valuable, but was actually new and very cheap. I knew if I photographed it selectively and failed to mention its age, someone on eBay might mistake it for the antique it was not, and pay too much for it.

"You know what to do with that one," Fetterman replied, chuckling.

We spent a second night in Las Vegas and got up early the next morning to visit a couple of stores before we left. Fetterman was fidgeting, eager to hit the road. He had our day planned and didn't want to miss any shopping opportunities. But I needed my coffee, and on the way out of the Venetian I insisted that we stop at a Starbucks for a double espresso.

This break in the action launched Fetterman into a tirade. "Jesus!" he spat. "You're killing me! What's more important to you!? Your coffee or making money? We need to hit the road!"

I glared at him, didn't say a word, and calmly opened the door and stepped out of the van. As I waited for my coffee, I looked out the window and saw him shaking his red face with exasperation. He couldn't wait two minutes for me to get a

coffee. I hated him. I hated his impatience and his deceit and his condescension. I hated how I saw more of him in myself every day.

Fetterman cooled off later in the morning, after we stumbled across another twenty good paintings. As we prepared to head back to Sacramento, he handed me the keys. "You drive," he said. "I've been driving the whole way."

We made our way back along a different route, up Highway 99, stopping at more shops along the way, and arrived in Sacramento late the next evening, the van packed with 122 paintings. Some of them were superb, many were good, and some were admittedly poor choices. In the rush to acquire as much as we could as quickly as possible, we had picked up a few pieces along the way that we regretted purchasing. Fetterman and I were splitting the profits of these paintings, so it didn't really matter who sold what, but neither of us wanted to get stuck with the dogs.

To decide who got to sell which paintings, we conducted a draft. We removed all the paintings from the van, stacked them against the side of my apartment building, and then took turns, choosing the best ones first, like schoolkids on a playground picking the best athletes for their teams. About midway through the draft I grabbed the orange and green abstract painting I'd excavated from the junky shop in Pearblossom.

"I like this one," I said.

Fetterman sneered. "You can have it."

Not all the paintings were up for grabs in the draft. Fetterman reserved a couple of them for himself. "These need to be cleaned," he said. I knew what he meant; this was his code. He had identified the paintings as ones he might be able to alter, perhaps add signa-tures to, and was ensuring that they ended up in his pile.

We spent five thousand dollars on the Las Vegas trip. Three weeks later we'd sold half of the paintings and had already taken in about fourteen thousand dollars.

I was, by this point, quite sure that Fetterman was adding signatures to paintings. At the most basic level, all this requires is an unsigned painting, the name of an artist, and something to write with. Combining these elements to create a convincing forgery, however, is difficult. But I'd been watching carefully, and I was learning what it took.

First, the painting has to be in the right style. This was Fetterman's true gift. He had an encyclopedic knowledge of art that helped him to pair paintings with artists. He could look at almost any antique painting and name three or four listed artists whose work it resembled.

Style alone is not enough. The age, size, and medium of an artwork also come into play. Knowledgeable buyers research these things carefully. The signature of an artist who painted in the 1920s cannot not be added to a painting from the 1970s. If an artist always created large oil paintings on canvas, buyers will be skeptical about a small watercolor bearing his signature. Each of the suspicious paintings I got from Fetterman was from the general era of the artist with whom it was associated, and generally fit in with that artist's other works.

Finding an unsigned, properly sized and aged painting that resembles a particular artist's style is only the first step. The artist's name, of course, must be added. Signature guides, used by art experts to authenticate paintings, are just as useful to forgers. A skilled forger pays attention to an artist's signing habits. Some artists always sign the same way, and others sign different works in different ways. Some sign differently at various stages of

their careers. Some always sign with the date, some never do, and others do occasionally. The location of a signature is also important. Some artists always sign in the same place on a painting, such as in the lower left corner. Some sign the backs of their paintings.

A forger adding a signature also has to worry about it being detected. Signatures forged in oil paint are easy to spot with a black light. Some forgers believe signatures painted in red do not "float" as much as those painted in other colors, but in my opinion, a signature added in red can be spotted by someone with a trained eye. More important, because red signatures are a forger's hallmark, savvy art buyers shun them.

I learned, over time, that the best way for a forger to avoid detection is to avoid using oil or acrylic paint altogether. Signatures added to drawings in pencil, ink, chalk, or pastel cannot not be detected. The same is true for signatures added in watercolor or gouache, or signatures added in ink to the backs of paintings.

I looked at several of Fetterman's probable forgeries under a black light, and none of the signatures floated. He'd probably been faking paintings long before eBay, and he knew what he needed to do to pass off a bogus work of art in the real world. This was probably what had kept us in business for so long. With just a few exceptions, most of the paintings Fetterman sold did not generate objections.

Not all art forgers add signatures. Some are more ambitious and actually create paintings, copying works by famous artists. Sometimes this involves precisely copying a particular work by an artist, and passing it off as the original. More commonly, a forger will create a new painting in one artist's style and try to pass it off as a work that slipped through the cracks.

Fetterman was not skilled enough to attempt such a stunt.

Other fakery is more subtle. Suppose, for instance, that an eBay seller finds a landscape painting signed "F. C. Smith" with a small paper tag on the back identifying the artist as Fletcher C. Smith of Denver, Colorado. *Davenport's* doesn't include this artist, but it does list Frederick Carl Smith of Pasadena, California, who was known for painting landscapes. By removing the tag, the seller could create the impression that the painting might have been done by this more notable artist. To invite even more speculation, the seller could scrawl "Pasadena, CA" on the back of the painting. With a little research, he might learn that Frederick Carl Smith showed his work at the Smith Gallery in Los Angeles in the 1950s. A fake Smith Gallery label added to the back of the painting might attract bids even from sophisticated collectors who are familiar with the artist's career.

Other more blatant tactics include the creation of fake provenance or bogus authentication documents from experts who do not exist. I am convinced that Fetterman probably tried these tricks at one time or another.

When I eventually became an art forger, I carried on a long tradition. Artists have always learned their craft by copying the masters, and for centuries prior to the Renaissance, making a precise copy of a master's work was considered a tribute. Only with the rise of the merchant class in the sixteenth century, when art became a commodity, could painters begin to make money by creating paintings that appeared to be by other more famous artists. Forgery thus became fraud.

Until the late nineteenth century, fraudulent art forgery was relatively rare for several reasons. First of all, there were few artists whose work was valuable enough to forge. The art market

was tiny, as there were fewer wealthy collectors competing for the best pieces. Second, it was more difficult to copy paintings. Art in the premodern era was meticulously representational, and each painting took considerable time and effort. A forgery required great skill and patience. Finally, because there were fewer artists considered to be truly accomplished, there were numerous experts dedicated to each of them. These scholars truly understood the style, brushwork, and color palette used by the artists they studied and were not easily fooled by imitators. Despite these obstacles, forgers nevertheless plied their craft, and plenty of faked paintings made it into museums and private collections.

In the late nineteenth century, and increasingly through the twentieth century, things became easier for forgers. As styles of painting became looser and less representational, paintings became easier to copy. A faux impressionist landscape could be turned out in a day. A simple drawing by Matisse or Picasso could be replicated in minutes. As artists began to shift styles, experiment with different media, and produce works of varying quality, it became more difficult to tell whether a piece was truly done by a particular painter. At the same time, the number of artists considered to be noteworthy increased greatly, and there was less scholarly expertise to go around. As this was happening, prices in the art market increased at rates that far outpaced inflation, which was all the more encouraging to forgers.

Because of these factors, history's most notorious art forgers worked during the twentieth century. Perhaps the most prolific was Elmyr de Hory, a Hungarian-born painter who created more than a thousand faked paintings during his twenty-year career in the 1950s and sixties. He was a highly skilled copyist who imitated the work of nearly every important postimpressionist

painter, including Picasso, Modigliani, Matisse, Vlaminck, Derain, and Dufy. He traveled around Europe and the United States selling these fakes to galleries and private collectors. During the height of his career, a seven-year span from 1960 to 1967, he claimed to have sold more than sixty million dollars' worth of art. According to de Hory's biographer, Clifford Irving, ninety percent of his fakes were never detected. De Hory's career inspired a book and a movie, and he became so infamous that even his known forgeries had significant value. Some sold for as much as twenty thousand dollars.

David Stein, a French-born painter who was active in the 1960s, was very adept at turning out works that appeared to be by Chagall, Picasso, Dufy, and other postimpressionists. His work was so realistic that one of his imitation Picassos was authenticated by Pablo Picasso himself. Eventually he was caught and spent time in prison in New York before being extradited to France to face charges there. While in prison in Paris, he was allowed to continue painting his skillful copies as long as he signed them with his own name. In 1970 the New York attorney general sued to stop these works from being imported into the United States, claiming that they were so good that unscrupulous buyers might be tempted to remove Stein's signature and convert them into forgeries.

The most notorious twentieth-century art forger was Han van Meegeren of the Netherlands. Unlike many contemporary forgers, van Meegeren chose to copy the work of an artist who lived several centuries ago, the great Dutch painter Jan Vermeer. After his own lackluster career as an artist sputtered, van Meegeren proved to be remarkably adept at the ambitious task of re-creating the work of an old master. Not only was his style convincing, he made the paintings look genuinely aged by mixing

his pigments with bakelite and cooking them in an oven, which added centuries of hardening and cracking in a matter of hours. Van Meegeren made a good living in the 1930s selling dozens of these "Vermeers," which were so good they fooled the experts. One of his creations hung in the Boymans Museum in Rotterdam for many years. His ruse came to light only when he was forced to admit it to save himself from being convicted of a more serious crime. During World War II he sold one of his fakes to Hermann Göring for Hitler's collection, and after the war he was charged with the traitorous act of selling a national treasure to the enemy. When he claimed he forged the painting, no one believed him until he proved it by demonstrating his process. He was then charged for his past frauds and later died in prison.

One artist even went so far as to forge his own works. Giorgio de Chirico, an early surrealist painter, was best known for the groundbreaking "metaphysical" series of paintings he created early in his career. His later works were much less popular, and his career went downhill as he watched these early paintings sell for more on the open market. To capitalize on this, he began secretly creating new metaphysical paintings and predating them by twenty years. He was caught and was not prosecuted, but his credibility suffered.

All of these forgers worked in the pre-eBay era. Things were different then. Each time one of these men sold a painting, he had to meet the buyer in person and look him or her in the eye. He had to stand in front of the painting, which he himself had just forged, and pretend it was by a master artist. The forgeries had to be of very high quality, or the scams would not have worked.

But eBay changed the rules. For the most part, eBay sellers are anonymous, and they need only show a few select photographs of

what they offer. They use "as is" and "no guarantee" clauses in their auctions. The paintings don't have to stand up to any kind of close, in-person inspection, so a forgery can be really bad and still sell on eBay. There is someone on eBay willing to take a chance on virtually every forged painting that is offered. The truly atrocious ones obviously sell for less than the skillfully rendered ones, but they all sell for far more than they are worth.

I stood over my dining room table and stared at the canvas sprawled across it. Freshly cleaned, the bright orange hues of the painting I'd bought in Pearblossom took on a new intensity, even under the dim light of the chandelier dangling above. I'd decided, shortly after we returned from Vegas, that this painting resembled an early work of the California painter Richard Diebenkorn, but it was not until now that I recognized how much so. This painting had been on my mind for weeks—it was the perfect candidate for a Fetterman-style "alteration"—but I didn't think I could sign it. I'd never done that before. Now, as I looked at it, I knew there was no way I could *not* sign it.

My face grew warm and I could hear my pulse racing in my ears. I glanced up at the windows. It was dark outside, and my apartment had a fishbowl quality that was suddenly very unsettling. I separated the miniblinds just enough to take a quick glance at the building across the street, then drew them tightly shut.

I tossed through a drawer in the kitchen and found a light brown watercolor pen with a flexible tip. This just might work. Water-based paints wouldn't fluoresce under a black light. The canvas in my dining room was painted with a thin, smooth wash of oil paint, and I wondered if I might be able to add a signature in watercolor.

I had seen enough of Diebenkorn's paintings to know that he always marked them with his initials and the last two digits of the year. I practiced a few times on a piece of paper, then leaned over the painting.

I paused for a moment with my hand hovering over the canvas. Then voices and laughter punctured the quiet night. It was late. Who was out making noise? I stopped breathing for a moment, my eyes darting back and forth as I listened. I let myself exhale. Just neighbors, walking down the street.

Then I did it. Quickly. RD52. Ten quick brushstrokes, just like Diebenkorn would have done it. It looked like a painting he might have done in 1952, and I knew I'd just created something that would be irresistible on eBay.

Then I heard my own voice.

"You're a con man," it declared, almost matter-of-factly.

And I guess I was.

Even as I descended into the world of art forgery, I was not yet savvy enough to avoid being tricked myself. About the time I brushed "RD52" onto that canvas, I met two local art dealers selling inexpensive paintings at a flea market outside Sacramento. When they saw my interest, they invited me to their house to see the rest of their collection. "Come over and check out the good stuff," they told me.

Their small 1960s ranch house was in the working-class suburb of North Highlands on a street lined with unkempt lawns, nonfunctioning cars, and oil-stained driveways. The two men invited me in with smiles. I took my time perusing their paintings, and only one piece intrigued me: a framed painting signed by Alexander Calder, the artist best known for inventing the mobile sculpture, examples of which can be found in many large

museums. Calder was also a painter, and his simple abstract compositions reflected the aesthetic of his sculptures. This painting was very basic—a few strokes of black and primary colors on a stark white background.

They wanted eight hundred dollars for it. I rushed home to do some research and discovered that similar works by Calder had sold for more than five thousand dollars. I returned to North Highlands with a wad of cash in my pocket. Before I bought the Calder, I took it out of the frame and looked at it carefully under a bright light. I could see the artist's brushstrokes, and concluded that it was definitely an original.

I called Fetterman that night to brag. At my apartment a few days later, a smirk crept across his face as he examined my Calder. "You've been had," he said calmly. "This is a print." Fetterman liked to denigrate my art-buying skills, and I could tell he enjoyed telling me I'd been ripped off.

"What?"

"Look here." Fetterman moved·his grubby finger to the edge of one of the black circles that formed the composition. "You can tell right here, this is a print that was painted over. It's completely flat behind the brushstrokes."

He was right. I had purchased a Calder print, crudely altered to look like a painting, for hundreds of dollars. I had no way of knowing if the dealers had altered it themselves, but I knew I wanted a refund.

Fetterman volunteered to help me get my money back. "How big are these guys?" he asked.

"Not very."

We hatched a plan. "We'll drive out there. You ask for your money back, and be nice about it," Fetterman said. His eyes widened and his arm twitched as he grew excited about what lay

ahead. "I'll play the bad guy and just stand back with my arms crossed, looking crazy. I can get a look on my face that will scare the shit out of these guys."

We took his car to North Highlands. "Hi, guys," I said with a polite smile when they answered my knock. "Guess what? You sold me a fake."

Our plan worked. The dealers refused to admit the piece was a print but returned my money anyway. Fetterman and I stood in awkward silence on their crabgrass lawn while one of them went to the bank to get the cash. I probably could have gotten a refund without Fetterman's menacing act, but I'm sure the argument was shorter because he was there. "You're missing out on a good painting," one of the men snipped in defiance as we left.

As we drove away, I wondered how many of my angry customers would have been able to get a refund if they'd met me face-to-face and brought a dangerous-looking friend to my house. EBay didn't give them that luxury.

A couple of weeks after I forged the "RD52" painting, I visited Peder, a friend in Santa Cruz. "You should stop working with Fetterman," he suggested. "Partner up with me instead." His long hair whipped in the wind as he hunched over the steering wheel of his Jeep. We were bouncing our way to the Santa Cruz flea market, and I had been describing Fetterman's antics in Vegas.

Peder and I shared mutual friends and had known each other for years. I'd gotten to know him better in recent months after introducing him to eBay. I had given him some pointers, but he was naturally skilled at finding good paintings and had a knack for composing good auction descriptions. He had just acquired his own copy of *Davenport's*.

"Think about it," he said, his mellow voiced pitched with

excitement. "We could go on art-hunting trips like you do with Fetterman, but it would be more relaxed, and you wouldn't have to put up with his shady stuff." I had hinted to him that doing business with Fetterman had a dark side, but I had not admitted my complicity.

"Maybe," I replied, my voice distant. I got along well with Peder, and he was obviously a more reasonable person than Fetterman. But did I have what it took to strike out on my own? I'd learned a lot about art over the previous year and had become a skilled eBay seller, but my knowledge was nothing like Fetterman's. And what about the dishonest tactics? Would Peder decline to work with me when he learned the whole truth, or would I, now an art forger myself, become his Fetterman?

"These auction houses are a gold mine," Fetterman said.

We'd been trying a new strategy. Small, real-world auction houses were entering the Internet age, building websites and posting pictures of items they were selling. These smaller houses often sold good paintings, but they didn't attract sophisticated buyers. Fetterman and I could place bids by telephone, buy the paintings cheaply, and then resell them on eBay for a profit. We did this several times in the spring of 2000. It was much easier than schlepping around in a van to look for art.

"I'm keeping my eye on Slawinski Auction," I said. "I made a thousand bucks on that nude by Pal Fried."

"I think we should focus on this." Fetterman said. He sighed. "Some of this shit we've been doing on eBay has been getting to me."

"What do you mean?"

"You know, all the tricky paintings—I'm getting sick of it."

I said nothing. This was the closest he'd ever come to admitting

he was doing anything wrong, and I wasn't sure if I wanted to com-
miserate with him. What we did was unspoken, and I wanted to
keep it that way. Talking about it would make it real.

Fetterman continued, his voice quiet and pained, as if he
were nursing a wound. "It's like . . . it's like it hurts the soul."
Dead air filled the line for several seconds, and he repeated him-
self, more quietly. "It hurts the soul."

I had never heard Fetterman express remorse before. Part of
me wanted to shout, "Yes! You're coming around. We can make
money at this without fooling people!" But I was no longer con-
vinced that this was true. I'd just quit my job and had become so
reliant on Fetterman's "tricky" paintings that I was afraid to give
them up. As much as I loathed working with him, I didn't want
to encourage him to cut off my supply. I was now so immersed
in our way of doing business that I had become a forger myself.
I couldn't join in on this crisis of conscience. I couldn't abandon
what had been working so well for the past year. So I just said,
"We'll keep looking for the auction house paintings. It's a good
idea." I assumed his doubts would pass, and things would be
back to normal by the next day.

THE SEVENTH PART.

I sold the would-be Diebenkorn in the most elaborate ruse I'd ever concocted, putting everything I'd learned about how to sell art on eBay, good and bad, into the auction. Knowing that people were growing wise to my main user ID, *advice,* I set up another ID, *golfpoorly,* to sell the painting. Over several weeks I used *golfpoorly* to purchase cheap items on eBay, to build up his feedback. I didn't bid on paintings or anything expensive, and instead went after things like yarn, books of children's Bible stories, and a ceramic poodle. Anyone researching *golfpoorly*'s history would find no evidence of art savvy.

On April 28, after *golfpoorly* finally earned a feedback rating of ten, I used him to host an online garage sale. Offerings included a deflated basketball I'd gotten for free at a Sacramento Kings game, a frightening wooden mask I'd picked up in Mexico, an unopened ball of twine, a computer network card, and a pewter picture frame.

And of course, among this junk was a treasure, the orange and green painting that I hoped would be mistaken for the work of Richard Diebenkorn. I took my time crafting the description for this auction.

GREAT BIG Wild Abstract Art Painting

I got this big abstract art painting at a garage sale in Berkeley, California, a *LOOONG* time ago, back in my bachelor days, and then I got married, and my wife has never let me keep it in the house. She says it looks like it was done by a nutcase, but I always kind of liked it. I used to live in a really dark apartment and this thing used to wake me up in the morning. YIKES! One thing I can say about this painting is that it is *BIG!* It is an original painting on canvas, and it is 2 feet, 11 inches along one side and 3 feet, 11 inches along the other side. The canvas is stretched onto a wooden brace and it has a thin wooden frame.

This painting is so big I took a close-up picture so you could see it better:

Unfortunately, this thing got a small hole punched into it by my kid (Big Wheel accident in the garage). You can see it in the middle of this next photo. The hole is only about an inch and a quarter long, and I think it would be easy to fix with duct tape, but I'll leave that up to you.

[Close-up photo of hole in painting, which also happens to reveal "RD52" in the corner of the canvas]

NO RESERVE!! Thanks for lookin'!

The ad was a shameless ploy designed not only to make *golfpoorly* look unsophisticated, but also to provide clues that shouted: Diebenkorn! The lack of sophistication was obvious in *golfpoorly's* down-home prose, in his reference to the painting's "brace" (as opposed to a stretcher), and in his pathetic suggestion that the damaged canvas might be fixed with duct tape. *Golfpoorly* clearly knew nothing about art, but his description provided tantalizing

evidence of the painting's creator. He wrote that he'd found the painting at a garage sale in Berkeley, where Diebenkorn lived in the early 1950s and painted similar works. His close-up photo of the small hole in the canvas revealed the "RD52" down in the corner. *Golfpoorly* didn't even mention these initials, let alone suggest that they could belong to the artist, which was likely all the more exciting to those who recognized it.

Of course, I didn't buy the painting in a garage sale. I didn't get it in Berkeley. I didn't have a wife or a kid or a garage. The puncture in the canvas was there when I bought it and hadn't been caused by a Big Wheel accident. I'd never seen the need to make up lies about paintings before, but this was my grand experiment, my first forgery, and I wanted it to go well, so I laced my description with a fable to enhance the illusion.

I had no idea how much I'd get for the painting. Ten thousand dollars? Fifteen thousand? At this point, the most expensive thing I'd sold was the "C. Still" painting, which brought in $30,000. The Giacometti sold for $10,600. I knew this Diebenkorn forgery would attract a good price, but I had no idea just how good it would be.

I launched the ten-day auction at 6:49 p.m. on Friday, April 28, setting the opening bid at twenty-five cents. At 10:53 p.m., an eBay user known as *jonapap69ld* posted the first bid. Early the next morning, with the high bid still at a quarter, Fetterman started shill bidding, using an ID he'd named *big-fat-mamba-jambas* to drive the price to $10.50. Shortly after that, two real bidders, *zwebber* and *doggiedaddy*, placed bids that pushed the price to $102.51.

Eager to see the price go up, Fetterman launched his "create a market" strategy. He placed a proxy bid for three thousand dollars with his ID *artpro* at 7:23 a.m., before I was even awake. "If

they want it they're gonna have to outbid me," he said when I called him later that morning. A couple of real bidders came along later and pushed the high bid to $449, and then Fetterman used his ID *jgle* to bid against himself and raise the price to $510.

That afternoon Fetterman pulled a stunt that would later have massive repercussions. He used my user ID *grecescu*, for which I'd once unfortunately given him the password, to place a bid on the painting. I noticed this and told him not to use the ID, but I didn't remove the bid from the auction.

Early the next morning, Sunday, April 30, *artpro* was outbid by *roxanneart*, an experienced dealer who placed a proxy bid of four thousand dollars. Less than two days into the ten-day auction, the painting had been spotted as a possible Diebenkorn and the chase was on. Fetterman responded by having his ID *education1* place a bid for $3,707, leaving *roxanneart* on top. Feeling the pressure of others bidding below him, *roxanneart* increased the amount of his proxy bid to $7,500.

The bidding activity brought in questions. People were spotting the painting, wondering if it could be real, and asking about the condition. No one was suggesting to me yet that it was a Diebenkorn. To respond to these questions, I made two additions to the auction description, carefully keeping up *golfpoorly's* lowbrow prose:

On May-01-00 at 22:28:50 PDT, seller added the following information:

I've been asked A LOT of questions about the condition of this painting. Well, like I said, it does have a hole in it. I also looked close and you can see some very small cracks in the paint, like spiderweb cracking. Not everywhere, just in

some spots. I don't know if this is a big deal, but I want to say everything I can about this thing. Also may be a couple of other tiny spots of missing paint—I'm not sure if it was intentional or if they are little spots of damage. Just a few little spots, not everywhere. Other than this, I wiped all the dust off of it and it's really in pretty good shape. Oh, the frame is made of wood and looks kind of homemade.

On May-01-00 at 22:33:57 PDT, seller added the following information:

OH—ONE MORE THING—The painting goes sideways from the way it looks in the big photograph. I didn't know how to flip it over. It is a horizontal painting, not a vericle painting. But I guess you could hang it however you want, anyway!

Several more shill bids by Fetterman pushed the price to $4,851 by the end of the third day. The next day a real bidder, *orderville*, placed a bid that brought the price to $5,300. The following day, May 3, another real bidder, *animationconnection*, drove it to $6,101, and Fetterman, wanting to keep things rolling, pushed it to $7,300 with *howdyhi*. The next morning *animationconnection* outbid *roxanneart* and took over as the high bidder.

On May 4 a Dutch software executive named Robert Keereweer, who used the eBay ID *robgarde*, noticed the painting. He had been on eBay for less than two months and had already bought thousands of dollars' worth of art, most of it without guarantees of authenticity. From his home near Amsterdam, he placed a bid of $8,800 and became the high bidder.

For one day he remained unchallenged. Six days into the

auction, the price was more than $8,000, and I was thrilled, but Fetterman wasn't satisfied. The next morning he used *howdyhi* to outbid Keereweer, and I was furious. I was afraid he may have taken over the best legitimate bidder we might find. At about this point in the auction, Fetterman and I started arguing about his shill bidding. I told him to let the price increase naturally, but he was convinced he was doing the right thing.

Just hours after Fetterman used *howdyhi* to take over, Keereweer returned and placed a new bid, putting himself back on top. Fetterman thought he smelled a sucker and responded with several more bids, pushing Keereweer's bid higher with each one. When Fetterman had nudged the high bid to over twelve thousand dollars, I called and begged him to stop, for fear that he would end up on top of the auction.

Fetterman controlled himself until the next morning. On Saturday, May 6, the eighth day of the auction, he entered a bid of $14,555 with yet another member of his roster, *mr.underbid*, and this time, he went too far. He outbid Keereweer. He knew he might have screwed up the auction, so he requested a "bid retraction," claiming, "Wrong item number for client . . . my deepest apologies." After Fetterman canceled his bid, Keereweer was returned to the high bidder spot.

Keereweer, noticing the bidding beneath him, raised his proxy bid. Fetterman, who hadn't learned his lesson, kept pushing him, bringing *howdyhi* back to shill up the price a bit more. When I went to bed on Saturday night, the high bid stood at $15,655. There were nearly two days left in the auction, but I thought we may have gotten as much out of the painting as we ever would.

I was awakened at one thirty in the morning by a call from Katherine. We hadn't spoken since our breakup, a month earlier.

"I'm sorry to call so late." Her words came out slurred.

"Where are you?"

"Streets of London. We've been drinking."

"Yeah, it sounds that way." It was strange to hear her voice. She'd been very upset when we broke up, and I hadn't expected her to call again. "Are you okay?"

"I'm fine, but I don't think I should drive."

"Do you need a ride? I could pick you up or call a cab."

"Can I just come over? It's only two blocks. I'll just sleep it off on your couch. Then I won't have to get a ride back to pick up my car."

"Um, sure, I guess." I wondered where she was going with this. I didn't even own a couch, and my love seat would be an uncomfortable place to sleep, even with the aid of intoxication. "Yeah, come over."

"Oh, don't worry, mister. I won't lay a hand on you."

Five minutes later she knocked. She stumbled through the door, giggled, put her arms around me, and whispered, "I've missed you." We kissed.

I awoke the next morning to the sound of Fetterman's voice on my answering machine. "Dude, you've got to get up. You're not gonna fucking believe this." His voice was uncharacteristically quiet and sounded serious. As I opened my eyes, Katherine groaned and pulled the pillow over her head. "Seriously, dude, get up. You've got to.check the auction. Call me." He hung up.

I rubbed my eyes and stumbled over to my desk. Katherine let out a half-second moan of annoyance. Sitting in front of my computer, I blinked my eyes six or seven times, waiting for them to focus and adjust to the light. A browser window was open on my monitor, and I clicked the refresh button at the top.

"Oh, God," I said. The number next to the painting: $126,800. One hundred twenty-six thousand eight hundred dollars. The price had exploded overnight when two new bidders, *antqdeakn* and *laliqueseller*, both of them real, got into a bidding war with Keereweer. I suddenly felt awake, my head swirling with thoughts of what I would do with the money. I could buy a house. I could sweep away my law school debt. I could build my practice, buy some real advertising, maybe hire a secretary. Then a cloak of dread slipped over it all and smothered any sense of anticipation. The painting was not real; I had forged the signature. The moral salve I'd slathered on in the past—the belief that I was wasn't doing anything wrong because I didn't really know that the paintings were forged—no longer soothed me. This one was all mine, and I would have to live with myself if I sold it. But I just had to see where it would go.

I heard Katherine gasp and realized that she was standing behind me.

"That's a joke, right? Someone messing with your auction?" I'd once explained to her how bidders sometimes bid an auction's price up to an artificially inflated level with no intention of paying, either as a prank or to exact revenge on a seller with whom they've had a dispute. I'd never experienced this myself but had seen it happen on other high-profile auctions.

"No, I think it's a real bid."

I turned and faced her, and I saw a look of concern in her eyes. "And the painting? Is it real?"

I looked away from her and sighed. "I don't know," I said. "I just don't know." I turned back toward my monitor and felt guilty for lying to her. But I knew I couldn't tell her the truth.

That day I communicated with *laliqueseller*, who was in

second place, just below Keereweer, on the list of bidders. "I live in Oregon," he said, "and I want to drive down today or tomorrow to look at the painting. If I like it, I'll raise my bid and try to buy it."

"Let me get back to you," I said. "Things are kind of crazy today." The person who went by the name *antqdeakn* also e-mailed and asked to see the painting.

But I didn't want anyone to look at it. Either of these guys might recognize it as a fake, or wonder about my nonexistent wife and child, and alert the other bidders. Part of me also wondered if this was a way out, a way to bring the auction to a close without perpetrating a six-figure thievery.

"Do *not* let him come down and look at the painting," Fetterman said. "You've got no idea who this guy is. Hell, he might try to steal it from you." Fetterman and I had been fighting about this auction for days and I was sick of him. I told him I would make my own decision about who got to see it. Shortly after that, I got an anonymous e-mail from someone who wrote, "I saw that *laliqueseller* is bidding on your painting. Beware of this guy."

This message was one of hundreds I got over the course of the auction. A curator from a museum in New York wrote and offered to fly out to inspect the painting. I told her I would be gone the weekend before the auction ended and wouldn't be able to meet her. Diebenkorn aficionados wrote and begged me to cancel the auction and get the painting authenticated. The story of *golfpoorly's* Big Wheel–damaged treasure became the stuff of instant Internet folklore, and hundreds of curious onlookers wanted to know if I knew who had painted the odd-looking abstract canvas. Many people offered congratulations, writing things like, "We all wish we were you and are rooting for you." One person, apparently noticing *golfpoorly's* penchant for

bidding on Bible storybooks, wrote simply, "Clean living pays off. Congratulations."

Not everyone was friendly. A few people wrote and told me they thought the whole thing looked "fishy," and a couple even accused me of running a scam. David Carlson, who owned an art gallery in Carmel, California, was one of the skeptics. He wrote, asked a few questions, and after I responded, told me he thought the painting was a fake. He didn't stop at this, however. For some reason he wanted to make me pay, and this became an obsession that would, in time, grow and bear fruit.

Facing this flood of messages and unable to respond to them all, I employed my skills as a lawyer and added to the auction description.

On May-07-00 at 20:53:33 PDT, seller added the following information:

Greetings once again. First of all, thank you for your questions and comments, and I appologize for not being able to get back to all of you. Honestly, we're freaked out by all of this, and because of the high price this painting is going for (WOW!!!!), I contacted an attorney and he told me to add the following: "This painting is sold in the same manner as the other items I am selling on eBay, and requires full payment within 7 days of the auction, in advance of delivery to the buyer, and is sold as described in the auction description, without representations as to authorship or authenticity." Again, I thank you for all of your e-mail, and I am sorry that I haven't been able to respond promptly to all of your requests for info, etc. This is turning into a full-time job!

After I was warned about *laliqueseller*, I decided not to let him or *antqdeakn* see the painting. *Antqdeakn* then canceled his bid, writing, "Seller won't let me look at it & I can't see the back or inspect the age & sig." *Laliqueseller* canceled his bid twenty minutes later, but left an odd explanation along with it: "Will bid again after I see the painting in person tomorrow in Sacramento." But I'd told him I wouldn't show it to him. Was he coming anyway?

With these bids canceled, there was nothing to prop up Keereweer's bid, and the price of the painting plummeted to $15,655. Fetterman panicked. "They're going to lose confidence in it!" he shouted. "I've got to go to work on this thing." I could picture droplets of foamy saliva soaring from his mouth.

"Dude, leave it alone," I said. "If you come back now it's gonna look so fucking obvious. Everyone knows *robgarde* has a huge bid on it. If you shill him up now, people are going to know. *He's* going to know. Let's just let this thing run its course!" A week of fighting with Fetterman, sorting through hundreds of e-mail messages, confronting accusations, fending off would-be buyers and lying, over and over, had taken its toll. I slumped in my chair and my temples ached.

As soon as he got off the phone, Fetterman did what I knew he would do. He used *howdyhi* to place five successively higher bids, each of them pushing Keereweer's bid back up closer to where it had been before the other bidders pulled out. Then he took one more bite of the apple and tasted the worm. For his sixth bid, he typed in $130,005 and overtook Keereweer. With less than twenty-four hours to go in the auction, *howdyhi* sat on top of the heap with a six-figure bid. I sat at my desk and pounded uselessly on my keyboard as I watched it unfold.

Then I was embraced by an odd sense of relief. Maybe it was for the best. Maybe this would teach Fetterman a lesson and put an end to what was becoming a maddening situation. He called but I didn't answer.

Forty minutes later he placed one more bid, his last on this auction. He called again, I ignored him again, and, through the speaker on my answering machine, he said, "I put one in for $135,505. Don't worry. He'll come back for it. Trust me."

I went to bed with my stomach churning. When I awoke on Monday, I found Keereweer back on top with a bid of $135,605. Fetterman was right. This guy would pay whatever it took to buy the painting.

All I did that day was watch the auction and wonder if other bidders lurked, waiting to place their bids until the last day, the last hour, the last minute. Fetterman came down to my office to watch the "show," the final moments of the auction, when last-minute bidders were likely to make their moves. Only one more bid came in on the final day. About an hour and a half before the auction ended, *laliqueseller* came back and placed a bid for a hundred dollars more than the high bid. It was an odd, half-hearted attempt, as he had written that he would bid again only after looking at the painting, and unless he'd snuck in while I slept, he hadn't seen it. Whatever his intentions, the bid was meaningless, and Keereweer's proxy bid prevailed. At the very end, when the bids typically tumbled in, the "RD52" auction closed quietly, at $135,805.

Reporters began e-mailing even before the auction ended. On a slow news day, a story about a guy finding a hundred-thousand-dollar painting in his garage apparently seemed huge. Judy Dobrzynski of the *New York Times*, Jessie Hamlin of the *San*

Francisco Chronicle, and Blair Robertson of the *Sacramento Bee* all sent messages to the Hotmail account I had set up for *golfpoorly*. "I'm sorry," I wrote to Dobrzynski. "Due to concerns about theft and the tax consequences of this sale, I have been advised not to discuss it with anyone at this time." I sent a similar message to Robertson, hoping he would just go away and leave me alone. I signed these messages "Ken."

By signing with my first name, I unwittingly revealed my identity. I'd forgotten that the e-mail account showed "K. A. Walton" as the sender, and with my first name, Robertson and Dobrzynski both found my home number in the phone book. They also unearthed an old copy of my résumé on the web and, although they weren't yet sure, they believed I was an attorney, a Hastings alumnus, and a (now former) employee of Kronick, Moskovitz, Tiedemann & Girard. Dobrzynski and Robertson both called me at home that evening and left lengthy messages pleading with me to talk to them. Someone I assumed was Robertson knocked on my door at about nine thirty p.m., and I didn't answer. In my short e-mail exchange with Dobrzynski that evening, I wrote, "You're not going to do a story about this in the *Times*, are you?"

"Of course I am," she replied.

My heart raced as I read her message, and I called Fetterman to tell him. "Do *not* talk to any reporters," he said. "Nothing good can come of it. The last thing you need is someone snooping into your business."

Unlike most of what he'd said over the last several days, this advice seemed to make sense. I didn't want the world focusing its attention on my auction for a forged painting, and I didn't want to encourage reporters by granting interviews.

I stayed up late reading e-mail and poring over Internet chat-board conversations about the auction. Everyone seemed fascinated

by this *golfpoorly* guy, the friendly family man who'd struck it rich, the man who didn't exist. I lay awake most of the night, wondering what the papers would print the next day and wishing Katherine were there. She was out of town on a business trip, and I felt very alone.

After a brief, fitful sleep I awoke and, for a moment, as I blinked at the ceiling and the dawn light leaked in through the miniblinds, I didn't remember. I forgot I'd just auctioned a painting on eBay for an ungodly sum. I forgot that reporters from major newspapers had been calling and e-mailing and knocking. Then, as I lifted my left arm over my face to look at my watch, the memories tumbled back into my head like rocks tossed into a metal bucket. I groaned, whipped the comforter off my legs, and leaped out of bed.

I opened the *New York Times* homepage first. My pulse quickened as I saw the story; this was no back-page human-interest fluff, as I'd hoped. *Golfpoorly's* mystery painting was on the front page of the most important newspaper in America. My faux Diebenkorn, in all of its glorious orange and green, was on display at supermarkets and newsstands around the country. Judy Dobrzynski expressed skepticism in the article. She'd interviewed the eBay user who went by *laliqueseller*, and she wrote about how I hadn't let him see the painting. She wrote about how I'd declined to speak with her, and she questioned why I didn't "withdraw the painting once people began attributing it to Diebenkorn in favor of selling it through the established art market, which might attract a higher price." She did, however, leave open the possibility that the painting might be real, noting that a 1952 Berkeley work by Diebenkorn would have been possible, and acknowledging that the colors in my painting matched those the artist was using in other paintings at the time. She also quoted Will Ameringer, a New

York art dealer who had sold works by Diebenkorn, saying, "The palette is right, and the signature is right on. . . . It's either a good fake or the real thing." Other experts agreed.

The *San Francisco Chronicle* also printed the story on its front page, under the headline BRUSH WITH GREATNESS? This article focused on whether my painting fit in with what Diebenkorn was doing in the early 1950s. It quoted Gretchen Grant, the artist's daughter, who said that although no one in the family had seen the painting, her father was "a very private painter." Ms. Grant recalled paintings that "surfaced during his lifetime that he had forgotten about—and maybe in a couple of cases wasn't thrilled about—but he had to say they were his." San Francisco art dealer Kim Eagles-Smith said that although the painting had "some elements of landscape that fit what he was doing in 1952," she had serious doubts that it was a real Diebenkorn, because it lacked the "subtlety of the color" found in his other works.

In the *Sacramento Bee*, Blair Robertson, whose knocks I'd ignored, focused on the fact that I had "refused to talk publicly about the item and declined interview requests." He was skeptical. "Does the painting exist?" he wrote. "Is it valuable? Does the buyer exist? Is the seller real?" He held open the possibility that a local man known as "golfpoorly" was about to receive a "major windfall" but noted that "nowhere to be found is the painting or the seller or any way to confirm anything. The mystery— and the knocking and calling and e-mailing of the seller— continues."

The stories weren't limited to the newspapers. Television stations in Sacramento, San Francisco, and San Diego were preparing reports for the evening news. Local news radio focused on the sale of the painting throughout the day, and

CNET radio had been repeating the story around the country since early that morning. Allan Dodds Frank, a reporter for CNN, was interviewing New York art dealers for a two-and-a-half-minute segment.

Later that morning I went to a newsstand downtown to buy copies of the newspapers with stories about me. When I returned to my apartment I found seven messages on my answering machine. I'd been gone less than an hour.

I closed my eyes and pressed play. First message: Cassandra, a friend I hadn't talked to in eighteen months, sounded cheerful. "I read about you in the *New York Times*," she said. I tossed the newspapers on my unmade bed and glanced again at the headline on the front page of the *Times*: EBAY ART AUCTION MAY OR MAY NOT BE MODERN CLASSIC.

"What a crazy story," Cassandra said, her voice obscured by static. She had no idea how crazy—how I'd barely slept for the past thirty hours, and how terrified I was that the world was going to discover the truth, or even some tiny bit of the truth.

The porch creaked, and I heard a knock at the door. I crept to my bedroom window and cracked the blinds enough to see a television camera propped on a blue-shirted shoulder. I shuddered and felt my heart thumping inside my chest. I didn't want to talk to the press about this. I didn't want to talk to anyone. And I certainly didn't want my frightened, sleepless, pasty face on the local evening news.

I tried to ease my shaking fingers from between the blinds slowly, so as not to be noticed. I was terrified that the man outside would see me and rap on the window. I walked quietly back to the answering machine and lowered the volume. Next message: A man from the *Today* show. Early that morning someone

from Channel 3, the local NBC affiliate, had slipped a faxed letter in the crack of my front door explaining why the *Today* show was the best place for me to tell my story. Now a reporter from New York was following up. The *Today* show? They had no idea they were calling a person who didn't exist.

My answering machine screeched and clicked into the next message. Blair Robertson of the *Bee*. Shit, these people weren't giving up. "Ken, I just talked to someone over at Kronick, Moskovitz, and no one there seems to remember you being married. You really should give me a call. I've got some other stuff I need to run by you."

I pressed the blue button to save Robertson's message, and the machine unleashed the acidic voice of Judy Dobrzynski. I winced. Out of all of them, she was the one I feared the most. This was her fourth message. "Ken, I need to talk to you," she said. "I just talked to a man who says he bought a painting from you that had a forged signature, and I really need you to comment on this. You can't hide forever."

THE EIGHTH PART. That

afternoon reporters discovered that *golfpoorly* was not the man
he'd claimed to be. Judy Dobrzynski of the *New York Times* not
only learned that I was a single, childless attorney, but talked to
Michael Luther about his purchase of the faked Percy Gray and
was sure I was running some sort of scam. "You're an attorney,"
she said, her voice stretched tight. "You went to Hastings, and I
know that's a very good law school." She paused for a moment.
"How could you be involved in this sort of milieu?"

I paced the floor of my office as I talked to her, walking from
one tiny room to the other and back again, squeezing the cord-
less phone between my cheek and left shoulder. For two days I
had not eaten and barely slept. My stomach felt like it was filled
with sawdust. Reporters were attacking me, cameramen loitered
around my apartment, and I felt besieged. For some reason, I

thought Judy might take pity on me. I explained to her that I'd come from a family of modest means, had put myself through school, and sold art on eBay as a way to finance my new practice. I tried to convince her I wasn't running a scam and that the sale to Luther had gone awry due to a misunderstanding. "I know some of what I've done looks bad," I said, my voice shaking. "All I ask is that when you write about this, please be fair."

"I always am," she said. But she wasn't buying my story, and she didn't feel the slightest bit sorry for me. "Are you at home right now?" she asked.

I paused. What, was she coming over? "Uh, no. I'm in a top secret, undisclosed location," I said, forcing a laugh that was met with silence.

"Well, I sent a photographer from our San Francisco bureau up to your house to take some pictures. We want to make sure you're not running a painting factory out there."

I had similar conversations with Blair Robertson, Ken Bensinger of the *Wall Street Journal*, and six or eight other reporters. I stayed in my office all day with the door locked, taking their calls, trying to convince each of them that the story about the painting was a harmless little sales pitch. I swore I didn't know the painting looked like a Diebenkorn when I put it up on eBay. The fact that I was a lawyer did me no good. If I'd been a garbage man or a groundskeeper or a mechanic, my story about the painting wouldn't have been news. But my profession was one everyone loved to hate, and the reporters seemed to take pleasure in grilling me.

"You're a lawyer. Do you really golf poorly?" one of them asked, with apparent seriousness, perhaps trying to catch me in another lie.

"Oh, yes," I said. "Very poorly."

After talking to reporters all morning, and realizing the world would soon find out that I'd lied about the painting, I finally heard from Robert Keereweer, the high bidder. It was nearly twenty-four hours after the end of the auction.

"These reporters are pestering me," he said. He spoke in an almost flawless British accent, so slightly tinged with Dutch that I would have almost been unable to tell he was not a native speaker of English, were it not for his formality. "They are calling at strange hours, bothering my wife and me."

"Me too," I said.

"Yes, so I heard about the story you made up and the problems you've had on eBay in the past. As you are an attorney, I am surprised you are telling lies such as this on the Internet. This may damage your reputation."

"It was very stupid of me." I stood outside my building, leaning against the concrete wall, plugging my ear so I could hear him over the passing trolley. "I'll understand if you want to cancel the sale." I wanted nothing more than for him to back out, so I could slink away from the spotlight in shame and be forgotten.

"Oh no, of course not. In fact, I would like to pick it up soon. May I fly into San Francisco? Is that close to you?"

"It's not too far," I said, frowning, trying to think of a way to stall him. "You know, I really have no way to tell if this painting is authentic. It might not be, and your bid was very high. If you want to change your mind, I won't be upset."

"You never said it was real," he replied. "I understand that. I have chosen to take a chance and I know the risk. I have a good feeling about this painting, and I want to buy it. I can come out to California next week."

"Yes, well . . ." I leaned my head back into the wall. There had to be a way to put this off. "You know, given the suspicion

about this sale—with the story and all—I'd like to make you an offer. I'll try to get the painting authenticated by an expert. If it's real, you can buy it for the price you bid. If not, we'll go our separate ways. This makes it much safer for you and would make me feel more comfortable."

Keereweer paused for a few seconds. "Well, I suppose this would be fine. I would ask that you keep me apprised of your authentication effort. I should like to know whom you are showing it to and what opinions you receive. I assume you may want to take it to Christie's or Sotheby's."

"I'll keep you informed," I said, and as I hung up, I let loose a heavy sigh and felt relief. I would fix this. I would ease myself out of this sale and quietly move on with my life.

I called Fetterman and told him about my arrangement with Keereweer. "Let me get this straight," he said, his voice strained with anger. "This guy was going to fly out and buy it and you let him off the hook?"

"You think I'm going to sell it to him with the whole world watching? I'm the one with my name in all the papers. You let me handle this."

"Oh, yeah, you're handling this one great," he said. "I told you not to talk to any reporters, and you go and have a little press party. Now you let the buyer off the hook. You're fucking this thing all up. I'm telling you—if we give this a few days to cool off, we can sell that thing. You—"

I cut him off. "Tell you what, man. You call the *New York Times* and tell them you gave me the Percy Gray, and I'll let you call the shots on this one."

He said nothing. We ended the conversation.

Upstairs in my office I got a call from Kevin Pursglove, eBay's public relations spokesman. "You must be dealing with a lot of

FAKE: Forgery, Lies, & eBay

reporters," he said, his voice pitchman-smooth. "We're pretty used to dealing with them here, and if you want, we'd be happy to help you with some PR. We were even thinking we could set up a press conference when the buyer comes to pick up the painting, and maybe have you guys exchange it at our head-quarters. We'd be happy to put that all together. We think we can get some good press out of it." I was surprised that anyone at eBay wanted anything to do with me, after they'd found out I'd lied in my description.

"Okay, I'll let you know," I said, my voice weak. I clunked down the phone, put my elbows on my desk, and squished my face into my open palms. I wanted to say that the whole thing was a hoax, a big joke, and put it all to rest. But I couldn't. I thought I could slip my way out of it with more lies.

The *New York Times* photographer knocked later that after-noon. I was at home, lying on my bed, glassy-eyed and wide awake, and was separated from him by just five feet and a win-dow shrouded by aluminum miniblinds. I slid my thumb and forefinger between two slats, separating them just enough to see him. A black Nikon 35mm camera bedecked with giant acces-sories hung from his shoulder. I eased my head back into my pil-low and was trying to breathe silently when I heard another voice, and footsteps on the stairs. Introductions. Someone from Channel 10, a local television station. Talk. Laughter. "I can't believe I drove all the way up here for this," the *Times* photogra-pher said. More talk. Cigarette smoke. How long were these guys going to hang out on my porch? "This place looks like shit," one of them said. "I hope it works out for this guy. It looks like he could use the money." More laughter. Assholes.

I stayed at Katherine's apartment that night. I needed rest, but I lay awake, my mind choked by thoughts of what the next

138

day might present. Every muscle in my body felt beaten and pinched. I finally dozed for a couple of hours, and awoke with a start at six, a sheet tangled around my legs and my back soaked with sweat. I crept from the bed, trying not to disturb Katherine, and went to check the morning papers.

The *Bee* led with another front-page story: EBAY PAINTING SELLER TALKS, BUT BIG PICTURE STILL FUZZY. Although I'd finally spoken with Blair Robertson, and the conversation had been polite, he was apparently still miffed at not having been invited to my apartment to see the painting and continued to suggest that there might not *be* a painting. "Ken Walton was in seclusion Tuesday, the blinds pulled shut on his modest midtown apartment as the art world went into a tizzy about a painting he may or may not have—one that may or may not exist." He referred to the sixteen-hour period after the auction during which I did not speak with him as a "lengthy game of cat and mouse." He mentioned the story I'd made up about having a wife and child, and noted that "despite his homey narrative on eBay, Walton is no bumpkin," ticking off lines from my résumé and mentioning that I drove a gold Mercedes coupe, which must have been revealed to him by a neighbor. He failed to point out that my car was twenty years old. Despite all this, the tone of Robertson's article was not overly suspicious. He interviewed Ed Russell, the owner of a San Francisco art gallery who, referring to the painting, said, "We all know these things exist. We do. It's definitely possible." Robertson also noted that I planned to get the painting appraised before proceeding with the sale.

Judy Dobrzynski, in another well-researched front-page story in the *Times*, recounted the tale of Luther's purchase of the P. Gray painting. Dobrzynski knew I was an experienced eBay art dealer and thought it was far from coincidental that I was offering another

unattributed painting and letting the eBay bidders take their chances. Nevertheless she was balanced in her reporting, and she quoted a lawyer who said that my conduct in the P. Gray auction would not have been considered fraud, if I had not made any mis-statements about it. She also began the article with an account of how I had offered to let Keereweer out of the sale if the painting turned out to be inauthentic, and she titled the piece, "Online Seller of Abstract Work Adds Money-Back Guarantee." This cer-tainly made the whole thing sound less nefarious.

I had the feeling Judy was not done with me, though. She'd clearly spent a lot of time on the story and had researched the items I'd sold in the month preceding the "RD52" auction, reporting that I'd taken in a total of $5,766.62 and even men-tioning two specific auctions for paintings that had sold for $697 and $1,100.

This was the first day the story appeared in the *Wall Street Journal*, which had missed out on it the day after the auction. Ken Bensinger was very friendly to me on the telephone but made it clear that he was out to get to the heart of the story. "We got scooped on this and my editor's not happy," he told me. Having been beaten by the *New York Times* the day before, he tried to break new ground, and he was the first one to report that I'd published an article in law school called "Fonovisa v. Cherry Auction: Is a Web site Like a Flea Market Stall?" The article, which had appeared in an obscure law journal, analyzed an appellate case involving the sale of bootleg music tapes at a flea market. I pointed out that the court's ruling might subject Internet service providers to increased liability for copyright infringement by their users. Although this article was about copyright law, and really had nothing at all to do with what I'd done on eBay, or eBay's potential liability for it, Bensinger seemed

eager to imply a connection. He also cited statistics about online auction fraud complaints to the National Consumers League, creating the impression that my auction was fraudulent, and he interviewed David Carlson, the Carmel art dealer who had been so ferociously skeptical during the auction. Carlson claimed that the eBay user *antqudeakn*, who'd bid on the painting, had asked him for an opinion about it, and he'd told him it had "one chance in a million" of being a Diebenkorn. This, Bensinger implied, was why *antqudeakn* had withdrawn his bid.

Television reports shared a "buyer beware" theme. Allan Dodds Frank of CNN interviewed David Redden, the vice chairman of Sotheby's, who pointed out that buying a valuable painting on the Internet, without looking at it, "seems totally bizarre. I mean, the auction process, buying art in the art market is not a lottery. . . ." George Lewis of the *Today* show interviewed Timothy Anglin Burgard of the Fine Arts Museums of San Francisco, who said, "Scholars and experts will have to look at the painting in real life, not digitized on the Internet. . . ."

In all, the stories on the second day, although very embarrassing, were not as bad as I'd feared. I went to my office and hoped for a quieter day. Then the phone rang. It was someone from eBay's Trust and Safety division, a man I would later learn was an attorney, but who did not identify himself as one to me on the phone. "Someone reported that you placed a shill bid on the painting," he said. "Your eBay account has been suspended and the auction has been canceled. We're starting to get a lot of calls about it, and I just wanted to call you personally to verify it. You did bid on your item, right?"

I remembered the bid Fetterman had placed with my user ID *grecescu*. I felt my chest tighten. What could I say? They knew. I couldn't blame it on Fetterman. It was my user ID.

I sighed. "Uh, yeah. I guess I got carried away when the price started going up."

"Well, I'm sorry, but it's a strict rule and we've got to enforce it. We're going to take some heat for this as it is." His voice was measured, mellow, and almost kind. He sounded like he regretted having to do this to me.

"I understand," I said. "Are all my accounts suspended?"

"Yes, we suspended, um . . . *golfpoorly*, *advice*, and *grecescu*."

"I see." They apparently didn't know about the others, but they'd gotten the important ones. My face felt warm and my entire rib cage felt like it was being squeezed. What would I do if I couldn't sell on eBay? "Is it permanent?" I asked, my voice quivering.

"It's the standard thirty-day suspension for shill bidding. If you get caught again, you'll be kicked off permanently."

We hung up, and I tried to log into eBay and couldn't. My user ID now had the words "not a registered user" next to it, the mark of death. My e-mail inbox filled with auction cancellation notices. I knew the phone would ring again soon, when the press caught on.

Within moments I realized how the shill bidding had been discovered. EBay hadn't figured it out on its own. Someone had researched the bidders in the auction and discovered that *grecescu*'s e-mail address was repoman@pacbell.net. The username "repoman" in this e-mail address matched up with the folder on the web server I'd used to store the photos of the painting: http://home.pacbell.net/repoman/. It was obvious that the photos for the auction were stored in a folder that was assigned to *grecescu*.

I immediately called Fetterman and told him about the suspension. I wanted him to know it was his fault.

"That wasn't a shill bid," he said. "I would've bought that painting. Why the hell did you tell them it was a shill bid?"

I hung up on him, left my office, and walked around downtown, along K Street Mall, feeling weak and dizzy. A breeze was scattering trash, whipping it into tiny tornadoes of debris. How would the press handle this latest wrinkle in the story? Would they even care? They'd already revealed me to be a liar and had published front-page stories about me two days in a row. I hoped the story was growing stale and that this latest turn of events would just make them roll their eyes and scrounge for something more interesting to write about. But this was not the case. As I shuffled around downtown Sacramento, eBay was being flooded with phone calls and was preparing a press release to explain my suspension.

When I tugged open the heavy glass door to my office building and slouched across the lobby to the elevator, someone called out, "Mr. Walton!" Two men in their thirties wearing Dockers and button-down sport shirts, one carrying a notepad and the other a Nikon, had been waiting for me. I glared at the security guard inside her little booth, and she shrugged. "Hi," the one with the notepad said, smiling. "We're from the Associated Press. Can we talk?" These were the first two reporters I'd met in person. They'd been lying in wait for me.

"Uh, sure. But no pictures." The guy with the camera smiled and said nothing.

We went upstairs, and the reporters sat in the chairs in front of my desk, like clients. The questions were simple. "So, where did you buy the painting?" At a garage sale in Berkeley. "You aren't really married?" No, it was just a cute story I made up to go with the painting, because I couldn't really think of anything else to say about it. "How long have you been selling art?" About

a year. "That's a nice one you've got on the wall there." Thank you. "I collect a little art myself." Oh, really?

They apparently had no idea I'd just been suspended from eBay for shill bidding, and they were asking the same questions everyone else had been asking the day before. Judy Dobrzynski called during our chat and I lifted one finger, smiled, said, "Sorry," and picked up the phone. I didn't want her tipping them off to the latest development on my answering machine.

"Ken, I'm sure you know what I'm calling about," Dobrzynski said. "I heard about your suspension from eBay, and I need to talk to you."

"Why did I know you'd be the first one to call me about this?" Some part of me respected her. She never missed anything and didn't buy my lies. I couldn't brush her off, no matter how much I tried. "There's someone in my office right now, but I'll definitely have a comment. I'll call you back."

The reporter with the notepad cocked his head to the left and frowned. "What was that about? Did something happen?"

"No, no," I said, and shook my head. "I should probably get to work here, though, if we're done."

The photographer begged me for a photo. "My boss is going to kill me if I come back without a picture," he said. "Can I just get one of you from behind, looking at your computer?"

"Sorry," I said. "No photos." It was day two of this fiasco, and no one had gotten a picture of me. I certainly wasn't going to just give one away.

The AP reporters excused themselves and made their way to the door. As they closed it behind them, I heard the photographer say, "He seems like a nice guy."

Right away I grabbed a legal pad and started a list of ways to lessen the beating I would take in the papers the next day. Judy's

call had convinced me that my suspension from eBay was indeed going to make headlines, and having been swarmed by the press for the last two days, I somehow felt like I was getting good at talking to them and knew how to handle this latest crisis. So I plotted. I knew, first of all, that I needed to own up to the shill bidding. I also knew that I couldn't tell the press what I'd been telling myself for the past year—that the shill bidding was simply a harmless sales pitch, a way to attract bidders. I knew they wouldn't buy into that. I needed a better explanation, a way to make it look less suspicious. I scratched out some notes and then typed up a "statement":

> Today eBay suspended my account for thirty days because I placed a bid on my own auction, the now-famous $135,805 auction for an abstract painting. I placed the bid for a friend who did not have an eBay account, and when I did so, I did not know that such bids violated eBay rules.
>
> As eBay stated in a press release earlier today, the bid was so low that it had no effect on the eventual price for which the painting sold. Nevertheless, I regret placing the bid and applaud eBay's efforts to enforce its rules and maintain a safe, trustworthy trading community.
>
> Even though the auction has been canceled, I still intend to show the painting to experts to determine whether it may be by Richard Diebenkorn, as many have suggested.

As reporters called, I took their questions and faxed this statement to them. They were far less kind today. Judy, for one, didn't believe the story about my "friend." "How hard is it for

someone to get an eBay account?" she asked. "Can I call your friend?" I told her I didn't want to subject my friend to media scrutiny. "How many eBay accounts do you have, anyway?" she asked. "Why would a person need more than one?"

"A lot of people have more than one user ID. Some people like to buy things with a different ID than they use for selling, so other sellers won't know what they're up to. Other people like to sell different things with different IDs. They don't want their porcelain doll customers knowing they sell porn, or their auto parts customers knowing they also do needlepoint."

"Fine, but how many IDs do *you* have?"

I paused for a moment and said, "Just those three."

"So, just *advice*, *golfpoorly*, and *grecescu*? Those are the only three?"

"Yes, Judy," I said, my voiced pitched with exasperation. "I've got another call coming in."

"I might call you back to verify a statement," she said. "We're done for now."

But she wasn't done. This shill bidding thing was new to her, and she was fascinated by its implications. It wasn't about me, it was about eBay, and what sorts of unscrupulous things the company allowed to occur on its site. My story was simply the illustrative anecdote.

For the third day in a row, my story blemished the front page of the *New York Times*. This article was less about me and what I had done than about the scourge of online auction fraud in general. "The episode . . . sheds light on the exponential growth of chicanery and fraud in Internet auctions," Judy wrote. She quoted Paul Luehr, the supervisor of the Federal Trade Commission's Internet marketing unit, as saying, "Internet auctions remain the

No. 1 source of consumer complaints related to the problems online, and they vie with sweepstakes for the top source of fraud overall." A private art dealer said, "EBay is one of the greatest avenues for selling questionable merchandise that's ever been invented." While admitting to some fraud, eBay itself claimed that it occurred in less than one-tenth of one percent of auctions. Judy noted that eBay relies on its members to help police its site, but wrote that "some eBay-watchers say eBay does not take reports of fakes seriously enough." These dissatisfied eBay-watchers included David Carlson, the Carmel art gallery owner who was so disturbed by my auction that he called eBay about it. "I asked for the fraud division a half-dozen times," he said, "but the girl on the switchboard refused to put me through. Instead, she went to *golfpoorly's* offer. She read it and said, 'I don't see any fraud here.' She made the decision right there." I'd never sold Carlson anything, but he seemed eager to bash me, and eBay, every chance he got.

Blair Robertson took it easy on me in the *Sacramento Bee*. He noted that my eBay suspension amounted to being "in eBay's penalty box for thirty days" and had "no direct legal consequences." He also noted that the suspension, which canceled the auction and let me off the hook with the buyer, "might be the best thing to happen" to me because, if the painting turned out to be authentic, I would be "an instant millionaire—one no longer obligated to sell it to Robert Keereweer." Perhaps hoping I would turn out to be a hometown hero after all, Robertson seemed to give me the benefit of the doubt, retreating from his earlier skepticism about whether the painting existed. He wrote, "One thing still might be for real, a painting worth a tidy fortune."

I was ashamed by the coverage and thought far too much

was being made of it. What about the guys who auctioned three dozen laptops, took in a quick sixty thousand dollars, and skipped town? What about the people who sold "vacation package" certificates, insisted on payment by Western Union, and left their buyers with nowhere to go? The unscrupulous art dealers who tried to pass off forgeries as the real thing, brazenly authenticating works they'd just dashed out in their garages? It seemed unfair that I was the one on the front page of the *New York Times*.

But then again, I'd just called a great deal of attention to myself by auctioning a painting for $135,805. I'd lied about it, sold dubious paintings in the past for large sums, and entered plenty of shill bids. Most of what they were writing about me was true.

One thing I'd feared—that another unhappy customer might tell his story—didn't seem to have happened. Or so I thought. That afternoon an article on CNET's News.com, a technology news website, detailed how I'd sold the "C. Still" painting to Kevin Moran. The painting "turned out not to be what I thought it was," Moran said. "I don't think he materially misrepresented the painting, but it was the way he went about it." I wondered why he'd spoken only to CNET and not gone to a major newspaper. I was glad he hadn't talked to Judy Dobrzynski, but it still troubled me that his story was out.

Keereweer called again on my cell phone later that morning, as I stood in front of the door to my office and fumbled for the key. "How is the authentication effort proceeding?" he asked.

"Well, I guess you must have heard about my eBay suspension. Things have been pretty crazy around here." I sank into my desk chair.

"Yes, of course. The press calls to tell me everything, but I've stopped talking to them. I think we should both agree to keep this whole thing between the two of us."

"Well, now that eBay has canceled the sale, of course you don't have to buy the painting."

"Oh, I still very much intend to buy this painting."

"But I've been kicked off eBay, and there's no obligation for you to buy it, so—"

"I don't care what eBay says," he interrupted sternly. "You and I have an agreement, and you are obligated to sell it to me. If you fail to meet this obligation, I am prepared to sue you. I have attorneys in New York and I have already spoken to them about this, and they have assured me that I stand on firm ground, legally. If you try to cancel this you will very much regret it, I assure you." He paused for a second and his voice softened. "We have an understanding?"

"Okay, Rob. Please give me a little time to find someone to look at it."

"That is fine. Just keep me informed."

I hung up and glanced at the menacing red message light on my office phone. I hesitated to press the play button, fearful of whatever bad news it might bring. What if someone had pieced together evidence of more shill bidding? What if the owner of the thrift store in Pearblossom had seen a picture of the painting on the news? Or worse yet, the person who'd actually created it? Anything could happen.

I tapped the play button. "Hi, Ken, this is Theresa Gibbons. I read about you in the *Chronicle*. Sounds like a pretty crazy situation."

Theresa and I had been friends in law school and hadn't spoken since graduation. She was a former television reporter, and her voice glided with professional smoothness.

"Listen, I'm still working with Harold Rosenthal doing criminal defense work down here in San Francisco. If you need any help with this situation, give me a call."

I frowned. She was calling to offer me help with criminal defense? I hadn't committed any crimes. Was this the criminal defense attorney's version of ambulance chasing? I leaned forward and stabbed a button on the answering machine. Its calm, female-robot voice said, "Message deleted."

THE NINTH PART. The

painting leaned against a table on a patio overlooking Folsom Lake, about twenty miles east of Sacramento. Jim Albertson crouched and blew on the "RD52" in the lower right corner. He touched the tip of his finger to his tongue, tapped it on the letter R, and watched his saliva evaporate in the heat.

"One thing for sure," he said, craning his head to look up at me, "is that you didn't add that signature. It was painted on by the artist. I'll vouch for that."

I exhaled, my eyes fixed on the painting, and felt a sense of relief as he said this.

Albertson stood, put his hands on his hips, and shook his head. "But I just don't think it looks like a Diebenkorn."

I was at the home of John Fitz Gibbon, an art critic and retired university professor who had known Richard Diebenkorn

for many years during the artist's life. It was Saturday, May 13, five days after the auction had ended, and this was Phase One of my attempt to "authenticate" the painting. Fitz Gibbon, slowed by Parkinson's disease, passed a quivering hand over the center of the canvas. "It looks especially weak in this area here." His voice wavered and his white head trembled as he spoke.

I'd come here with Steve Vanoni, a Sacramento artist I knew through a mutual friend. He'd called the day before and offered to help me try to get the painting authenticated in exchange for a small portion of the profits if he succeeded. He scheduled this meeting with Fitz Gibbon and picked me up that morning in his white 1970 Cadillac Eldorado. Fitz Gibbon had invited Albertson, a local artist, to lend a second opinion.

We all stood around the painting in silence for a moment, and then Albertson said, "One thing I can say in its favor is that the materials look right. The handmade frame? It's dead on." He leaned the painting forward and examined the back. "These stretcher bars? Look, they're just one-by-ones, sawed off and nailed together. That's the kind of thing those guys did back then." He looked at Fitz Gibbon. "Hey, John, don't you have a couple of Diebenkorns inside? Let's look at the backs of them."

We walked through sliding glass doors into Fitz Gibbon's modest house, which could have qualified as a small museum of postwar northern California art. Richly hued paintings hung on every wall, in a way that seemed less about tasteful placement than maximum coverage. Fitz Gibbon, taking small, hunched steps, escorted us to a guest bedroom and pointed to a painting hanging high on the wall. "Can you get that down, Jim?" I followed his trembling finger and—*Jesus!*—an original oil by Diebenkorn, a landscape from the early 1960s. It was so much

better than mine I felt ashamed to have even come here. Fitz Gibbon's real Diebenkorn was small—half the size of my fake one—but was probably worth several hundred thousand dollars. And here it was, adorning the wall of an unused bedroom.

Albertson pushed the painting up and pulled it out slowly. He held it in front of us. "See how much thicker the paint is?" he said. He was right. It was textured and muscular. My painting looked weak in comparison.

"Yeah, but this is from ten years later," Vanoni said.

"True," Albertson replied. He spun the canvas around, showing us the back.

"Look at that," Steve said. The stretcher bars were exactly like the ones on my painting—boards sawed off at right angles and nailed together. It was a rarely used technique, almost amateurish.

We followed Fitz Gibbon into another room and plucked another small Diebenkorn off the wall. It was also from the 1960s, painted much more thickly than mine, and stretched over the same kind of sawed-off, nailed-together boards.

"Well, I can't say for sure that it's not Dick's work," Fitz Gibbon said as we stood by the door. "But it just doesn't look like it to me."

Vanoni and I hiked down the steep driveway, and he set the painting in the Jacuzzi-sized trunk of his Cadillac. The busted passenger door wouldn't open, so I stepped in through the driver's side and slid across the front seat. "Don't worry," Vanoni said as he backed the car onto the road. "We're not giving up yet. That's just one opinion."

As it happened, I would get another opinion later that afternoon. John Metropolous had called me the day before and convinced me to show the painting to Rudy Curiel. I flinched when

I heard his voice on the phone. "I saw the auction and read about you in the *Bee*," he said. I thought he'd figured out my game. Perhaps he wanted a refund for the Giacometti and would threaten to call the newspapers with his story.

But no. "That painting looks really good to me," he said. "Rudy and I want to take a look at it and see if we can help you authenticate it. It'll be worth a fortune if it's real."

And so, after Steve and I returned from Fitz Gibbon's house, I took the painting to Rudy's gallery, which was located on the ground floor of a sleek, cinnamon-and-saffron-colored building full of artists' lofts. Rudy met me at the door with his Geraldo smile, shook my hand, and glanced furtively up and down the street as he took the painting and invited me inside.

His gallery was long, narrow, and dim, and it was crammed with bulky antique furniture and paintings of all sizes and styles. My eyes landed on a little oil by Seldon Gile. The signature looked almost identical to the one on the "Gila" painting I'd sold a year earlier. I followed Rudy as he navigated a narrow path back to his desk and propped the painting against a table.

"So," he said, and paused to let a small sigh escape from his lungs. "Another great find by Mr. Walton." He looked me in the eye and smiled, and it wasn't that cheesy salesman's smile this time, but something different, more subtle. A *knowing* smile, perhaps? Was he onto me? Had he agreed to look at this painting so he could tell me that he knew I was running a scam, had taken advantage of him and his friend John, and had better not try it again with this atrocious fake Diebenkorn?

"Yeah, well, this one really took me by surprise." I wondered if I could grab the painting and make a run for it.

"I'm sure it did," he said, and laughed. And it wasn't a malicious laugh or an *I'm onto you, asshole* laugh. Just a friendly

chuckle. Maybe this wouldn't be so bad after all. "Let's take a look at it." Rudy perched his glasses halfway down his nose, lifted the painting close to his face, and scanned it for at least a minute without saying a word.

"So where did you buy this?" he said finally. "Did it come from the same estate sale as the Giacometti?"

"No, I've actually had it for a few years. I bought it at a garage sale in Berkeley back in law school."

"Interesting." He frowned.

I gripped my chair, waiting for him to continue.

"Let's take a look at it under the black light," he said. I followed him to the bathroom in the rear of the gallery and watched him scan the surface of the canvas. "See that?" he said as he passed the wand over the "RD52." "It disappears right into the painting. Looks good."

Back in the gallery, Rudy propped the painting up near his desk, opened a large book, and flipped through it. He stroked his chin as he looked at a page, then the painting, then the next page, then the painting, then the next page, then the painting. I stared at him and bit chunks from my thumbnail. Finally he turned to me and said, "Well, my friend, I think it could be real."

"Really?"

"Yes, really. When John called I was skeptical, especially after what I read in the papers. But now that I see it in person, I have a good feeling about it. A couple of things do trouble me. First of all, it's got acrylic varnish on it, which Diebenkorn wouldn't have used in 1952. But that could just mean someone added it later."

I glanced down and tried to force any expression from my face. I'd added the varnish myself and hadn't thought about the fact that it was acrylic. This mistake should have made the forgery obvious, but Rudy, ever the optimist, was willing to look beyond it.

"Also, the paint is very thin, and Diebenkorn's work generally has a very thick impasto," he said, making a brushing gesture with his hand. "But again, that doesn't mean it's not real. He was experimental, and he changed his style several times in his career. This could have been an experiment. It looks a little weak to me in this area here," he said, indicating the splotchy green in the center of the canvas. "But it looks much stronger along here." He moved his finger up along the top of the painting, across the flat, rectangular panes of orange.

I secretly agreed. That was the spot on the painting that had made me think I could pass it off as a Diebenkorn. I sat and nodded, trying to look interested and bewildered.

"Still, just because it has some weak spots doesn't mean it's not real. Every artist has his off days." He paused for a moment and gave me a serious look. "I don't want to mislead you. It's not going to be easy to get a stamp of approval for this. New paintings are sometimes controversial. But I'm no stranger to controversy. Not long ago I authenticated a recently discovered painting by Jackson Pollock. No one thought it was real because it wasn't done in the type of paint he typically used. But I did a chemical analysis of the paint, tracked it back to the store in New York where it originated, and found the person who sold it to Pollock back in the 1950s."

"Wow."

"Yes," he said, smiling and nodding. "My findings have been accepted by other experts, and we now have a consensus. We're marketing it quietly right now."

"Amazing."

He laughed. "Just good research, my friend. The point is, I know these things happen. Great paintings from the fifties and sixties are still being uncovered in garages and attics." He paused.

"I'm glad John sent you back to me. I think we have a good chance with this one, and I'm excited to give it a try."

Avoiding Rudy's eyes, I glanced around the gallery. Then I saw it, hanging about fifteen feet away from his head, squeezed between two nude figurative paintings: The Giacometti. I wondered what he'd done with it. Had he showed it to any experts? Had it been analyzed in any way? It had been six months since he picked it up at my office. I averted my gaze and looked at the floor for a moment, and then looked back at Rudy, who was still mesmerized by the would-be Diebenkorn.

"So where are you keeping this?" he said.

"In my apartment."

"Is it secure? Do you have an alarm?"

"Uh, not really. No alarm, anyway." I thought for just a moment that I would welcome a thief into my house if it meant I could get out of all this. I could throw my hands up and say, "It's gone. What can I do? Look, someone broke the window! Bastards!" But would anyone really believe me?

"Would you like to keep it here? It's very secure."

"Yes, I would. Thank you."

As I drove away I felt lighter; I was glad to leave the painting in someone else's hands. What was I doing with all this authentication bullshit? Of course, I couldn't *really* get it authenticated. I knew it would never hang on the wall of Keereweer's house with a notarized appraisal letter taped to the back. I just wanted to keep his attorneys from issuing threatening letters.

But I suppose there was something else at work. Although I knew no one would be able to say the painting was by Diebenkorn, I desperately wanted someone to say that *I* hadn't forged it. I'd cheered inside when Jim Albertson said it. Now Rudy, having looked at the painting under a black light, had

come to the same conclusion. I wanted the world to know this: That guy who made up that story about the painting and bid on it himself—at *least* he didn't forge the signature.

Of course, I *had* forged it, just a few weeks earlier, but I desperately wanted to forget this, pretend it had never happened. I told myself that if I could be forgiven this *one* thing, I'd *never* try to pass off another questionable painting. I'd stop working with Fetterman. I'd stop shill bidding. I just needed to sell art for another nine months or so while I built my law practice.

I tried to keep my authentication escapade quiet, but someone—probably Fitz Gibbon or Albertson—called the *Sacramento Bee*. The story the next day was called "Painting in eBay Auction Divides the Experts." Blair Robertson somehow understood my agenda for the day, describing how I "drove in secrecy to Fitz Gibbon's isolated home." He quoted Fitz Gibbon and Albertson, who described the painting as "Diebenkornesque" but lacking the "assurance and quality" of a good Diebenkorn. He had also talked to Rudy Curiel, who was more optimistic. "It's the right period, the paint is old enough, and it's pretty much Diebenkorn's palette," Curiel said. Robertson concluded that "no one seems willing to dismiss it as a fake."

As I was promising myself I would never place another shill bid if I could get back on eBay, David Carlson, one hundred fifty miles away in the tiny seaside resort town of Carmel, was trying to prove I was a shill bidder. I didn't know it at the time, but he was piecing together evidence that my cohorts and I used numerous alternative IDs to bid on our items. This was no easy task. In addition to *advice*, *golfpoorly*, and *grecescu*, I had at least seven other fake IDs. Fetterman and Beach each had at least this many of his own. To uncover evidence of shill bidding, Carlson

had to scan every auction I'd hosted in the last thirty days and find every bidder in each of them. Then he had to research every bid these bidders had placed within the previous thirty days and look for patterns.

The patterns weren't obvious. Fetterman, Beach, and I had spread our bids around, and this dense, tangled net of bidding was not easy to unravel. But Carlson kept at it, and he didn't just research bidding activity. He also looked at the feedback for all the bidders on my auctions, and in this, he began to find clues. My user *grecescu*, who'd been caught bidding on the RD52 painting, had two feedback comments, one from *advice* and one from *skapie*, another one of my IDs. The user ID *skapie* also had two feedback comments, one from *grecescu* and one from *slance@youpy.com*. The ID *slance@youpy.com* had a feedback comment from *big-fat-mamba-jambas*, which Fetterman had used to bid on my auctions. Little by little, Carlson pieced enough of it together to convince himself to search for more evidence.

Countless hours of sleuthing eventually led him to the Rosetta stone: the feedback record for *pigroast*, the user ID created by Scott Beach to host the "feedback auction" a year earlier. This gave him the proof he needed, and he started calling reporters with his findings. Judy Dobrzynski called my office on Monday and questioned me for twenty minutes. She asked about fifteen different eBay user IDs, many of which belonged to Fetterman, Beach, and me. She seemed eager to get me to admit to something, anything, that would lend credence to Carlson's claims.

"What about *warpspeed111*?" she said. "Is that your user ID?"

No. It was Fetterman's. "I have no idea what you're talking about, Judy."

"What about *education1*? That's yours, isn't it?"

Fetterman's also. "Judy, this is a ridiculous line of questioning."

"It doesn't seem so far-fetched to me, Ken. I think you use a bunch of different user IDs to bid on your paintings. Why do you need so many IDs?"

"I don't have 'so many' IDs." I was frightened, but trying my best to sound like her questions meant nothing to me.

"I think you do, Ken. It's obvious. Why don't you just admit it? This isn't about you, it's about eBay, and how they don't stop sellers from bidding on their own items. This is a big deal."

"Well, if it's not about me, maybe we shouldn't be having this conversation."

"What about *cheesesix*? Is that one yours?"

I blinked. This one *was* mine. "No," I said. "I really need to get back to work."

"So *cheesesix* isn't yours?"

"I think I just answered you."

Some of Judy's accusations had no foundation at all. "Your brother's on eBay too, isn't he?" she said, her voice pitched and threatening. "You and your brother work together."

"What? Judy, that's absurd! I think two of my brothers have eBay accounts, but I've never worked with them, and as far as I know, they've never even sold anything on eBay."

"What are their names? What are their eBay IDs?"

"I'm not going to give you my brothers' names. No way." I felt my face grow warm. I wondered if she would be able to track them down without my help, and I didn't want them to be bothered by her.

"Why not? If they haven't done anything wrong, why can't I call them?"

"Judy, I have to go now."

"Ken, if you're lying to me, you know I'll find out."

"Judy, seriously . . . I have to go."

Carlson also captured the attention of Ken Bensinger of the *Wall Street Journal*, who called me that afternoon with a similar list of questions.

"Jesus, not again," I said.

"What, is someone else working on this story? Has the *Times* called you?" Bensinger still felt the sting of having missed the auction story when it first unfolded.

"Nothing," I said. I certainly didn't want to feed their competition.

Bensinger was younger than me, in his late twenties, and he often spoke to me like we were pals. When he questioned me after the auction, our talks often turned from interviews into conversations. He asked if I ever came to New York, and he said he'd like to meet me. "You can crash on my couch next time you make it out here."

Now, even as he accused me of harboring a battalion of shill bidding IDs, he was friendly about it. And his kindness, though I knew it was a ploy, was disarming. As he patted me on the back, he was unbuckling my armor.

"What about *slance@youpy.com*? That one seems to belong to you."

"Come on, give me a break. I already admitted to being a shill bidder. EBay kicked me off the site. I'm gone. Don't you think they'd know if I had more IDs?"

"Okay, I see your point, but let me just ask you a few more questions."

I sighed.

"So, what about an ID called *artpro*? Does that one belong to you?"

"No."

"Okay, what about *cheesesix*?"

"What?"

"*Cheesesix*. The word cheese and the numeral six, spelled out. Cheese S-I-X. Is this one yours?"

"Yeah."

I'm not sure why I said this. It just came out, and right after it did, I lurched forward in my chair and beat my forehead with my palm. He'd been working on me for ten minutes, playing his I'm-a-good-guy-but-I-gotta-ask-you-some-tough-questions act, and it worked. I cracked, for just a moment.

"It is?" His excitement leaked through the phone. "It's yours? Because you've used it to bid on some of your items."

Fuck. Could I somehow backpedal? Could I say I made a mistake? "Wait, what was the name again?"

"*Cheesesix*. You just said it was yours. It is, right? You just said it was."

I grimaced and gave in. "Yeah, okay, so *cheesesix* is mine. But I hardly ever use him."

"You told me *advice*, *golfpoorly*, and *grecescu* were your only IDs. Now you say you have a fourth. How many others do you have?"

"There was one other from about a year ago. I forget the name of it. I don't understand what the big deal is about a seller bidding on his own item. It doesn't force anyone else to bid, or make them pay more than they're willing to pay. How is this news?"

"Well, it's against eBay rules, isn't it?" he asked.

"Yes, it's against eBay rules."

"And they don't seem to have a way of stopping it, right?"

"I have no idea."

As Bensinger went back to writing his story, I imagine that

David Carlson, having found someone to listen to his shill bidding theories, was frenzied. They believed him. They took his calls. He was taking me down. He had to gloat.

So he called me at my office. My answering machine picked up and Carlson spoke, his voice menacing and frothy. "Yeah, hi, I'm doing an investigative report. I want to see if he's *pigroast*, *warpspeed*, *slance-youpy*, *estatequeen*, *education1*, *big-fat-mamba-jambas*, et cetera." Then he hung up.

I listened to his message the next morning with confusion. Investigative report? For whom? Who was this anonymous "investigator"? Only much later would I discover that he was a Carmel art dealer–cum–eBay vigilante. At the time, I just knew someone out there knew about the *pigroast* auction, and this terrified me.

Bensinger called a couple more times over the next two days and couldn't get anything more out of me. His article, "EBay Art Seller Used Aliases, Submitted Phony Bids at Site," appeared in the *Wall Street Journal* on Thursday, May 18, 2000. Bensinger revealed that, in addition to the bid on the RD52 painting, I'd also used *cheesesix* to bid on a $152.50 landscape by an artist named M. J. Rothenberger, a $104.49 maritime scene, and a landscape painting that sold for $91. He also quoted me as saying, "I do not make a practice of using screen names to bid up my own items," which, obviously, was a blatant lie.

I felt cursed. How did a few shill bids on hundred-dollar paintings warrant an article in the *Wall Street Journal*? Sure, I'd actually placed scores of other shill bids that I hadn't admitted, but Bensinger didn't know about them, or at least couldn't prove them.

I took some comfort in the fact that the article was buried deep inside the paper, but of course, Judy Dobrzynski saw it. She called the day it appeared.

"I asked you about *cheesesix*," she said. "You told me it wasn't yours."

"Judy, I . . . I was just trying to . . . I just want this all to go away."

"Ken, I think I told you this already. You should never lie to a reporter. We'll find out and never trust you again. This whole thing may be over now, or it may not be. But I'm not going to be able to use you as a source."

Of course, it wasn't all over. Bensinger continued to uncover evidence of my bidding network, and he began to believe I was involved with other sellers. After his May 18 article, he kept calling and asking me about different user IDs, but I gave him no more ammunition. I didn't admit to anything. Finally he seemed ready to write another story anyway, despite my protests.

"My editor says we're going to run this tomorrow," he said. "We've got so many IDs that seem to belong to you or other sellers you're involved with."

"Write what you will," I said, doing my best to sound like I didn't care. Desperate to throw him off my trail, I paused for a moment and deepened my voice. "But if you don't have proof of your accusations, and they're not true, you and your paper will regret it." I counted in my head: one, two, three. "Do you understand?"

He waited a moment. "I understand you completely," he said, his voice no longer buddylike. Our conversation was over. Bensinger didn't call back, and there were no more shill bidding stories in the *Wall Street Journal*. As guilty as I may have looked, Bensinger simply couldn't prove it. All the evidence was circumstantial, and his paper wasn't willing to take a chance it might be wrong.

Fetterman, meanwhile, wasn't taking any chances either. Shortly after I realized that someone was researching our shill bidding, I told Fetterman, and he launched Operation Obscure-a-Shill.

Every day he and Beach woke up and started bidding, and they kept bidding all day long. They used their entire roster of shill bidding IDs, as well as a few of mine, to place bids on all kinds of eBay items. They didn't just bid on paintings. To make their fake bidders look more real, they bid on children's clothing, CDs, kitchen appliances, and Coca-Cola memorabilia.

To further the illusion, Fetterman and Beach even used some of the IDs to make purchases. Fetterman complained about this. "I'm spending a lot of fucking money to try to keep you out of trouble," he said. "One of my guys just ended up high bidder on a fifteen-hundred-dollar painting that I don't really want, and now I've got to buy it. I hope you appreciate this."

"If it hadn't been for your shill bidding, we wouldn't be in this fucking mess in the first place," I said.

"No, what got us into this mess was your fucking cute little story about the painting. Now I'm up here trying to save your ass. Me *and* Beach."

"Hey, if the shill bidding gets uncovered, it's your ass on the line as much as mine, so you keep doing whatever you need to do."

He did, and for the next couple of weeks, things were quiet. Reporters didn't call. No one tried to take pictures of me. I began eating and sleeping again. I started thinking about how to attract more clients to my law practice. I saw friends, and the infamous painting wasn't the first thing they asked about.

I couldn't relax completely, though. Every day I checked the *New York Times* to look for stories by Judy Dobrzynski, and she didn't seem to be writing much. I wondered if she was up to something.

On May 30, as I sat at my desk reviewing a contract, my fears were fanned by another phone call. When I answered, a voice snarled, "Yeah, the cops are onto you guys and your eBay shill

bids." It was the same voice as before, a voice I would later learn belonged to David Carlson. "I suggest you keep quiet. The first one to talk and you all go to jail."

Click.

Fuck.

The now familiar rush of fear overtook me. My heart leaped into action and squeezed adrenaline into every cell in my body. Why wouldn't this guy leave me alone? I called Fetterman.

"Dude, this is bad," he said. "And something else—Beach got an e-mail today from the *New York Times* asking him a bunch of questions about bidders on his auctions." His voice wavered. He sounded terrified.

"Oh, man, she's still at it. Tell him not to respond. I should never have talked to her."

"Don't worry," he said, snorting. "He's not responding." Fetterman vowed to keep placing innocent bids with his IDs. "There's nothing else we can do but ride this out."

Two days later, on June 1, Judy called. It had been nearly two weeks since we'd spoken, and I'd hoped I would never hear her voice again.

"We've got another story coming out," she said. "We think you're part of a shill bidding ring, cooperating with other sellers."

"What?"

"Are you part of a bidding ring, Ken?"

"You're doing a story about a 'bidding ring'? What on earth is that?"

"It should be obvious to you," she said. "It's where a group of eBay users gets together and bids on each other's items to drive up the prices. Do you know Alice Therrell in Placerville?"

Alice was Lane's first name. Alice Lane Therrell. Fetterman had probably used her name to register his eBay ID. I'd warned

him numerous times about using Lane's identity, and now I worried that she would get dragged into this.

"I'm absolutely not in any kind of bidding ring, whatever that is. There's nothing going on like that. EBay got me, I'm off, and that's it."

"So, do you know Alice Therrell in Placerville? Let me run through the connections between you two and then you can tell me if it's just a coincidence."

"Judy, I've got to go. I have no further comment."

The story was called "The Bidding Game: A Special Report— In Online Auction World, Hoaxes Aren't Easy to See." It started in the upper left corner of the front page, the most coveted spot in the paper, and ran 2,802 words, a length reserved only for serious investigative reports. I knew, after reading the first paragraph, that it was bad. For me, anyway. For Judy, it was a virtuoso piece of reporting. She was an arts reporter, and this may have been one of the most important articles she'd ever written. Katherine stood behind me, her hands on my shoulders, as I sat at the desk in her bedroom and read the story.

Judy made us out to be some sort of eBay Mafia. "Mr. Walton, a Sacramento lawyer who used at least five Internet names selling and buying on eBay, appears to be just one of a circle of people who have engaged in cross-bidding activities that may have influenced the outcome of eBay auctions," she wrote. She referred to us several times simply as "the circle" or "the ring," terms that could have just as aptly described a satanic cult. With meticulous detail she listed off names, user IDs, and specific auctions with fake bids.

In Judy's hunt for shill bidders, she ensnared a few innocent bystanders. She suggested that two East Coast eBay art dealers were involved in our scheme. Neither of these men was directly

involved with us, but they did appear to bid on each other's items a lot, and Fetterman and I exchanged "courtesy bids" with them now and then.

Just about everything else she wrote was correct. She fingered twenty-two different user IDs that belonged to Fetterman, Beach, and me. She mentioned the *pigroast* auction and the ridiculous feedback we'd left for one another. She saw right through Fetterman's attempt to obscure our shill bidding. "Those in the circle may have changed their bidding patterns in recent weeks, lying low to avoid attracting attention once Mr. Walton's auction began making headlines May 9," she wrote.

The story was as much an attack on eBay, the Internet's darling, as it was an exposé of our bidding. "The fact that the circle surrounding Mr. Walton would not have come to light without the media glare illustrates just how easy it is for people acting in concert to fly beneath the devices eBay uses to root out rigged bidding," Judy wrote. She quoted Louis Richman, the financial editor of *Consumer Reports*: "EBay has created a monster that has grown beyond its capacity to monitor and to police. . . ." She cast doubt on eBay's "shill hunter" software, its new weapon against shill bidding, noting that "critics of eBay contend that the company's screening system is not fine enough to detect all ring-bidding." She claimed that eBay's rules, which allowed users to have more than one user ID and let friends bid on each other's items, made online auctions "ripe for manipulation."

The response from eBay was anemic. Robert Chestnut, its associate general counsel, told Judy that "there are things that look like shill bidding that are not. . . . Sometimes bidding just looks suspicious." Chestnut recounted the tale of a judge the company had mistakenly suspended for shill bidding, and described how the user had been indignant about the accusation. He noted that

the company acted with caution before suspending a user for shill bidding, because sometimes the evidence of it was circumstantial. He admitted that there was "a limit to shill hunter."

As I read the story, a barbiturate numbness spread through my body. "Well," I said to Katherine, "she pretty much got it all, and then some."

"You didn't tell me you guys were using that many IDs," she said. "That's pretty pathetic."

"Well, I recognize them now that I see them in print, but I wouldn't have been able to remember that many on my own."

She lowered her head to my shoulder and tightened her arms around my chest. "Look at it this way," she said. "Now that it's all out, how much worse can it get? What else can they say? There's nothing more to hide, right?"

I reached up and touched her arm. "Yeah," I said. "Maybe you're right." As ashamed as I was about what had been revealed, I thought everything that could be discovered had been discovered. I wanted to believe I had nothing more to fear.

Most of the friends who'd called when they'd seen the first articles now remained silent. What could they say? I was sure some pitied me, and others were disgusted, and I couldn't blame them for not getting in touch. I didn't want to talk to anyone anyway.

Katherine and I stayed inside her apartment for most of the weekend, and I didn't go into my office on Monday and Tuesday. I didn't want to run into anyone I knew. I just wanted to sulk and wait until it felt safe to emerge.

On Tuesday afternoon I checked my office voice mail. Judy had called again. As usual, she just "needed to talk" and didn't give a reason. What now? I sat on my front porch and thumbed her number on my cell phone. She answered.

"Ken, I'm doing another story. Have you heard from the FBI?"

I'd love to recount the thoughts that tore through my head like bullets, the horrible sensations that swept through my body, and the way I trembled, cringed, or felt tears filling my eyes. But at that moment I didn't feel anything. I just sat there, numb, unflinching.

"No, I haven't."

"Oh," she said, and let loose a little giggle it seemed she was trying to smother. "Well, you will. They've announced that they're starting an investigation into your eBay bidding."

There was an awkward silence.

"Do you have a comment?"

THE TENTH PART.

I squinted into my rearview mirror. Through the Vaseline haze of the plastic back window of my ragtop, I could still see the white sedan. It turned when I turned. Was it following me? I glanced at the four-inch stack of paper on the passenger seat, looked ahead down El Camino Avenue, and plotted my next move. I would pull into the left lane, as if I were going to turn on Watt, and then I would make a U-turn instead. Then I would know.

My cell phone vibrated in my pocket. I flinched and fumbled for it as I eased into the left lane and slowed. I looked back at the white car. It was accelerating right by me.

The call was from Tara, one of my roommates from law school. We'd shared a flat in the Mission District of San Francisco for two years. Now she was an assistant district attorney in Alameda County, across the bay from San Francisco.

"How are you?" she asked. Everyone seemed to ask this same question in the same way, with the emphasis on the verb: How *are* you?

"I'm hanging in there. It's scary. I'm just taking it day by day." Yeah, day by day. It had been two days since the investigation was announced.

"You know," she said, "in a way, you're kind of a victim of bad timing. The tech stocks are crashing and people are blaming the dot-coms for the economy. Everyone's focusing on Internet fraud right now, thinking the government isn't doing anything about it, and then you pull this stunt and it gets a lot of press. You're like the poster boy for Internet fraud."

"Huh," I said blankly. "Maybe you're right." I was watching another late-model American sedan parked across the street.

"Anyway, I can't give you legal advice, but I just wanted to call and tell you to keep your chin up. If you don't have a good attorney, get one and just sit tight. This might not go anywhere, but if it does, you're going to need good counsel."

"I know. I'm not sure how I'll afford it."

"Let me just tell you this, from experience: Don't do anything rash or start throwing stuff away. People always do that and it just makes them look guilty, and sometimes gets them in more trouble. I'm sure you know this, but I'm just reminding you."

"Don't worry," I said. "I'm cool."

Hanging up, I glanced again into the rearview mirror and turned into a Chevron station. I pulled up to a row of gas pumps, reached over to the stack of papers on my passenger seat, and pinched a quarter-inch slice from the top. I got out of my car, stretched and yawned and looked around, and tossed the papers into a plastic barrel between the pumps. I slid back into my seat and drove away, looking for my next target.

The papers? Color inkjet printouts of every auction I'd ever hosted on eBay, including photos of all the paintings, my mellifluous descriptions, and lists of all the bidders. I'm not sure why I'd saved them, but I was terrified that the FBI might seize them to use as evidence. I knew I had to ditch them.

I was too paranoid to toss them into my own garbage can for fear it was being searched. They always did that, didn't they? I thought about trying to hide the papers somewhere, maybe in the attic, but that also seemed risky. They would find them. I considered, for a moment, stashing them in my mother's garage, but I didn't want her to be involved in this in any way. I shuddered at the thought of black-booted, rifle-toting FBI agents storming her house and yelling, "The printouts! Where are the printouts?" And she wouldn't know.

I decided to toss them into public trash cans and drove around for two hours scattering them, watching for special agents the entire time. I pulled into gas stations and furtively slipped the papers into grimy cans between pumps. I drove behind apartment buildings and grocery stores and tossed them into Dumpsters. I wound through residential neighborhoods and shoved them into green plastic cans awaiting pickup. No one would be able to piece it all together.

The printouts weren't the only things I purged. I noticed other suspicious items in my apartment. I'd claimed to know nothing about Diebenkorn, for instance, but owned several books with pictures of his paintings. These had to go. I ferreted through my closets and also found some old art supplies from classes I'd taken in college. These had to go too, lest someone think I'd used them to forge masterpieces. I stuffed these things into a backpack and tossed them into garbage cans around my neighborhood.

When Judy had told me about the FBI investigation, I hung up the phone and felt confused, more than anything else. What did it mean? Would I come home one day to find my door kicked in and my apartment torn apart by men with guns? Would I be followed? Was I being watched at that moment? Were my phone calls being monitored?

And why in God's name had I found out about it from a reporter? How had the investigation been announced to the press before they'd even searched my house? Wasn't this shoddy law enforcement protocol? Didn't this give me a chance to run, or cover my tracks, or warn my co-conspirators? Was it just a publicity stunt by the FBI, a chance for it to look like it was cracking down on eBay fraud?

I knew I should call Katherine and cringed at the thought. So far she'd been convinced this would all work out for the best, lessons learned, bad habits changed. I didn't know how she would react to this latest announcement. I knew I would have to call my mother to warn her about the story, and I wondered how I would explain it.

Instead I called Fetterman.

"I just heard from the *New York Times* reporter. She says we're being investigated by the FBI."

He was silent, and then in a raspy whisper, he said, "What?"

"The FBI is investigating our eBay activities."

He breathed into the phone and didn't say anything for several seconds. "Stay where you are." He hung up.

I then did something I hadn't done since I was traveling in Turkey after law school. I walked down to a corner store and bought a pack of Marlboro Lights. I'd never been a regular smoker. Sometimes I bummed one when I was out at a bar with a friend who smoked, and occasionally I joined in when traveling

in a country full of heavy smokers. But now I felt for the first time like I *needed* a cigarette. Something churning inside me was crying out, and I had to quiet it.

Half an hour later I was stubbing out my third cigarette when the phone rang. It was Fetterman. "Walk out to your porch," he said.

I opened my front door and saw him driving down I Street toward my apartment. As he pulled closer, he slowed and twisted his neck to glance up at me through the front window. He turned his head forward and nodded to someplace farther down the street. Then he gave me a look that said, "Understand?"

I descended the stairs and started down I Street. Fetterman was now two blocks ahead of me, and as he turned left at 19th, he glanced back and nodded. What the hell was he doing? Did he expect me to follow him all over town? I slowed my pace but kept walking, and a moment later I saw him right in front of me, crossing over I Street at 20th. He'd circled around. I watched him creep into the parking lot of a seedy mini-mart, the place that had just supplied me with cigarettes.

I met him inside, next to the soda machine, where he was filling a thirty-two-ounce cup with Diet Coke. He didn't look at me but whispered, "Meet me outside."

As we pulled out of the parking lot, he said, "Be careful what you say while we're in the car."

"What?"

He frowned and shook his head. "Dude, I'm serious." We drove in silence for a moment and he said, "Did you see that guy in the old El Camino parked on 21st?"

"No."

He nodded knowingly. "FBI. Watching your place. I drove around and spotted him before I called you. That's why I had you meet me down the street. He lost track of us."

"You think the FBI is driving old El Caminos?"

"They do that to throw you off, man. It's the last thing you'd expect, isn't it? These guys are tricky."

I had neither the energy nor the desire to argue with him. What did it matter, anyway? Even if the guy in the El Camino wasn't watching me, someone probably was. "I can't believe this is happening," I said.

"Shhhh. I'm going someplace we can talk. Just hold it for now."

"What, you think your car is bugged or something?"

He shot me an acidic glance and raised his finger to his lips. I leaned my head back and turned toward the window. People were walking along J Street, shopping, enjoying their day. I would have given anything to be one of them, to be a normal person with normal concerns living out an average day. Other people were able to roll through life contentedly, but I was different, and I hated myself for having gotten into a situation that forced me to ride in this car and wonder if the FBI was following.

We drove to the campus of California State University, Sacramento, about four miles from my house. Fetterman wheeled into an almost-empty parking lot and we got out.

"The FBI has already been up to my house," he said. His eyes were bloodshot, his cheeks carpeted with stubble.

"What? They've knocked on your door?"

"No. But I saw them," he said, scanning the parking lot. "White trucks. Government trucks. I've been seeing them for the last couple of days."

I looked down. "No El Caminos?" I said quietly.

"The solution to this is simple. If no one admits to anything, they've got nothing. I didn't forge any paintings. Did you? They

can come look at all my paintings. None of them are forged, and as far as I know, none of them are stolen. See what I'm saying?"

"What about the shill bidding?"

"What shill bidding? All my bids were honest. I would have bought any painting I ended up high bidder on. How are they gonna prove otherwise? They're not inside my brain," he snorted.

I couldn't look at him. I felt anger welling up inside me, but I knew it was pointless to lash out at him.

"I'm serious, man," he said, straining his voice. "If no one admits to anything, they can't prove shit!"

"Yeah," I said quietly. I pinched my brows together between my thumb and index finger. "Right."

"One other thing—I'd highly recommend getting rid of your computer. A hard drive is like an onion. You might think you've deleted something, but they can peel away the top level of it and find shit underneath."

"I can't afford to buy another computer. Anyway, if we didn't do anything wrong, what are they going to find on it?"

"Hey, it pays to be on the safe side."

We drove back to my apartment without speaking. I felt numb. I wanted to blame it all on Fetterman, but I knew I'd gotten myself into this mess.

I waited until Katherine got home from work to tell her. I met her at her apartment for dinner, and she cried when I gave her the news. And as she cried, I, for the first time, cried too. The whole afternoon had felt like a surreal dream, and now, as I saw how my predicament affected her, I woke up and let my fear rise to the surface.

"If this scares you off, I'll understand," I said. "It's serious."

She squeezed her eyelids tight and said nothing for a moment. I could see that she wanted to believe in me—she was, at her core, a nurturer and an optimist—but this was testing her resolve. Then she released a heavy sigh and looked at me. "I know it's serious," she said. "But what does it all mean? They're just looking into it, right? If you really didn't do anything wrong, there's nothing to worry about."

"I hope you're right," I said.

She leaned in to kiss me. "Have you been smoking?"

I nodded.

"God, that's disgusting."

Of course, the FBI's announcement triggered more media coverage. Katie Couric told America about it that evening on *NBC Nightly News*. Judy's *New York Times* story appeared on the front page of the business section, and Linda Wertheimer interviewed her later that day on NPR's *All Things Considered*.

As the story leaked out, reporters called. This time there wasn't much I could say in my defense.

"No, I haven't been contacted by the FBI," I told them.

"No, I haven't been arrested."

"No, I'm not worried. The truth will come out."

"Yes, it was very strange to find out about this through the media."

"No, I have no further comment."

Some reporters seemed almost gleeful about my predicament. One woman, at what turned out to be the end of her interview, asked, "Since you're a lawyer, will you defend yourself in court?" and then laughed.

Fetterman, true to his word, went home after our parking lot rendezvous and disposed of his Macintosh. He spoke vaguely

about its final fate, but I got the impression that he had delivered it to a dump in a condition far beyond repair. And his defensive measures didn't stop there. As he described it, he turned his hilltop house into a fortress, removing all the paintings from his walls and taping bedsheets over the plate-glass windows. He strung yellow plastic construction-zone tape in front of his steep gravel driveway and posted a KEEP OUT sign.

Several days after the announcement, I arrived at work and found a note on my door from the guy in the office next to mine: "Come see me—Important!" He told me that two FBI agents had visited earlier that day, asked a few questions about me, and left a card. I thanked the guy and mustered a smile. "Hey, what's this all about?" he asked as I opened his door to leave.

"Oh, no big deal," I said, folding the FBI agent's card in my fist. "I'll tell you about it another time. Gotta go."

I drove back to my house, clomped up the stairs to my porch, and fumbled for my key. The man who lived in the apartment next door appeared behind me. "I'm supposed to give you this," he said, holding out the same card I had in my shirt pocket. "From the FBI."

I took it from him. "Thanks," I said, and pushed open my door.

"You weren't home, so they came by my place."

"Yeah, looks that way," I said, turning to offer a brief smile as I stepped inside. "Thanks for the card."

"So," he said as I started to close the door, "how *are* you?"

I sat in my living room and dialed the number slowly. I could do this. I would call them. I would get things out in the open, be straight with them, and we would work this out.

The agent answered. He was businesslike but friendly. "We're just following up on a request for us to investigate the *New York Times* story about the shill bidding ring. Just doing our job," he said. I wanted to hear: *We know this is all bullshit, and we'd rather be out looking for real criminals, but hey, we've got to go through the motions of "investigating" you, wink wink, nudge nudge, because we can't let people think we're not serious about cracking down on Internet fraud and all.* But somehow, this didn't come through. I couldn't read him, and I guessed that he was trained to be unreadable. "We'd just like to sit down and talk with you about the whole thing," he said.

"Yeah, I want to clear this up. But you know, the lawyer in me says I shouldn't sit down and talk without getting another lawyer to sit next to me, so I think I'd better do that first."

"That's fine, of course," he said. "Some people like to have their lawyer come down and meet with us in person; other people do it over the phone and have their lawyer listen in. However you want to do it is fine."

"I'll let you know," I said. "This whole thing was really blown out of proportion, and I'd like to set the record straight."

"I understand," he said. Then, after a moment, he added, "So you're not part of a shill bidding ring?"

I paused, knowing that each millisecond of hesitation would make whatever I said next sound less believable.

"Heh-heh," I said. Yeah, that's it. A little laugh. Sound casual, like this is all absurd and kind of funny. "A shill bidding ring? I'm not really sure what that is."

"Okay, well, when you're ready to talk, just let us know."

When I got off the phone I looked up Theresa Gibbons, the law school classmate who'd called and offered me help with criminal defense. I *needed* help.

• • •

By Fetterman's account, the FBI agents were not as polite to him and Lane as they were to me. Two days after my conversation with the agent, Fetterman called me on my cell from a number I didn't recognize, breathing heavily.

"Dude," he said in a whisper. "Are you somewhere you can talk?"

I was at home, but I wasn't yet ready to buy into Fetterman's notion that my apartment might be bugged. "Yeah. Where are you?"

"Never mind that. Dude, the FBI was at the house. They were making threats to Lane. 'We know you're in a shill bidding ring, Miss Therrell! The passwords for all your eBay accounts are the same!' And that wasn't my thing. I used different passwords for all my accounts. If anyone used the same passwords, I'll bet it was you."

He was right. I was lazy. I used the same password for every one of my shill bidding IDs. Apparently the FBI had discovered this and confronted Lane about it. I was sure Fetterman, in a paranoid stupor, was exaggerating the agents' behavior. But it still wasn't good. It meant they were gathering information from eBay and taking this seriously.

"They tried to come into the fucking house! They caught us out by the car and we had to run back inside and lock the door. They were following us and yelling."

"Man, you can't let Lane take the fall for this."

"You let me handle that, okay? Lane's not gonna get in trouble."

"How do you know?"

"Just listen. It gets worse. Afterward Lane got all weird and was making phone calls from her car and wouldn't tell me who she was talking to. I felt like I couldn't trust her. We've been

together for years, man, and she was freaking me out. It was like I didn't know her."

"What do you expect? You never should have used her name and—"

"I don't need a sermon from you, okay? Lane and I had an arrangement. It was between the two of us."

I heard the sound of a diesel engine and air brakes screeching. "Where the hell are you?" I asked.

"Listen," he said. "It gets worse. Last night I was so freaked out by Lane that I left and slept in the car. I wasn't sure what she was gonna do."

"Have you been back yet? Maybe she's cooled off."

"No, she hasn't. When I went home today there was some guy there I'd never met. Some friend she went to college with. It was like she called him in for protection or something. So I packed up a bunch of shit and got out of there. I'm afraid she's gonna go to the FBI, man. I really am."

"She must be pretty scared," I said.

He sighed. "I think it's over with us. After all these years and it comes down to this. I can't believe it. I guess sometimes you just have to move on."

"Where are you gonna go?"

"I'm not sure," he said. "I'm not sure."

I stood in my living room and paced the floor. It was the middle of the day, and all my blinds were drawn. "I'm so scared. I can't believe this is happening." I waited for Matt to speak, and he said nothing. "I think I'm going insane," I said.

"You did what they said you did, right?" His voice sounded cold.

"What?"

they wrote in the papers was true. Or mostly true."

I sighed. "Some of it, yeah, but they made it sound way worse than it really was, like we're some kind of crime syndicate."

"Ken, they just wrote about what happened. You and Fetterman bid on each other's stuff all the time and you sold fake paintings for him. I told you to knock that shit off a long time ago. It was dishonest."

"Matt, maybe I made some mistakes, but do you think I deserve to have the FBI after me?"

He waited a moment and said, "Maybe not. I don't know. I'm really pissed at you for getting yourself into it."

I felt confused. "You're what?"

"You got yourself into this, man. I know it's rough, but you have no one but yourself to blame. This wasn't just a mistake you made. It was something you did over and over for a year."

Sadness welled up in my throat. "I was just looking for a little support, man. I'm having a rough day."

"I know," he said, "but I can't be there for you on this one. I'm too upset about it. I'm your brother, and I love you, and you know I'd do anything for you. But I can't back you up on this."

We exchanged an awkward good-bye, and I slumped into a chair. My chest ached. Matt had always been there for me, but this was all too much for him to take. I was sure others felt the same way, but this was the first time anyone had thrown it in my face, and it hurt.

The San Francisco Bay was slate blue Plexiglas, the day cloudless and bright. The temperature dropped ten degrees as I shot out from the Treasure Island tunnel and sped across the bridge toward the cluster of skyscrapers at the edge of the water. This

83

drive usually filled me with anticipation. I came to San Francisco to visit friends, eat at restaurants, wander through museums, see concerts, drink at bars, and then crash on futons and couches. But today held no such promise. I could think of nothing but being arrested and prosecuted, and my stomach churned with nervousness. I was on my way to meet Harold Rosenthal, the criminal defense attorney my friend Theresa had worked with since law school. "He's legendary," she'd said. "He's done a lot of big federal fraud cases, some of them involving hundreds of millions of dollars. He's good. You'll like him."

Harold's office was in a paint-starved Victorian on Octavia Street in Hayes Valley, and it was much different from the corporate law offices I had once inhabited. But it felt comfortable, like the apartment of an old friend. I sat in a waiting room with an eleven-foot ceiling. Theresa walked in, smiling, and we hugged.

"It's been a long time," she said. "How *are* you?"

"I've had better months."

"I'll bet."

I followed Theresa into the conference room and we sat on opposite sides of the table and talked about mutual friends, avoiding the real reason I was there.

At last Harold tapped on the door and entered. I stood. "Mr. Walton," he said in a cheerful, resonant voice, grasping my hand with his thicker, more muscular hand. He smiled from beneath his bushy, salt-and-pepper mustache, and I liked him immediately. Theresa had described him as having the courtroom demeanor of an absent-minded professor, a quality that was very appealing to jurors, and I noticed this about him right away. I felt safe around him.

After some chatting, he said, "Okay, let's talk about this

eBay thing. But first I just want you to know that anything you tell us in here is privileged. I know you know that. The only way we can really help is if we know the whole story, and we're not here to judge you if you did anything wrong." He paused and said, "Okay?" and smiled. "So, Theresa showed me the *Times* stories. Why don't you tell us what happened."

I explained how Fetterman, Beach, and I had bid on our own auctions and sometimes bid on each other's auctions. I gave my pitch for why it really wasn't very harmful. Harold looked up from his yellow pad and said, "So this shill bidding thing, it's against eBay rules, right?"

"Yes, it is. I just don't see how it's a federal crime."

"I guess that remains to be seen," he said. "Doesn't sound like it to me, but you never know what these guys will go after."

I told them about some of the mysterious paintings I'd gotten from Fetterman and how I doubted their authenticity, but didn't know for sure. Eventually the inevitable question arose. "So, it sounds like there may have been some forgery going on," Harold said. "Did you ever try it out yourself? Ever put anything on a painting?"

There wasn't even a hint of accusation or judgment in his voice. He just needed to know the truth if he was going to represent me. But I couldn't admit it, even to him. I was too ashamed, and I knew that giving voice to what I'd done would mean I could no longer pretend it hadn't happened.

And so I said, "No."

"Okay. And what about the Diebenkorn?" he said. "Where did you get that one?"

I sighed. "It really did come from a garage sale in Berkeley. I

know it sounds crazy, but I had it around forever, and it caught me by surprise when I put it up on eBay."

Harold looked at me again, pushed his glasses up the bridge of his nose, and blinked several times. "I see," he said.

We talked for ninety minutes, and Harold offered to represent me at half his normal rate of three hundred dollars per hour, because I was a friend of Theresa's. "Listen," he said. "I want you to try to relax. That's part of my job. Right now, we don't know if this is going to go anywhere, and my gut says it probably won't. I know this seems like a big deal to you, but believe me, for the feds, this is small potatoes. The amount of money involved here is really nothing compared to most of the stuff they go after."

"You think so?"

"Well, there are no guarantees," he said. "All we can do is wait it out. The FBI investigates a lot of things that never end up turning into prosecutions. That's what they do—they investigate. It doesn't mean you're going to be charged."

Oh, how I wanted to believe this.

"In the meantime, under no circumstances will you speak to anyone about this whole thing, including your girlfriend and your family. I know that won't be easy, but it's for their own good. If you talk to them and end up going to trial, they might have to testify against you. You don't want to put them through that, do you?"

I shook my head.

"And for God's sake, don't talk to any reporters, either," he said, his voice growing stern. "Period. No exceptions. If anyone calls you, tell them to call me. Do you understand?"

"I understand."

I drove back to Sacramento in better spirits, replaying

Harold's words in my head. Over the past month everything that could have gone wrong had. Each time I thought things couldn't get worse, they did. It had to stop somewhere.

I got home, cleaned my apartment, and asked Katherine to come by after she got off work. For the first time in weeks, I cooked. She let herself in and sneaked up behind me in the kitchen.

"You did your dishes," she said, gasping in feigned surprise. "What's the occasion?"

I turned and kissed her. "I'm thinking about rejoining the human race. I may even start going outside again."

"How was the meeting? I thought you'd call afterward."

"My attorney told me not to talk to anyone about it," I said. "Doesn't that sound weird? I have an attorney now. Or I will, when I send him a check for fifteen hundred dollars." Katherine reached for the open bottle of Cabernet on the counter.

"The glasses are in the dishwasher," I said.

"So you can't tell me anything he said?"

"He just doesn't want me talking about the eBay stuff."

She frowned. "Well, I pretty much know all that already, right? The shill bidding. The paintings you got from Fetterman. What else is there?"

I gave her an exasperated look, the one that said, *Can we please stop talking about this particular topic?* And she raised her left eyebrow and put her hand on her hip, which meant, *You're not going to change the subject so easily.*

"I will say this: He thinks it'll probably amount to nothing. He thinks it's too small for the feds to prosecute."

"Well, that sounds good, right?"

"I think so."

Katherine gave me a smile that faded quickly as she looked

down. After a moment, she said, "If I find out you did something that you didn't tell me, I . . ." She sighed and continued. "I don't think I could handle that. It would be over with us."

I hesitated, and then reached for her and held her tightly. I closed my eyes, said nothing, and felt guilt washing over me.

I sat at my bedroom desk on a sunny Tuesday afternoon and stared at the list of paintings for sale on eBay. Why was I tormenting myself? I couldn't sell anymore. Ever. EBay had turned my thirty-day suspension into a lifetime ban in the wake of Judy's big shill-bidding story.

I'd socked two hundred paintings in a rented storage unit on the edge of downtown and had no way to sell them. I wondered if I could I have a yard sale and sell some of them to raise rent money, but I knew that wouldn't work. Someone would figure out it was me. A reporter would visit and take pictures. The caption under the photo would be: "Crooked eBay art seller liquidates his assets," and it would show me with bedhead, pasty and unshaven, peddling paintings on the tiny lawn in front of my apartment. I would be holding a wad of cash and my mouth would be hanging open, talking to someone, or maybe I'd be looking directly at the camera, terrified. Or angry. The short article accompanying the photo would speculate about whether some of the paintings were forgeries. Harold would be upset.

Without thinking, I clicked the shortcut button on my browser that, until my suspension, had logged me into the account management page of my main eBay user ID. I'd clicked it hundreds of times, and my hand, a creature of habit, sometimes still moved in its direction, even though it no longer worked.

But to my astonishment, it *did* work. I blinked and leaned

into the screen. My heart raced and I started clicking links, going to pages that suspended users were not allowed to visit. My account had been reactivated. Had eBay reconsidered the permanent suspension? Maybe they'd met with some FBI agents, talked it all over, and decided I'd learned my lesson.

Or maybe it was just an oversight. Someone just forgot to flip the right switch. I checked my other accounts and they were all still suspended. But how could they have been so careless?

I thought about testing it. I could put something small up for sale and see what happened. But this seemed too risky. My user ID was well known around eBay, and if I put up as much as a bar of soap for auction it might prompt another *New York Times* story. What, then?

Something imperceptible. I changed the name of my user ID to *fouroneone*. I would just make this small change to my account and keep an eye on it. I wanted this to be a harbinger of good things, a return to normalcy, and, perhaps eventually, a return to eBay.

My cell phone chirped and vibrated in circles on my desk. It was Blair Robertson of the *Sacramento Bee*. What now? Had he already seen that my eBay account had been reactivated? Did he somehow know I'd just changed the name on it? I answered cautiously.

"I've spoken with Gerald Nordland, a Diebenkorn expert who's looked at photographs of your painting," Blair said. "He told me he doesn't think it's authentic, and he's sent you a letter about it. How do you feel about this?"

I knew Rudy had sent transparencies to Nordland but didn't know we'd gotten an answer. How did Blair know before I did? I had to get off the phone. Harold would kill me if he knew I was talking to a reporter.

I politely got rid of Blair and called Rudy. He seemed hesitant

to talk. "Remember what we talked about?" he said. "It's probably best if you come by my gallery."

Of course. The FBI. By this time I thought my phone might be tapped, and Rudy agreed. "I'll be over in a few minutes."

I drove to Rudy's gallery and slipped into its dimness.

"Well, the response was basically negative, but I'm not sure that's the whole story," Rudy said.

He passed the letter to me. It was a half-page long, but basically said the painting didn't look like a Diebenkorn. Rudy had a faint smile on his face. "Do you see how he didn't give a definite 'no'? In the art world, if you're evaluating a painting, you say yes or no. He just said he didn't 'recognize' it as the work of Diebenkorn. That's very noncommittal."

I looked back down at the letter. It seemed like Nordland was just trying to be polite. "Maybe you're right," I said.

"Now, the most important part. Look at the last paragraph."

He waited for me to read it again, so I did. I looked at him and his smile was wider.

"You see that? He says it's unusual for him to evaluate a painting without compensation." He paused, arching his brows, and nodded slowly. "He's basically asking us to pay him before he'll give the painting a real shot at being authenticated. That's what *I* think, anyway."

I frowned. "Really? That seems kind of—"

"Oh, it's all too common among art experts. They're the gatekeepers, and they sometimes want to collect a cover charge before letting you in. Trust me; I've been in situations like this before. Think about it. If he was giving us a final opinion, why would he have even mentioned compensation? He's leaving the door open for us, inviting us to take another try if we're willing to retain him."

"Well, if he wants to be paid, I'm not sure I can—"

"Don't worry," Rudy said. "We'll cross that bridge when we come to it. About this letter—I don't want you to get your hopes up. It's not a positive opinion. But if we approach this right, we may be able to get a different answer. Remember that he hasn't seen the painting in person. And he's not the only Diebenkorn expert. We're just getting started."

"Okay," I said. I looked down at the carpet. I would go home and e-mail Robert Keereweer about this, to keep his lawyers in check.

Blair Robertson apparently didn't recognize the subtleties in Nordland's opinion. His article was called "Experts: eBay Painting Isn't by Master" and left no doubt that the piece was not by Diebenkorn. "Walton," he wrote, "is all but out of luck."

I pulled into the treeless parking lot in front of Ye Olde Sticky Wicket, a dive bar in a decrepit mini-mall several miles outside the Sacramento city limits. I was pretty sure I hadn't been followed. I pushed the door open, eyed the room, and spotted Ron at a table near the back. He stood, smiled, and extended his hand as I approached. "Good to see you, cuz," he said.

Ron was my father's nephew, and the family tree had assigned him better-looking genes. He was two years younger than me, several inches taller, and wrapped in thick muscles. His face was smooth and boyish, his smile charming. We saw each other often as kids, when he lived near San Francisco and my family visited, and we'd reunited a year earlier when he moved to Sacramento.

We sat with beers and talked. He told me about his new job as a computer network administrator. He was struggling with his girlfriend, but trying to make things work. He'd heard about the

"eBay thing," but didn't really know what to make of it and wasn't sure what to say, so he hadn't called. He assumed it would all work out. I told him about the FBI investigation and how I didn't know if it was going to lead anywhere.

"The problem is, I'm broke," I said. "The bills are piling up. I've had to hire an attorney. My law practice isn't bringing in much. And now I'm kicked off eBay. Well, I think I am, anyway. My account went active again, but I'm afraid to use it. I haven't sold anything for over a month, and I was really relying on that income."

"Hey, if there's anything I can do to help . . ." His voice trailed off.

This was what I was hoping he might say. I hadn't wanted to resort to this, but I felt desperate and couldn't think of any other way out. "Well, I've got all these paintings in my storage unit, thousands of dollars' worth, and I just can't sell them. I'm stuck. I was wondering . . ." I paused. "You've got an eBay account, right?"

"Yeah," he said. "You want me to help you sell the stuff?"

"Oh, man, that would be such a huge help."

"Ken, seriously, it's no problem."

"I don't want you to get in any trouble, but I don't see how you can. You haven't done anything wrong."

"I'm not worried," he said.

"I'll basically be consigning them to you, and we'll do it all on the up-and-up. No shill bidding. No tricky paintings. Everything will be totally legit."

We made arrangements. I would write the descriptions for the auctions, take photographs, and handle packing and shipping. He would post the paintings on eBay, respond to e-mail, and receive the checks. Every week or so he would pay me what he'd received, taking out ten percent for himself.

Our first auction went up several days later. I, the perpetrator of the most infamous eBay fraud scheme ever uncovered, was selling art again.

Katherine and I stayed up late that night talking, our heads six inches apart and propped on her big white pillows. I told her about my arrangement with Ron and saw her face, all silver and gray in the darkness, lapse into a frown. "I don't want you to get in trouble," she said. "This is all bad enough as it is."

"I know, but what else can I do? I'm desperate." She pulled her hand from beneath the sheet and rested it on my cheek. "We're not going to do anything wrong," I said.

She slid her hand up the side of my face and stroked my hair. "I've been thinking," she said.

I realized I'd been talking about myself all night and hadn't even asked about her day. "Yeah?" I said, and smiled. "What have you been thinking?"

"Things are good, right?"

"Things?"

"I mean *us*. Things are good with us, right?"

"This is the *only* thing in my life that's good right now."

I pulled her closer and kissed her. What would I be doing without her? Wandering the streets, most likely. She took care of me. She called me during the day to ask how I was doing, even when she was busy at work. She dragged me out of my apartment when she knew I needed fresh air. She made sure I ate. She calmed me down when I got scared.

"I think we should get a place together," she said, her voice a whisper.

I felt shocked and suddenly very awake. This wasn't something we'd talked about before. "Things are so uncertain right

now. I could end up in a lot of trouble. Are you sure you want to take a chance on me?"

"I am," she said. "Things seem bad for you now, but they'll get better. Life is long. This will pass. And right now, I want us to move to the next level. It feels right."

I was speechless. I'd been so concerned with my own problems that I hadn't put much effort into considering whether my relationship with Katherine should be permanent. We hadn't been back together very long, and I was focused on surviving from day to day. Making long-term plans of any kind seemed like folly, considering the uncertainty of my future. But I didn't want to lose her. I needed her.

"Listen," she said. "It's not like we're getting married. If things don't work out we can move on. But I want to give this a try."

Several weeks later we moved into a low-ceilinged apartment on 33rd Street, the first floor of a ninety-year-old white clapboard house surrounded by sycamores and elms. I hung my paintings on the walls. She stacked her nice white dishes and expensive wine glasses in the cupboards. I put my old love seat on the sidewalk and taped a laser-printed sign to it that said FREE! It felt good to abandon the apartment where I'd been stalked by reporters. This place felt safe. It felt like home. We had a fireplace.

I was sitting in the living room on Katherine's couch, *our* couch, sipping a double espresso and watching CNN. I decided to check the messages at my office, and there was one from Ryan Yamamoto, a reporter for Channel 10 in Sacramento. He was doing a story and needed to talk. That was what they always said.

Harold talked to Yamamoto and called me. "An artist named

Kevin Carey says he sold you two paintings back in January," he said.

"Yeah, I remember that guy."

"He says he offered to sign one of them, and you pulled it out of his hand before he could and told him you didn't want it signed."

"Harold, there was no pulling. That's not what happened."

"Well, apparently Carey's been called before a grand jury to testify about it."

I paused. "There's a grand jury?"

"According to this guy there is. Yamamoto's going to interview me. A camera crew is coming to my office this afternoon."

A grand jury. It started to sink in that this was a *worst-case scenario*. This was what they did when they wanted to prosecute someone.

"I think you should come down," Harold said. "Remember to bring those paintings."

An hour and a half later, I met Harold and Theresa in the conference room at their office. "We don't have much time," Harold said. "Tell me what happened."

"I can't believe this is happening."

"Ken, the TV crew is on its way."

"Okay, so I bought these two paintings from this guy. They were good. I thought I could make a profit on them."

"And they weren't signed?"

"One of them was signed on the back in ballpoint pen." I turned over one of the two paintings to show them Carey's name.

"And he offered to sign the other one?" Harold said.

"No. Well, yeah—but only after I asked him whether he typically signed his paintings. I'd already bought them, and I noticed that neither of them was signed on the front, so I asked

if he didn't like to sign his work. Some artists are like that. He said he usually didn't, and kind of smirked, like he thought it wasn't important. I looked and realized that he *had* signed his name on the back of one of them, and then he grabbed a ball-point pen and said, 'Do you want me to sign this one, too?'"

"And you told him no?" Theresa asked.

"Yeah, I just said, 'No, that's okay,' and tucked the paintings under my arm and left. I was holding the painting from one side and he was holding it from the other, and he just let go. There was no struggle. I can't believe he said that."

Theresa glanced at Harold and then at me. "Why didn't you want him to sign it?"

"Well, here's the thing: When you sell a painting by a local artist who's not listed, you have to be able to say something about him. Maybe he's a member of an art club or has shown his work somewhere. Maybe he's studied with someone famous. But this guy? Nothing. I asked him if he'd ever shown his work during Art Second Saturday, this once-a-month event when all the galleries are open in the evening. You know what he said? 'No, that's too commercial. I'm not into commercialism.' It's like he was too cool to sell his art."

A woman poked her head into the conference room and said, "Harold, they're here. Do you want me to set them up next door?"

"Yes," Harold said. "Tell them I'll be right in." He turned to me. "I think you should stay in here for now. They might spot you if you walk out."

"Anyway," I said, "without anything to say about the artist, I'd rather describe a painting as 'an unsigned work by a talented but anonymous artist' than one by a guy who's never done anything."

"Well, the obvious implication is that you didn't want him to sign the painting because you wanted to add a signature," Theresa said.

"Yeah, but that's just not true. These paintings don't look like anyone else's work, and they're brand-new. Even if I'd wanted to, I couldn't have passed them off."

"I'd better get going," Harold said. "I'm going to bring these paintings so they can get a shot of them."

Theresa and I sat in the conference room. We could hear Harold talking to the television camera next door.

"This grand jury thing," I said, shaking my head. "It's not good, is it?"

"No," said Theresa. "It's not."

THE ELEVENTH PART.

Maybe I was mentally ill. This was the type of thing an insane person would do. But what? Sociopathy? What exactly *was* a sociopath? Was it even treatable? I couldn't diagnose myself while driving. I would Google it when I got home and then, if necessary, check myself in someplace. And Katherine? She would break up with me because she couldn't be in a relationship with a sociopath, or whatever I was. But she would feel guilty and would visit me and hold my hand and bring smoothies and magazines. My mother would bake cookies, and I would have to eat them during visiting hours because I wouldn't be allowed to bring food back to my room. Other patients whose families brought them Taco Bell would be envious.

My back ached. Caffeine molecules tickled the nerves behind my eyes. I'd been driving for five and a half hours and had

stopped only once to refuel. I glanced at the plastic bag in the passenger seat. Was I really going to do this?

I let the car slow. There it was—the Orbit, the place where Fetterman and I had purchased the orange and green painting back in April, the painting I wished had never entered my life. I passed the shop and looked for a spot down the road where people wouldn't see me. I needed to prepare.

I'd felt much saner a month earlier. After Kevin Carey told a grand jury that I'd ripped a painting from his hands before he could sign it, things got quiet. We didn't hear anything for the next five weeks, and I tried to go on with my life. Katherine and I settled into our apartment. I attempted to go into my office on a regular basis.

All the while I kept watching for clues that something might be happening, and I was cautious. Every time the phone rang, I wondered if it might be a reporter or my attorney calling with bad news. I was careful about what I said on the phone. When I talked to Harold or Theresa, we started the conversation with, "Well, let's first just say that this is a privileged attorney-client conversation," so the person who might be listening would have to hang up.

But after a while, I started to relax. If they were still investigating me, how could it all be so quiet? The FBI agent never called back after our first conversation. No one searched my apartment. I listened for, but never heard, those little clicks that meant my phone was tapped. I watched for special agents in late-model American sedans, or white trucks, or aging Chevy El Caminos, and never saw them. Surely if this were going to turn into a prosecution, they would be doing something, right? There would be evidentiary seizures and indictments and arrests and

bail and hearings. The investigation, if it was indeed progressing, was creaking along at a bureaucratic pace, and I wanted to believe it would eventually grind to a halt.

In the second week of August, I e-mailed Kris to ask if she wanted to meet me for a drink. It was her birthday. She wrote back right away. "Thank you for your invitation. However, given your situation with the investigation, and my position working for the judge, I think it is best if we not meet or speak until this whole thing is over. I'm sorry."

I felt like a blunt object had been hurled at my chest. Just like that, we couldn't talk until it was over? How would we even know when it was over? Would they send me a letter? There were other people in my life—acquaintances, mainly—who had stopped calling or e-mailing when the investigation was announced. I expected that. Would you pal around with a guy who was the target of a federal criminal conspiracy probe? Would you invite him to your dinner party? If nothing else, the FBI scrutiny thinned out my large circle of friends and left me with a smaller group of people who really cared about me, and I thought Kris was among them.

I tried to understand. The investigation had been going on for more than two months, and Kris and I had spoken and seen each other several times since then. We talked about the FBI probe, and she never once indicated that she shouldn't associate with me because of her job.

That night, as I lay awake in bed, it occurred to me that Kris might have known something. She worked in the federal courthouse, in the same building as the U.S. attorneys. Things got around. Maybe she'd heard about a prosecution brewing. If this was true, my case could end up in front of the judge she worked for, a man I'd had dinner with on more than one occasion. Of

course she couldn't hang out with me if she might end up advising her judge about evidentiary matters in my criminal case.

I called her the next morning from Katherine's phone. "Kris? I got your e-mail." I paused. "It really bummed me out."

"I know," she said. "I'm sorry."

"Harold says these things can go on for years, even if they never end up going anywhere." I waited for her to speak, but she said nothing. "Is there some kind of courthouse rumor about a prosecution? If you know something—"

"No, Ken, it's not a courthouse rumor. Really." Her voice was strained, and I could tell she wanted to get off the phone.

"Okay." I sighed. "Bye, then. Take care of yourself."

"Bye, Ken."

I sulked through the rest of the day. Losing Kris's friendship made me realize how much I valued it. I tried to guess the cause of her sudden change of heart. If it wasn't a courthouse rumor, then what? Something *more* than just a rumor?

This unsettled feeling eventually wound itself into paranoia, and once again I began obsessing about being prosecuted. But what would they charge me with? They knew I was a shill bidder. This was easy to prove, but it wasn't a federal crime.

Of course, there were also the paintings. Several of my customers felt like they'd been defrauded. But to prove fraud, a prosecutor would have to show that I made a "material misrepresentation" about something I sold. I was always careful to let bidders make up their own minds, rather than coax them with lies, and I thought this protected me from anyone ever claiming I'd committed fraud.

Well, except for the Diebenkorn. Aside from the story about the wife and kid, I'd said I bought it in Berkeley years ago when I'd really found it weeks ago in Pearblossom. I'd also added the

initials. This, of course, trumped everything else I'd done. It was the thing that kept me awake at night, the act over which I suffered the most guilt. No jury would acquit me if a prosecutor could prove I'd added "RD52" to the canvas.

I had to prepare for the worst, and I needed more information. So I hatched a plan. I rented a toothpaste-green Dodge Neon for the drive to Pearblossom and left my cell phone at home so the trip couldn't be traced. I bought everything with cash along the way so as not to leave any record of my journey.

I drove past the Orbit and found an empty gravel parking lot a half mile down the highway. I looked around to make sure no one was watching, then removed my disguise from the bag on the passenger seat.

Who but a sociopath would drive 370 miles in a rented car to don a disguise, walk back into a junk shop, and ask if the proprietor remembered a painting he'd sold months earlier?

My Hollywood-quality props had cost me almost fifty dollars. The neatly trimmed brown mustache was made from real human hair. After affixing it with sickening pine-scented theater glue, I slid the matching wig over my head and topped it with a Peterbilt trucker's hat. The glasses were wire-framed, large, and unfashionable. No prescription.

I looked at myself in the rearview mirror. The disguise looked real. Then it looked ridiculous. No, it looked creepy. What the hell was I thinking? But it was too late to change my mind. I drove back to the Orbit, parked my car far from the entrance, and walked inside.

A man shopping glanced up at me, looked away, and then looked back quizzically. He seemed about to laugh. I think he wanted to laugh *with* me, to grant me the courteous chuckle he'd

share with a man who'd walked through the door wearing, say, a clown suit. But I didn't play along; instead I returned a glance that said, *What? You looking at me?* The man stifled his laugh and looked away sheepishly.

My heart thumped as I made my way to the counter. I smiled at the thin, elderly proprietor. "Can I help you find something?" he asked.

"I just wanted to ask you a couple of questions." I laid a snapshot on the counter and yanked my hand back to hide the fact that it was trembling. "Do you remember this painting?"

He picked up the photo and held it at arm's length, squinting. I held my breath, expecting him to say, *This is the one from the* New York Times, *right?* Instead he said, "Yeah, this looks familiar. We sold it a while back."

I exhaled. "Do you remember who bought it?"

He cocked his head to the left and rubbed his chin. He was going to say, *You did, fool. Don't you remember? You're the one with the picture. And hey, why the getup? Are you supposed to be Tom Selleck?*

But instead he said, "No, can't say as I do."

I removed another photo from my shirt pocket and laid it on the counter. "What about right here," I said, pointing to the close-up image of the signature. "Do you remember this writing on the painting?"

He smiled and shrugged. "To tell you the truth, I don't remember much about it. I guess I never took a close look."

"Okay," I said. "Thanks a lot."

I slipped the pictures back into my pocket and walked to the door, trying to measure out a normal pace. I glanced back at the customer who'd spotted my disguise. He was inspecting a Coca-Cola sign, watching me over the top of it.

Pulling back onto Highway 138, I winced as I tore the mustache off my face. I tossed the wig and glasses into the backseat and breathed out a weighty sigh. If the FBI could somehow trace the painting back to this shop, the owner would remember it. This was not good. But he didn't remember who bought it, and he couldn't say whether or not it had been signed. This was good. At least now I knew. This knowledge didn't give me the sense of relief I'd hoped for, though. I was too frightened by everything else to be comforted by anything I discovered on this trip to Pearblossom.

As I made my way back to Interstate 5, I remembered an antique store, up ahead, just off the freeway, and thought about stopping. I'd gotten some good paintings there once. It wouldn't hurt to pull over and look.

A week later I leaned against the wall outside the Golden One Credit Union and chewed my thumbnail. Why did this always take so long? If something was going to go wrong, it would happen right here. There would be a delay, a furtive phone call, men in suits. Questions. Handcuffs, maybe.

Finally, Ron pushed through the glass door and smiled.

"Mission accomplished?" I asked.

"Man, sorry they're so slow. I go in there every week and they act like they don't know me." He held out an envelope stuffed with cash.

"You got yours, right?"

He laughed and said, "You think I'd forget that part?"

We were selling about fifty paintings a month. There were no shill bids, no faked works of art, no false naïveté. I wrote the descriptions for the auctions with scrupulous accuracy. Then I met Ron at his bank about once a week to pick up cash. He

called me in the evenings with questions. "Some guy wants to know how old the seascape painting is."

"Tell him it's not as old as it looks. It was probably done in the seventies."

I told Harold what I was doing. He didn't particularly like the idea but assured me that as long as Ron and I weren't doing anything wrong, I wasn't getting myself into more trouble by selling art.

I went to my storage unit every few days to stuff the art I'd sold into boxes and prepare the packages for shipping. The manager of the place hopped on his golf cart and whirred over to my unit whenever he saw me enter the complex. He was like a loquacious coworker who hovered around my cubicle talking about sports and politics.

I continued using the same post office on Alhambra Boulevard to mail my packages and felt conspicuous going back to it. I'd been there every week for a year, always lugging large boxes with me, and had gotten to know all the clerks. Then came the "RD52" auction and the newspaper stories, and I disappeared. Now I was back, and I wondered if they knew. Benny, the short Asian guy with the braided rat tail, left me no doubt. I hoisted a boxed painting up onto the counter, and as he slid it onto his postal scale, he stifled a smirk and said, "What do we have here, a Picasso?" After that I started using other post offices.

As I depleted my once inexhaustible stock of paintings, I began buying more, cautiously at first, and then with the same enthusiasm as I had before I'd been expelled from eBay. Katherine, who was at first wary of the selling, began to enjoy hunting for art with me. On a weekend trip to Mendocino, we picked up a dozen good paintings along the way. Her rule: If she spotted something first and liked it, she had the option of keeping it, rather than

letting me buy it for resale. For me this was a liability, because she had a keen eye for good paintings.

By the time the venture with Ron brought in money, in August, I'd gone three full months without income and was destitute. I'd stopped paying my credit card bills and student loans. After I paid Harold his initial retainer fee, the next two checks I sent to him didn't clear my bank, and he asked for a ten-thousand-dollar retainer to continue. "We shouldn't have to keep going through this every month," he said. He was right. He was representing me for half his usual fee, and I was turning him into a collection agent.

I had no idea where I would get the money. I thought I might have to switch to a public defender, but this seemed too risky. Harold was an accomplished defense attorney with decades of experience, and I was lucky to have him. I had to find a way to keep him on my case.

I thought I might be able to raise part of the money by selling my car, but that would have taken more time than I had. My mother told me she would take out a home equity loan, but the very idea of putting her house into hock crippled me with guilt. I was thirty-two years old and had supported myself since I'd left home at age eighteen. After all she'd done to raise my brothers and me after my father left, I wanted to be the one *she* could come to in times of need. But as she pointed out so succinctly, I had no choice but to accept her offer. She wanted me to have a competent attorney as much as I did. We would manage. She would manage. She borrowed twenty thousand dollars and sent half of it to Harold. "You keep the rest in your account," I told her. "Use it to make the payments on the loan. I won't touch it unless I really need it." I hoped I never would.

• • •

Two weeks later I sat across from Harold in his conference room. "I think we should give Kevin Moran his money back for the Clyfford Still painting," he said. "It was the most expensive thing you ever sold, right? And you said you thought Fetterman probably forged the signature. It just makes sense to refund his money. It seems like the right thing to do."

I stared at my hands, palms down on the table in front of me, and they looked like they belonged to an old man. My knuckles had always been wrapped in wrinkly, chimplike folds of excess flesh, but now the skin on the backs of my hands looked like crepe paper stretched over fragile blue veins. I slowly lifted my finger up and away from the polished wood. It trembled worse now than ever. This was not the hand of a surgeon or a watchmaker. I'd once visited a doctor about this shaky finger problem, thinking I might be suffering from the early stages of multiple sclerosis, and he diagnosed it as "familial essential tremors," which meant, in layman's terms, inherited shakiness.

"Are you listening to me? Are you okay?"

I blinked and looked up at Harold. "Yeah, sorry. It's just that—you're right, it is the right thing to do. I just have no idea how I'd come up with thirty thousand dollars. I only got half the money from that sale in the first place." The rest went to Fetterman, and I hadn't heard anything from him in months. I had no idea where he was.

"Well, think about this: If the U.S. attorney's office is on the fence about a prosecution, this could help."

"Don't you think it might make me look more guilty, like I'm admitting I've done something wrong?"

"Not necessarily. They're not going to use it against you in court. If anything, it would make you look better to a jury, like

you're willing to admit your mistake and do something to correct it."

I rubbed my chin. My whiskers reeked of cigarette smoke. There was no way I could come up with thirty thousand dollars. I'd come to hate these trips to San Francisco, these eighty-five-mile pilgrimages to drink from the chalice of bad news.

"Is there anyone you might be able to borrow the money from?" Harold said.

"I don't think so. I'll see." I pushed back from the table and stood. Harold walked to the door and opened it for me.

"Ken, I'm concerned about you. You don't look good. Have you thought about getting some help? Someone to talk to while you're going through this?"

"Yeah, I should probably do that. Thanks, Harold."

That night, from my front porch, I called my father in Korea and told him Harold had recommended that I issue a refund to Kevin Moran. My father knew about the FBI investigation, and I'd let him believe it would all work out and wouldn't turn into anything serious. "A big misunderstanding," I'd called it. Now I had to admit that my situation might be perilous.

My father's finances were a mystery. He seemed to live comfortably, but I had the impression that his wife, Hui Sun, invested most of his income in Korean real estate. "I feel bad asking you this," I said. "But if there's any way you can help . . ."

"I'm not sure if I can do it," he said, "but I'm going to try."

Four days later I held a crisp American Express cashier's check for thirty thousand dollars in my hand. I imagined my father had battled with his wife to free up some assets. "I know I wasn't there for you guys financially after I left your mother," he said. "Now that I'm able to do this, I want to." I e-mailed and told him I would repay a thousand dollars a month, with the help of my eBay sales.

Six months earlier I'd have assumed it would be impossible for me to raise fifty thousand dollars, no matter how much I might have needed it. And yet somehow, my parents were able to rescue me. As I stared at the pale green check, I felt intense guilt for having had to ask for it. I also felt resolve. I would repay my parents and someday, when they needed help, I would be there for them.

Kevin Moran was happy to discover that he would be getting a refund. Harold made plans to fly back to Virginia to interview him and give him the check in person. Before he could make this trip, the U.S. attorneys intervened. "They're flying Moran to Sacramento to testify before a grand jury," Harold said.

I closed my eyes and winced as I processed his words. "Does this mean we can't give him a refund?"

"I spoke to the prosecutor. They don't want us to give him a refund because they think it might affect his testimony."

"His testimony? Harold, this sounds really bad."

"It's not good. I'll call this prosecutor back and see if I can get a meeting with him. I'm going to find out what's going on."

The next afternoon I sat in my living room with Matt's five-year-old daughter Dahlia. "I think I want a bite of your hand," I said, my voice high-pitched and scratchy. I opened and closed the furry puppet's mouth and reached toward her. "Monkey-boy wants to taste your hand!"

She squealed and hid her hands behind her back. "You can't eat my hands!" she said, staring into the monkey's face.

"How about some of your nose, then? Just a little bite. Pleeease?"

"No! Eat this." She grabbed a piece of her grilled cheese sandwich and shoved it into the puppet's mouth.

Because I had a flexible schedule, I often got to watch Dahlia when other daycare options fell through. She was the only person in my life who didn't know what was happening to me. She was innocent. My legal problems weren't a topic she had to avoid when she was around me. She didn't judge me or pity me. When I played with her I could forget it all for a little while, and I cherished this about her.

I heard steps on the porch and the door of the mailbox slam shut. "Monkey-boy's gotta check the mail," I said in my Monkey-boy voice.

I slipped my hand out of the puppet and pulled a stack of envelopes from the mailbox. Inside, I stood over the dining room table and flipped them into four piles: junk mail, Katherine's mail, bills I had to pay, and repeat notices about bills I had not paid.

One envelope didn't belong in any of the piles. I stared. It was from the Department of Justice. I tore it open and clutched the letter with a shaky hand. Pursuant to a court order, my bank records had been seized. The government was legally required, after a certain period of time, to inform me of this. And so it did.

They'd seized these records months ago. I wondered what else had been seized that they weren't *required* to tell me about. It was all suddenly real, this investigation. It was happening and had been happening since the day it was announced. This was *not* going to go away.

"What's wrong, Uncle Ken?"

I looked at Dahlia and forced myself to smile. "Monkey-boy wants to know if you're finished with lunch."

I was on the couch, staring at the screen of my cell phone, when it finally lit up and chirped. "Harold?"

"Hi, Ken." Static and freeway noise obscured his voice.

"How did it go?" I stood and paced into the dining room.

"Well, it's not good news. They're going forward with a prosecution."

The muscles in my chest went limp, collapsing inward and pushing out a breath. "Really?" I said weakly. "Harold, what are they going to charge me with?" I felt dizzy.

"Well, they've got the shill bidding, the story you made up, the other paintings you sold that weren't real. They're lumping it all together into a wire fraud charge."

I reached up and grabbed my hair. "They're going to charge me with a felony? They're going to try and put me in prison for this?"

"That's right," he said. "But listen, we're going to get through this. Try to stay calm. It sounds like the one they really want is Fetterman, and they've made you an offer." Static took over his voice for a moment. "Shit," he said. I heard a click, then more static. "Hey, Ken, we've got a bad connection. I've got to go. I'll call you a little later. We need to talk about this."

The line went silent. I dropped my head. I pressed my thumb into the button that dialed my mother.

"Hi, honey," she said anxiously. "Did you hear from Harold?"

The sound of her voice loosened the muscles that held my knees in place and they gave way. I slumped to the floor and sobbed. I tried to tell her what happened, but I couldn't speak because I was gasping for air and wailing. She said, "Shhhhhh" into the phone, the sound she'd whispered into my ear to comfort me when I was small enough for her to hold in her arms.

THE TWELFTH PART.

The room had no windows. My eyes ached from the fluorescent light reflecting off the bare white walls. I was here to answer questions. We'd been at this for hours.

I sat farthest from the door, near the end of the oblong table. My suit smelled like mothballs and the collar of my shirt felt like cardboard, digging its way into my neck as the day wore on. Harold sat to my left, at the center of the table, his hand hovering over a legal pad. Theresa sat next to him.

At the other end of the table, two assistant United States attorneys sat behind piles of paper and binders. Michael Malecek, slouching back in his seat, was about forty years old and paunchy, his dark hair succumbing to male pattern baldness. He looked bored. Christopher Sonderby was about my age, trim and handsome, with refined, almost delicate facial features. He

leaned forward and stared at me. To his right sat Matthew Perry, the stocky FBI agent heading up the investigation. He looked uncomfortable in his suit, like a fraternity boy with a crew cut at his first job interview. Across from me sat two young women, criminal investigation agents for the Internal Revenue Service, whose sole job seemed to be presiding over the stacks of blue binders that held my bank records. They'd said almost nothing.

It was December 2000, seven months after the "RD52" auction, and I was here to cooperate. I was going to tell the men at the end of the table everything I knew and then plead guilty to fraud charges. They had promised to recommend to the judge that I not be sentenced to serve time in prison. It was Fetterman they wanted, and I would testify against him in exchange for leniency.

When we arrived, Sonderby had explained the arrangement. "You've got a good attorney, Mr. Walton. The fact that Harold came in and talked to us is the reason you've got this deal."

"He's good," I said.

"One thing you need to understand is that this agreement's between you and us. The judge will be free to sentence you however he chooses. We'll recommend a sentence of probation, but we can't guarantee the judge will go along with it."

I nodded. Sonderby passed a paper down to my end of the table and I signed it, promising to be truthful in my answers. I realized, as I passed the agreement back to him, that I'd just chosen a path from which I could not retreat.

After his initial meeting with the prosecutors, Harold had told me they'd made an offer. In exchange for cooperating with their investigation and pleading guilty to a fraud charge, they would recommend that I receive no time behind bars.

"Harold, if I plead guilty to a felony I'll be disbarred."

"I know," he said. "I don't think it's a very good deal. I'm obligated to tell you about it, but I don't recommend you take it. The amount of money involved here is really so much less than what they usually go after, and I don't think they have enough to make it stick."

"Do we have some time to decide?"

"Yeah, we've got some time. You can think about it."

I considered the choice. I could cooperate, saddle myself with a felony conviction, and lose my license to practice law, a profession in which I'd invested tens of thousands of dollars and to which I'd devoted years of my life. But I would stay out of prison. Or I could spend more thousands of dollars going to trial and perhaps exonerate myself, but risk time behind bars.

I researched the federal prison system and learned that, if convicted, I would most likely be assigned to a minimum security facility. "They're like camps," Harold told me. "No fences, no guard towers. Just nonviolent offenders." I would be housed with tax evaders, computer hackers, embezzlers, counterfeiters, check forgers, and drug dealers. I'd probably be the only shill bidder among them, unless Fetterman and I were assigned to the same camp. I read the memoir of a computer hacker who'd spent several years in one of these camps. He claimed there were no rapes, and very little violence, inside them. But these places were not plush. They were not the country-club prisons of urban folklore—they were dreary, crowded institutions where grown men slept on bunk beds in small rooms and were required to work menial jobs.

But even if I wouldn't face physical danger, I was horrified by the idea of being ripped away from my family and friends and trapped inside a building I would not be allowed to leave for

months, or even years. I consulted the federal sentencing guide-
lines and tried to guess how much time I would have to spend
behind bars if I were convicted. It would depend on the amount
of loss I'd caused as a result of my actions. Would this just
include the value of paintings I'd sold that were fake? Would it
include the value of all the paintings on which I'd placed shill
bids? Would it include paintings sold by Fetterman and Beach?
Would it include the Diebenkorn, which I never actually sold? I
had no idea, and Harold could only guess. I could face anywhere
from a year to three and a half years, depending on how a judge
defined the scope of my crime.

Any amount of time in prison seemed unfathomable. I
would lose Katherine. I would go bankrupt. Friends would aban-
don me and employers would shun me after I got out. I would
have to explain it to my children someday. And perhaps worst of
all, I wouldn't be able to repay my parents the money they'd
loaned me. Harold had said he would take the case all the way
through trial for thirty thousand dollars. I knew my father would
let me use the money I'd borrowed to pay for a trial, but I could
barely stand the thought of spending it with no guarantee I'd be
able to repay it.

I asked Harold about my odds of winning at trial. "I wouldn't
want to speculate on that," he said. "I could never make any kind
of guarantee."

"I know that, Harold. I'm an attorney. I just want you to give
me some kind of a ballpark guess. Is it better than fifty percent?"

"Ken, it's never that good. We're talking about the federal
government. They've got unlimited resources. The odds are
never in your favor as a defendant."

"But you think we should fight it."

"Listen, I think you've got a decent shot at acquittal—a better

shot than most of my clients. If I didn't, I would have advised you take their deal. I think it's wrong that they're coming at you with a federal fraud charge for what you did, and I don't want to see you lose your license over it. But the odds are not going to be in your favor."

I agonized for several days over whether to accept the offer. As horrible as prison sounded, I didn't want to just wilt in the face of their demands. I felt like I was being prosecuted because I'd attracted a lot of publicity. I just couldn't fathom how they could turn what I'd done into the foundation for a federal fraud case. These were the feds; they went after the big stuff. I knew I'd been dishonest and manipulative by breaking eBay rules and playing dumb about fake paintings, but I thought I was always careful not to step into illegal territory. I thought I'd covered myself, but apparently I had made a gross miscalculation. I just wasn't ready to admit it, or admit to myself that I'd done anything really wrong.

I spoke with a few close friends about what to do. They all told me I should trust my instincts and give heavy weight to my lawyer's advice. My mother, who'd been devastated when she found out I was going to be prosecuted, was so relieved when I told her about the offer that I didn't, at first, tell her I was thinking about rejecting it. I didn't want her to worry.

But I told Katherine right away, and she had a strong opinion about what I should do. "You're risking so much if you try to fight this," she said.

"If I plead guilty I'll get disbarred. How can I just give up my license without a fight?"

"Think about what you'll be giving up if you go to trial," she said, bewildered by my choice. "You could still lose your license, and everything else along with it."

Part of me knew she was right, but I wasn't ready to give up.

I told Harold I would follow his advice, even though I had reservations. He didn't call the prosecutors and tell them we were rejecting their offer—he just didn't accept it, and stalled. I wondered if we might be able to negotiate a better offer if we waited, making them think we would go to trial.

"It doesn't work that way in the federal system," he said. "If we were going up against a district attorney's office, we might be able to play that game, but with the feds, the first offer you get is generally the best one."

For the next several weeks I prepared myself for battle. I sold more paintings and tried to build a war chest. I bought a book called *How to Survive Federal Prison Camp: A Guidebook for Those Caught Up in the System*, just in case. I told my parents I might fight the prosecution, and begged my mother not to tell my grandparents, because I didn't want them to worry. I tried to convince Katherine I was doing the right thing, but I knew she was worried.

She had reason to be worried. I wasn't eating much and rarely left the apartment except to buy cigarettes, beer, or coffee. I was smoking almost a full pack of Marlboro Lights every day. I drank at least four double espressos every morning, and in the afternoons, I drank Sierra Nevada Pale Ale. When Katherine came home from work at six thirty, I'd often finished a six-pack and, more likely than not, had left the kitchen sink littered with coffee grounds. The smoking and drinking repulsed her, and she couldn't avoid it now that we were living together.

"You're killing yourself with this shit!" she once yelled, throwing an empty pack of cigarettes at me.

I didn't know how to respond. "I'm trying to quit," I said quietly.

"You've been saying that for months! I know you're going

through a lot, but this is a *big* problem for me. It's disgusting, and you're destroying your body." She put her hands on her hips, sighed, and said, "This isn't how it was supposed to be." We'd only been sharing this apartment for a short time, and I was turning our home into an unhappy place.

In the face of all this instability, Katherine fought back by maintaining normalcy. She was, above all else, an optimist, and she wanted things to work. November 23 was my birthday. My cousin Ron took me out for a beer, and when we returned to the apartment I found about a dozen of my friends and all three of my brothers waiting for me. Katherine had organized a surprise party, which wasn't so challenging, considering that I usually walked around in a stupor. I felt loved and incredibly lucky to have these people standing by me.

At the party I admitted to my brother Matt that I was questioning my decision to fight the prosecution. He was the first person I told.

"But if I lose my law license and can't sell art, I'm not sure what else I'll do."

He smiled faintly. "Software," he said.

"You think I could do it?"

He nodded.

Meanwhile, the FBI collected mountains of evidence against me. EBay dredged up old log files that gave the prosecutors an even more detailed picture of my shill bidding. Sonderby called Harold and said the offer was still on the table but would be withdrawn soon if I didn't accept it.

Harold tried to bargain and asked if I could plead guilty to "misprision of felony," an obscure crime involving the witness of a felony without reporting it. He thought this plea might spare my law license. The prosecutors rejected his request. "They think

if they let you plead guilty to anything less than what they charge Fetterman with, you won't be a good witness," Harold explained. "Fetterman's attorney will try to make it seem like you got a slap on the wrist in exchange for testifying against him, and you won't be as persuasive to a jury." Harold also asked if I could plead guilty to a tax evasion charge, as I hadn't reported all the income I'd made on eBay. This was my idea. While a tax crime probably wouldn't have spared my law license, I thought it would be easier to live with, and explain to others, than something as crooked-sounding as "fraud." Sonderby and Malecek didn't like this idea either. I would plead guilty to fraud, on their terms, or they would take my case to trial.

Several weeks into this morass, I got a call from Harold. "The FBI wants the painting," he said.

I set my beer on the coffee table and stood. "What are they going to do with it?"

"I'm not sure. They're going to have someone from the de Young Museum look at it, I think."

I still hadn't admitted to Harold that I'd written the initials on the painting. I wondered if the FBI would be able to detect my fingerprints in the varnish or would find a strand of my DNA lodged somewhere under the letter R. Out of everything I'd done, this forgery was the thing I most feared they'd be able to prove.

"Are you still there?" Harold asked.

"Yeah, I'm here." I paused. "Harold, I need to talk to you about the painting."

"What, did you deep-six it?"

"Did I what?"

"Did you deep-six it? Did you get rid of it? If you did, just tell me and we'll deal with it. It's okay, I just need to know."

"No, it's at Rudy Curiel's gallery. He's still trying to authenticate it, supposedly."

"Okay, good. I'd rather they pick it up from me here. How soon do you think you could bring it to San Francisco? When you come down we can talk about it."

"Do I have to give it to them?"

"Well, it's evidence. If you don't turn it over voluntarily, they'll just get a warrant and take it. It's probably not a good idea to piss them off."

I sighed.

"Ken, just get the painting and bring it down. Don't do anything stupid."

I wrapped the faux Diebenkorn in a blanket, secured it in my trunk with bungee cords, and drove to San Francisco. I parked several blocks from Harold's office and felt conspicuous walking down Hayes Street with a giant abstract expressionist painting under my arm. I met Harold in his conference room, and he asked me what I needed to discuss.

I cleared my throat. "Well, the painting—I told you the initials were on it when I bought it. That wasn't true."

"Did you get it from Fetterman? Do you think he signed it?"

"No."

I tried to read his reaction, but his face remained expressionless, and he waited for me to continue.

"I signed it." I looked down at the table. "Harold, I'm really sorry I never told you. I was so ashamed. I know you agreed to represent me at half price because I'm a friend of Theresa's, and I didn't tell you the whole truth."

When I glanced back up at him, he was smiling.

"Well," he said, "I guess I can't put you on the witness stand now."

I stared at him, perplexed, wondering why he was not upset.

"Your story didn't really add up, anyway," he said. "I suspected something like this."

"Harold, it was the first time I ever did anything to a painting. I'm really afraid they'll be able to tell it was forged."

"I hate to break this to you, but they probably *assume* it's forged. They think you and Fetterman sold a bunch of forged paintings. If this one turns out to be a forgery, it's just another piece of evidence for them. It's not as big a deal as you think."

"Look, I've been thinking a lot about my decision to fight this prosecution. I've been going back and forth for the last week."

"Tell me what's on your mind."

"Well, I don't know—it just doesn't feel right."

He waited for me to continue. I hadn't planned to tell him this. It was just coming out.

"The thing is, I did *exactly* what they're accusing me of. They're accusing me of shill bidding and selling fake paintings, and you know what? That's what I did. Maybe it wasn't the grand conspiracy they think it was, but they're going to try to prove it to a jury. How can I fight that?"

Harold looked like he wanted to interject, but I couldn't stop talking. "I never thought what I did was criminal, but that's their call. Maybe one shill bid isn't a big deal. Maybe selling one fake painting for Fetterman and playing dumb wouldn't have warranted all this. But it was more than that. I did it over and over, and it was wrong, and I was foolish to think I couldn't get in trouble for it."

I felt sadness creeping up my throat. "Harold, I've had to lie to my family. I've lied to Katherine. She goes to work and they think she's crazy to stay with me. I lied to Steve Vanoni and Rudy Curiel and let them try to authenticate the painting. This shit is

eating me alive. To fight it is to just keep lying, and I don't think I can do that."

"Tell me something," Harold said. "What are you going to do after you plead guilty, and you wake up one day without your law license? What will you do for a living?"

"You know, I've been making such a big deal out of that, but the more I think about it, the less I care. I've never liked practicing law."

I waited for Harold to respond. I needed him to validate what I was saying. "Part of the reason I recommended that you fight this is because I couldn't imagine being stripped of my license," he said. "I love what I do."

"I know, but for me it's different. I feel like going into law was a mistake in the first place."

"Okay, but what else will you do?"

"I've been talking to my brothers about it. They're software developers, and they love it. The job market is wide open. They say I can learn how to code and get a job within six months."

Harold's voice became soft, almost sympathetic. "Listen, I'm not trying to be negative, but you need to think about the implications of pleading guilty to a felony. Suppose you learn to program computers. What are you going to do when you fill out a job application and you come to the section about having been convicted of a crime? You've got to check the box. Do you think an employer is going to hire a convicted felon? You're not talking about digging ditches."

I looked away from him and took in a deep breath. "Harold, I'm not fooling myself into thinking it's going to be easy. But it could be way worse if I try to fight it."

"Okay," he said. "I just wanted to make sure you know what you're getting into. If you want to take the deal, I'll arrange it."

• • •

The prosecutors' questions were, at first, quite simple. Malecek and Sonderby took turns asking about various user IDs, e-mail addresses, and auctions. Perry took notes and piped in occasionally to clarify an answer I'd given. They worked from a script and had clearly spent hundreds of hours doing background research for this interview. EBay, eager to quash its site's reputation as a haven for fraud, had given the FBI its records without even asking for a subpoena. Perry had a database of hundreds of bids placed by Fetterman, Beach, and me. The database included the amounts of the bids, the exact times when they'd been placed, and the computers we'd used to place them. The prosecutors knew every auction we'd hosted and the titles we'd used. They knew the name and address of everyone who'd ever bought anything from us on eBay. They produced copies of e-mail messages I'd sent a year earlier. They asked me about particular paintings we'd sold. When I told them I'd gotten certain paintings from Fetterman, they seemed to know this already.

What they didn't have was the descriptions we'd used for our auctions; eBay didn't save this information. The printouts I'd thrown away might have been useful, but I didn't mention them.

Other than this, they seemed to know everything. With all this information, then, why did they even need me to cooperate? Perry explained it. While they knew about all the shill bidding IDs, gathering enough physical evidence was cumbersome. They had to request up to three separate subpoenas to get enough data to prove that a single user ID belonged to one of us. Some of the information was so old it was difficult to find. Some of it was stored on computers in other countries. The FBI would eventually have gathered enough proof on its own, but this would have been expensive and might have drawn out the investigation for

another year or more. It was much easier for them to entice me to cooperate, and then put me on the stand to testify against Fetterman.

I resented having had to accept this plea bargain and was, at first, defensive in the face of their questions. I felt like they were trying to bully me into saying that Fetterman had come to me in December 1998 and proposed that I join him and Beach in a shill bidding and forgery scam. But it wasn't like that.

"So you're saying you and Fetterman didn't orchestrate these fake bids?" Sonderby said, leering at me. "You want us to believe that you just placed them on your own?"

"Yes."

"And you're saying you didn't know these paintings—the Giacometti, the Clyfford Still, the Percy Gray—were fake? How could you not have known?" Sonderby shook his head and looked at Malecek.

Malecek said, "Try to understand, Mr. Walton. We're prosecutors. We're skeptics."

"What do you want me to say?" I said, shrugging, frustrated, palms in the air. "I'm here to plead guilty. I'll say whatever you guys want."

There was a pause, and then Sonderby looked at me and said, with forced, almost mocking sincerity, "We want you to tell the truth."

Harold cleared his throat and said, "Can we take a little break?"

Outside the room, he pulled me down the hall and pushed his face close to mine. "What the hell are you doing?"

"Harold, I'm not going to say—"

"Oh, come on, Ken. Lay off the martyr act. You're not here to convince them you're not such a bad guy. It's too late for that. You've got to give them what they need."

"It didn't happen how they think it did. We didn't sit around and plan out all the shill bidding."

"Fine, but what about the paintings you got from Fetterman? You can't try to pretend you didn't know they were forged. Maybe the first couple of times, but there were at least ten of them, right? Everyone in that room knows you knew."

I sighed and looked away from him.

"Listen to me," he said, putting his hand on my shoulder. "If you keep this up, you're going to jeopardize your deal. I worked really hard to put this together, and you're pissing me off. Now, let's go back in there and give these guys what they want, okay? And one more thing. We've talked about this a dozen times, but I'm going to say it again. If they ask you about the painting, you've got to tell them the truth. If you lie to them and they find out later, your deal is dead."

I nodded. We walked back into the conference room, and I started talking before I reached my seat. "All right, here's the thing. I'm here to cooperate and I have no reason to lie to you." I sank into my chair and leaned forward, looking down the table at Sonderby and Malecek. "I've told you about all our shill bidding IDs. If you find any others I haven't remembered, I'll be happy to verify those, too. As for the shill bidding itself? It's really like I said. We didn't orchestrate it. We just bid on each other's paintings, and it was kind of understood. If you go back and look at it, the shill bidding is all pretty haphazard."

No one had interrupted, so I continued. "The paintings you mentioned—the ones I got from Fetterman? He never told me they were forged. He never would have admitted it. But after a while, I pretty much knew, and I didn't care. I didn't ask, and I didn't want to know. But I basically knew."

Perry scribbled notes. Sonderby nodded and glanced at

Malecek. What I said seemed to satisfy them. "Let's move on, then, shall we?" Sonderby said. He flipped a page and continued with his questions.

After a while he said, "The first time you went out looking for art, was there someone you went with?"

He was talking about Kris. How did he know? I didn't want her to be involved in this in any way. I nodded cautiously.

"And who was that?"

"My girlfriend at the time. Her name was Kristine."

"And did you go shopping for art very often with Kris?"

I looked away from them and shook my head. "Kris wasn't involved in my eBay sales. She just went shopping with me a couple of times."

Sonderby looked at Malecek and back at me. "We've talked to Kris. We just want to ask you a few questions about what she told us."

I closed my eyes. This explained it. They'd dragged her in, perhaps sat her down at this same table, and interrogated her about me. Of course, in the midst of all this, she would have severed ties with me.

"I need to take a little break," I said weakly. I slipped around Harold's chair and rushed for the door. In the bathroom I looked in the mirror and blew my nose violently into a scratchy paper towel. I couldn't believe they'd called Kris in to talk about me. The thought of what they may have put her through made my stomach twist with guilt. I pushed open the door of a stall, leaned over the toilet, and vomited. At the sink I lowered my head to the faucet and filled my mouth with water, trying, but failing, to purge the acrid taste.

I wondered what Kris could have told them. She knew about the shill bidding and some of the paintings I'd gotten from

Fetterman, but that couldn't have been any great help to the prosecutors. Perhaps she'd told them Fetterman led me down the path I'd taken. Maybe she told them he was the ringleader of our conspiracy of dunces. Perhaps I had her to thank for my plea bargain.

As I returned to the conference room, Harold asked, "Are you okay?"

"I'm fine. Let's keep going."

The prosecutors didn't ask many more questions about Kris, and we moved on to other topics. Perry explained how international treaties prevented the FBI from contacting Robert Keereweer without going through the State Department and using Dutch law enforcement agencies as an intermediary. He asked if I could ask Keereweer to call the FBI. Sonderby said we should wait before taking this step. He didn't think it was a good idea for me to be helping the FBI circumvent international treaties, and he wasn't yet sure if they would even need a statement from Keereweer.

Many of their questions focused on Fetterman's whereabouts. The FBI apparently had no idea where he was. I hadn't heard from him since August, when he'd called from what I assumed was a pay phone and tried to get me to meet him at a thrift store near my house. "Want to meet me over at Miller's?" he asked, speaking in code. We'd once gotten about twenty paintings by an artist named Miller at the Sacramento SPCA thrift store on F Street, and he was obviously referring to this place. I told him I didn't think it was a good idea, and that was the last time we'd spoken. Perry nevertheless peppered me with questions about him. Did he ever talk about his sister? Did he know anyone who lived on 16th Street? Did he drive a white Ford Escort? They seemed to have leads, but I was of no help.

I was amazed by the bulk of information they'd collected. When Perry held up a copy of a check I'd written a year earlier, I glanced around at the five people who'd spent months preparing for this meeting. The boxes of information they'd collected cluttered the room. I thought about the grand jury, and what it must have cost to shuttle in witnesses from around the country. I shook my head and said, "Wow. You guys have spent a lot more on this than we ever made on eBay."

Malecek smiled. "Yeah, well, we're hoping to send a message."

As the day dragged on and we all grew tired, things became more relaxed, and at times, almost cordial. Sonderby and Malecek made jokes at Fetterman's expense and Harold and Theresa and I laughed. I learned that to cover his tracks while selling on eBay, Fetterman used names like "D'Artagnon Cole" ("Dart" for short) and had customers make their checks payable to these fake names. He would then endorse the checks over to Lane and deposit them into her account. I also found out that Fetterman had recently applied for a California driver's license and used the address of the federal public defender's office as his own, so as to evade the authorities. Perry held up an enlarged copy of the license to show us. "Looks like he's put on some weight," he said.

This friendly banter was surreal. These men were ruining my life. I hated them. I hated their smug self-righteousness, their snide, unwavering sense of superiority, their uptight prickliness, their faked sincerity, their bristly barbershop haircuts, their clenched asses, their conservative politics, their gas-guzzling sport utility vehicles, their gun collections, their stucco suburban homes, and their playground-bully children. Or did I? I really knew nothing about them. They were just guys. They worked for

the government, and they did what they were told. But I felt like I *should* hate them. And here we were sitting around a table making jokes, as if we were settling a lawsuit, and this was all just a bit of awkward business we were working through.

At one point Sonderby asked if I'd known, when I first started shill bidding, that it was against eBay rules. I told him that when I first signed on, sellers were allowed to place bids on their own items. Sonderby was not aware of this. I told him how I rationalized my shill bidding by stretching the scope of this rule and viewing it as permission to bid on my items with other user IDs. "Oh," he said. "So you were violating the spirit of the law, if not the letter of it."

I blinked twice. Had he called an eBay rule a "law"? I knew it was just an expression, but I shuddered at the notion of eBay rule violations being punished by the federal government with criminal penalties, being given the lofty status of "laws." I wanted to say, *Actually, Chris, it's a contractual provision, rather than a law, but I'm sure you know that.*

But I didn't say that, because Sonderby and I weren't on a first-name basis. For some reason, though, I felt the need to justify my conduct to them. I explained how shill bidding was a minor infraction under the law of California and most other states. "So you researched it, eh?" Malecek said, smiling down at me from his end of the table. He seemed to be amused by this and oblivious to how shill bidding was penalized under state law. He worked for the feds, and they were perfectly happy to call it wire fraud.

As we neared the end of the day, I began to wonder if they would even ask me about the initials on the faux Diebenkorn. Their whole case seemed to rest on shill bidding. Whether or not any of the paintings were actually fake seemed almost incidental.

Finally, though, Sonderby said, "So you've never actually added a signature to a painting yourself, right?" He asked the question as if he knew the answer. I wasn't the forger. That was Fetterman's role. He was just asking so he could get my response on the record.

I processed his words and felt my heart skip a beat and then start thumping. Harold and I had gone over this countless times. I should just tell them. That's why I was here.

But the shame! If I admitted to the forgery, the whole world would find out. Pleading guilty to a felony was bad enough, but I thought I could explain the shill bidding. *Who knew? Everyone was doing it, and they decided to prosecute me.* But this was different. Art forgery was not something that could be explained away.

And would admitting it put my deal in jeopardy? They'd called me in here thinking I'd never forged a painting. Perhaps Kris had told them I would never do something so dishonest—that it must have been Fetterman. Maybe my deal was based on this. If I told them, they might leap from their chairs and throw up their hands and shake their heads and say, *Hey, whoa! We didn't know this! All bets are off now, buddy. We think you'd better leave.*

And for God's sake, why did it even matter if I forged the painting? I was admitting I had committed a crime. Wasn't that enough? They would get to parade me in front of the judge and issue press releases and clack their tongues in disgust and puff out their chests in triumph. That's what they wanted, right? This disgusting detail about the forgery didn't really matter, did it?

Harold was silent and unmoving, and in my peripheral vision I could see him staring down at the table. I knew I had to tell the truth. I'd been trying to lie my way out of this for the last eight months. If I didn't come clean now, I would have to keep

looking over my shoulder, wondering whether they would find out, and I didn't want to live my life that way.

I swallowed. I was taking too long to answer. I cleared my throat and said, "Just once."

Sonderby looked up from his pad and arched his eyebrows. "Which one was that?"

"The one with 'RD52' on it."

My eyes darted from face to face, watching for reactions. Perry blinked several times. Sonderby's jaw dropped and he turned his head slowly to Malecek, who twisted his face into a grimace. It was several seconds before anyone spoke, and I wanted to shout, *It was my first time!* But I waited, and finally Sonderby said, "We need to take a little break. Could you please wait out in the hallway?"

Harold and Theresa and I stood in the hallway. I shoved my hands into my pockets and rocked back and forth on my heels. "You did the right thing," Harold said. "You had to tell them. I was starting to wonder if you were going to do it."

"Did I take too long?"

"Well—long enough to make me wonder."

"They looked pretty shocked."

"Yeah, they did. They weren't expecting it. But a deal's a deal. They're not going to go south on you just because you signed one painting."

Perry called us back into the room. Everything seemed okay. Sonderby asked a few more questions about the Diebenkorn painting and how I'd forged it. He asked why I'd tried to authenticate it, and I explained about Keereweer and his lawyers. Malecek seemed to find this amusing.

Toward the end of the day Perry said, "So, have you been selling on eBay using a different ID?"

"Yes," I admitted. "My cousin has been helping me sell paintings with his user ID."

Okay, so they knew. I would have been surprised if they hadn't figured this out. With the help of Ron, I'd sold truckloads of art since I'd been booted from eBay, and I wasn't exactly sneaking around. As a matter of fact, I'd sold more paintings in the previous six months than I had in fifteen months working with Fetterman. It was how I paid rent and chipped in for the groceries. It was how I was making payments on the huge loans I'd gotten from my parents. It was how I was saving up to pay the taxes on the eBay income I hadn't reported to the IRS in 1999.

I'd continued to buy art, and now had nearly two hundred paintings in my collection, which had been moved to the brick garage facing the alley behind my apartment. At a thrift store in Orangevale, the suburb outside of Sacramento where my mother lived, I discovered over a hundred paintings from the estate of Hal Runyon, an artist listed in *Davenport's* who painted campy pinup nudes. Some of them were rather risqué, and my mother was repulsed by them, but I had a hunch that someone on eBay would like them. I bought them all for less than two thousand dollars, and then discovered that the good ones sold for between two and five hundred dollars apiece. Despite being under the cloud of an FBI investigation for eBay art fraud, I was enjoying selling art more than ever.

The fact that Perry brought it up worried me, because I didn't want the FBI to bother Ron. But I felt confident that we hadn't done anything wrong.

"No shill bidding on these auctions?" Sonderby asked.

I shook my head. I could tell he knew this already, like most other things I'd told them that day.

Ironically, I was making as much per painting as I had when

I was working with Fetterman, which discredited the prosecutor's theory that shill bidding raised prices to artificial levels. A lesson learned too late.

"Let me get this straight," Malecek said. "You have paintings up for sale right now, this very moment?"

"Yes."

He snorted and shook his head in contemptuous disbelief. "What do you think eBay would say if I called them and told them?"

I bristled at the thought of this federal prosecutor even caring what eBay would "say," as if a corporation in San Jose were dictating the direction of a criminal case. "My cousin hasn't broken any eBay rules," I said.

Perry took down Ron's name and phone number but did not contact him. We were coming to the end of the day. There would be a few more questions and then I could go home. There would be one more session like this, and Harold would drive up from San Francisco to sit next to me while I went through it. But the worst part was over.

"Well, we did it," I said.

"Yeah, you did a good job," Harold said, smiling. "They got what they wanted. They told me they were satisfied with your statements."

We stood in the parking lot in front of the Amtrak station, across 5th Street from the federal building. Theresa had just said good-bye and driven away. I was shivering from the cold and fumbling for a cigarette.

"You did the right thing," he said.

"What do you mean?"

"Cooperating. It was the right decision."

"Yeah."

"I don't just mean because you took responsibility for your actions. That's good too. But you did the right thing because there was no way we could have beaten these guys. When I told you we should fight it, I had no idea they'd invest this kind of time and money into the case. I've worked on a some really big federal cases and I've never seen them prepare for one like this."

"You think?"

"I couldn't believe it. Those IRS agents with all those binders? Those database printouts? These guys put a lot into this. They seemed kind of excited by it, in a way. This is interesting stuff for them. Think about it. Imagine if you did the same thing over and over—prosecuted guys for lying on loan applications, for instance. Then something like this comes along and it's never been done before. They're loving it."

"So they know about me selling art on eBay through Ron. They didn't seem very happy about it."

Harold grinned. "Well, they didn't tell you to stop. A guy's got to make a living."

"If I can keep doing it, I'll be able to pay off any reparations they throw at me."

"Well, I wouldn't count on eBay as a long-term strategy."

I looked him in the eye. "Harold, I want to thank you for everything you've done. It's like those guys said—if you hadn't gone in early, we might not have gotten this deal. I might be on my way to prison if it weren't for you."

"Just doing my job."

I coughed. "It's cold out here. I should get going."

"Take care of yourself, Ken."

"You too."

THE THIRTEENTH PART.

I met once more with the U.S. attorneys and survived several tense phone calls. Now they were piecing together an indictment. All I could do was wait, and then, as planned, plead guilty.

I knew I would be disbarred. Well, actually, I would disbar myself. A lawyer facing disbarment is asked to resign from the profession, rather than force the California State Bar court to remove him against his will. Voluntary resignation was a more dignified end, I supposed, but the result was the same: I would lose my license. I wouldn't be able to apply for readmission to the bar for ten years, and then, in the unlikely event that I was allowed back in, I would have to take the bar examination all over again. In essence, my legal career was over.

I'd been preparing for this. I vacated my law office on 8th

Street when my lease ended at the end of 2000, and I hadn't taken on any new clients in months.

My last official act as an attorney was a favor for an old friend from college who lived with his wife in San Diego. She was pregnant with their first child, and her HMO was canceling its contract with her obstetrician midway through her pregnancy. She'd pled with the insurer to allow her to continue seeing her doctor until her son was born, but it refused. I wrote a lengthy and somewhat threatening appeal letter to the HMO, and it reversed its decision. I charged my friends nothing for the letter, but hearing their excitement on the phone when they won their appeal was the greatest reward I'd received in my short legal career. For all that I was throwing away—the years of law school education and the small fortune I'd spent on it—it was things like this I would miss the most.

But I couldn't dwell on my losses. I was sinking my teeth into a new career and it tasted good. In three weeks I devoured three books about Visual Basic, a Microsoft Windows programming language, and wanted to do little else but sit at my keyboard and tap out computer code. Writing code felt natural to me, and vaguely familiar, as if I were rewriting something I'd written before and lost. It felt right. For me, crafting software was like doing math and writing poetry at the same time. It was like drawing a map while painting a picture. It was becoming my new obsession.

I strove to construct elegant algorithms that tumbled from one simple, clean line of code to the next. Matt and Keith became my mentors, and I was an eager student of their well-honed philosophies about graceful software design. I saw it as an art, and I wanted to master it. Matt once glanced at something I was working on and beamed. "Wow, that's pretty code," he said. "You're learning quickly."

Perhaps I latched onto software development in desperation, and clutched it so tightly because I had nothing else to do and no other way to make a living. It was a respectable career that required no formal certification, a meritocracy in which I thought I might be able to exhibit merit. I also relished the isolation it provided and enjoyed working alone in front of my PC because I didn't want to go out in public.

Really, though, although these factors may have played a role, my simple love for coding is what drove me to pursue it so relentlessly. I wanted to make my living doing it, but the very idea of this seemed too good to be true, like getting paid for eating delicious food or drinking good wine. I would have done it for free.

And for now, at least, I *was* doing it for free. I still spent time handling the eBay paintings, but the rest of the time I sat behind my keyboard. Although I was still smoking and gulping down espresso, I quit drinking beer so I could concentrate on writing software. Katherine appreciated my sobriety but resented being abandoned for the hypnotic glow of my computer monitor. I ate meals at my desk. I stayed up and programmed late into the evenings, long after Katherine went to bed, and woke up early with my mind churning out algorithms. She begged me to keep a more normal schedule, or at least to come to bed when she did, but I felt helplessly driven to master my new trade and couldn't tear myself away from it.

Every day I called Matt and Keith at work with questions about programming. Matt said the best way to learn to write code was to create programs I would find useful, rather than simply rewriting the sample applications I found in books. And so, as soon as I was able to bolt together a few pieces of code that made my computer do something, I began conceiving of new programs,

many of them related to eBay. The first application I wrote was an eBay fee calculator. The fees charged by eBay to list and sell an item were complicated, and a fee calculator would make them easier to sort out, so I built one.

I called it FeeFinder. It was somewhat crude on the inside, hewn together with the simple commands I learned during my first few weeks as a programmer, like a house built by someone with only a screwdriver and plywood at his disposal. But the program was functional, easy to use, and pleasing to the eye.

I built a website called HammerTap so people could download it. I chose the name because it sounded vaguely auction-related, as an auction ends with the tap of the auctioneer's wooden hammer, but not so auction-specific that I couldn't use it to distribute other kinds of software. Plus, the domain hammertap.com was available when everything else I thought of was taken. I offered FeeFinder for $4.99 and gave users a thirty-day free trial. Within a week I'd sold my first copy and had gotten some supportive messages from users.

Over the next couple of months, I built two more applications. BayCheck was a simple program that showed everything an eBay user had bought or sold within the previous thirty days, as well as all the feedback comments he'd exchanged with other users. Ironically, this application was handy for spotting shill bidding because it made it easy to check the bidding activity of different eBay accounts. The other program, BayMail, allowed eBay users to send e-mail messages to each other without using the cumbersome system built into the eBay website.

I charged nothing for these programs. Frankly, they weren't really worth much, and my intent was not to make money from HammerTap. Almost no one who started a software company from his bedroom computer made any money at it. I was just

learning to write code, and, because I worked alone, I ached for a connection with the people who used my software. I hoped to build skills that would help me find a job as a programmer and begin reconstructing a career from the wreckage I'd created.

It was too soon to start job hunting, though. I still had much to learn. More important, two assistant United States attorneys were preparing to indict me for fraud, and I knew I would have to wait until all this was over before distributing my résumé.

Harold had recently received a draft of my plea agreement, the contract by which I would pledge to plead guilty in exchange for the prosecutors' recommendation of leniency. As we suspected, the fraud charges were based almost entirely on our shill bidding, the fake user IDs, and the false feedback Fetterman, Beach, and I had exchanged. I was asked to plead guilty to seven counts of fraud, each related to a different auction on which shill bids had been placed. I would agree to be disbarred, to testify against my co-conspirators, and to pay $62,000 in restitution to the people who had bought paintings in the auctions listed in the charges. This included $30,000 to Kevin Moran, who'd bought the C. Still painting; $10,600 to John Metropolous for the Giacometti painting; and $7,600 to Mike Luther for the Percy Gray. The other three paintings were from Fetterman's auctions. Even though I'd never received any money from these sales, because I'd bid on them I would be required to compensate the buyers.

I called Harold after I read the agreement.

"Harold, this doesn't look like what they promised."

"What do you mean?"

"They said they would recommend that I get no jail time, but look at Section III(C). It says they'll 'recommend at the time of sentencing that the defendant's sentence be reduced to a term as

low as probation.' *As low as* probation? It looks like they can rec-
ommend anything they want."

"Yeah, I know. That's how the feds word these plea agree-
ments. They don't want to make it look like they've obligated
themselves to let you off the hook. Fetterman's attorney could
make it look like you're only testifying because you got a sweet-
heart deal. But I've spoken to them and they swear our agree-
ment is intact."

"I told these guys everything, and now they won't put what
they promised in writing?"

"Yeah, there's a certain level of dishonesty to it, but there's
nothing we can do. I've been through this before. It's how they
do things in this office."

"It seems wrong."

"Look at it this way: If these guys enticed people to come in
and cooperate and then reneged on their deals, they'd have no
credibility. Word would get out and no one would cooperate.
They want people to be able to take them at their word."

I sighed. "What about this other clause? They want me to
relinquish ownership of the painting? I just have to give it to
them?"

"Yeah, I didn't really understand that either. It's your paint-
ing. It's not illegal to own a painting that's been forged. They
seem to think they may be able to sell it to help satisfy restitu-
tion. It's probably got some value, just because of its notoriety,
even though it's forged."

"Do you really think they're going to sell it?"

"I have my doubts that they'll actually follow up. What do
they know about selling art? But I don't think we'll be able to get
that clause taken out."

I was angry, but I had to take the deal on their terms. I read

the agreement several more times and was relieved that it contained nothing that would prevent me from continuing to sell paintings with Ron's help. The restitution seemed onerous, but I was convinced that by stepping up my eBay sales, I could pay it off over the next several years.

"The FBI wants me to come in and talk to them." John Metropolous's voice quivered. We hadn't spoken for several weeks. Rudy Curiel told him the FBI had taken the RD52 painting, but the two of them were still hopeful we would eventually get it authenticated. John had no idea I'd already admitted to forging it. Now he was being asked to tell his version of how he'd been victimized by me.

"John, I'm really sorry you're getting dragged into this."

"I'm going in there and telling them they've got this all wrong," he said. "There's nothing wrong with that painting. And I've got a copy of the eBay rules from when I first signed up, and they say that a seller can bid on his own auctions. I'm going to show it to them."

"I appreciate your support, John. I'm not sure if they're going to care about those rules."

"They asked me to bring the Giacometti painting. There's nothing wrong with it either, and they need to know it."

I didn't know what to say. Metropolous had supported me through this entire ordeal. He'd called several times just to ask how I was holding up in the face of all the scrutiny. He was sure I'd done nothing wrong and was certain I would be exonerated.

"I really appreciate everything you've done, John. I just want you to know that this thing will probably get worse before it gets better, but I'll survive. You don't need to go in there and defend me—just tell them what you know."

Several days later I saw Rudy Curiel ahead of me in line at the post office. He looked at me, smiled faintly, and turned away. After a moment he left his place in line and walked toward the exit. When he passed me, he stopped, moved close, and said, "I guess you heard John met with the FBI." His voice was low and serious.

"Yes."

"He found out some things about you. We're both pretty disappointed."

I looked down. Surely the FBI hadn't told John I'd forged the RD52 painting, but they may have said I'd sold other fake paintings and colluded with other people in a shill bidding ring.

"I'm sorry," I said. The words sounded feeble and incomplete. I wanted to tell Rudy how much I regretted letting him think the painting was real. I wanted to tell him how the guilt I felt for lying to him was just one stone in the giant sack of guilty rocks I lugged around all day and heaved onto my stomach at night when I went to bed. But I couldn't say any of this. Until the charges were brought, I was under a gag order, and I wondered if, with my hollow little apology, I had already said too much.

"Good luck to you," Rudy said. He touched my shoulder and walked away.

I watched as he drove out of the parking lot. Then I left my place in line and walked out, without having shipped my package.

I'm not sure why I did it. Just curious, I suppose. I was looking at one of my eBay auctions (well, one of *Ron's* auctions) and wondering about Scott Beach, and whether he knew what was happening. I clicked on the eBay search page and typed in his old user ID, *boyscoutsofamerica*. I hadn't checked it in nine months, and I'd assumed he'd abandoned it.

When Scott's page loaded, I was astonished to see that he was selling art again, employing all the same techniques we used to use. Several of his paintings appeared to be by minor listed artists, but he didn't mention the artists' names, and just showed the signatures in close-up photos. In one auction he claimed he couldn't make out the signature, even when it was obviously that of an artist in *Davenport's*. Were the paintings fake, or was he just using the "naive seller" technique to sell art he wasn't sure about? Had he gotten them from Fetterman? Was he shill bidding?

He must have had no idea the FBI was closing in on him. I felt guilty even looking at his auctions, as if their appearance on my monitor would set off a buzzer at the FBI office and dispatch the men in suits with business cards to his door. I wanted to warn him, but I was terrified that any contact with him might jeopardize my agreement with the prosecutors.

I wondered if I was obligated to report this. Matthew Perry had told me to call him immediately if I heard anything from Fetterman. But this was different. Beach's eBay sales were not a mystery I'd uncovered. Surely the FBI already knew. I closed the browser and hoped Scott wasn't doing anything to get himself into more trouble than he was already in.

While Scott was oblivious to the fact that trouble was on the way, Fetterman was living his life as if trouble were flying overhead looking for him at all times. He had no way of knowing the FBI was after him, but he was evading them nevertheless. All the years he'd spent covering his tracks and living in paranoia now served him well. It was as if he'd been preparing for something like this to happen, and when the time came, he knew what to do. He hadn't spoken to me, or anyone else from his past, for months. No one knew where he went after he left Lane with his

car full of paintings. No one knew he was renting a condomini-um overlooking Lake Tahoe, or that he'd been unloading art at auction houses in the San Francisco Bay Area.

On a quiet night in December 2000, about the time I was meeting with the prosecutors, Fetterman was simply a lonely man at a bar, chatting with a woman he'd just met.

"What's your name again?" the woman said.

"Landon," Fetterman replied. He looked up at the bartender and smiled. "How about another Jägermeister for the lady?"

"Are you trying to get me drunk?" She lifted her shot glass filled with saliva-thick liqueur and tapped it against Fetterman's beer. "To new friends."

He let her drink the shot and gulped his beer, then leaned in close to her and whispered, "I'll tell you a secret. My real name isn't Landon."

"Oh, really?"

"Yeah, I just go by that because I'm up here hiding out from my fans and the media."

She giggled. "You have fans?"

"Yeah," he said. "I'm in a band. Have you heard of Pearl Jam?"

She smirked and tucked a strand of long brown hair behind her ear. "You trying to tell me you're in Pearl Jam?"

He nodded. "My name's Stone Gossard. I'm the lead gui-tarist."

She lowered her eyelids and said, "Well, I've got to hand it to you. That's the most original line I've heard in a while."

"Hey, you don't have to believe me, but it's not a line. And music isn't the only thing I do. Everyone thinks that's my whole life, but I've got a lot of different interests. I'm also a published science fiction writer, but I do that under a nom de plume, for obvious reasons. I'm also really into art, and I buy and sell a lot

of paintings." He smiled. "Looks like you're ready for another Jäger."

Terri Lee Galipeaux didn't believe Fetterman was Stone Gossard, at least not then. But despite the mystery of his identity, something about him seemed safe and comforting. He made her laugh all evening. He asked about her children. He seemed intrigued by her decision to go back to school to study art. As the evening wore on and she got drunk, he didn't try to grope her; he touched her once in the small of her back with gentle fingers. She was forty-five years old and had been treated poorly by men for most of her life, but this man seemed different. He was younger. He was intelligent. She thought he was handsome. There was something vulnerable about him.

Fetterman didn't care if she believed him that night. He would stick to his story, and if she was right for him, she'd eventually come around. Over the next few weeks, she did. He invited her to his condo on a hill above the lake, made breakfast in the mornings, and packed lunches for her when she went off to school. For Valentine's Day he bought her a huge bouquet of roses and seven boxes of chocolates. He took her out to bars and bought drinks for her friends, regaling them with wild stories of life on the road with the band. With tears in his eyes, he told her that his wife had died, and he was waiting for her estate to be settled.

She didn't care if he wasn't Stone Gossard. He treated her with respect, and that was all that mattered. "If it isn't true, just tell me," she said one day. "It doesn't make any difference to me."

"Everything I've told you is true," Fetterman said. He would tell her this again, and he wanted her to believe him. He wanted to make a new start. He'd left so much behind.

Sometimes he regretted telling Terri that he was a rock star,

and he wondered how and when he would eventually reveal the truth. But for now, he couldn't. All that was really important was that she didn't know his real name.

As Scott sold art on eBay and Fetterman pawned paintings to Bay Area auction houses, I discovered that my career as an art seller was about to come to an abrupt end. Harold sent me the final version of my plea agreement, which contained a new clause prohibiting me from "directly or indirectly" participating in eBay auctions. I called him when I got it.

"They just added this, didn't they?" I asked.

"Yeah, they must have forgotten it in the first draft."

"Harold, the only way I'm surviving right now is by selling paintings with Ron."

Harold took a moment to respond. "You don't really think you're going to be able to keep selling paintings on eBay after you're convicted, do you? Think about it. How would it look if they let you keep selling art through your cousin?"

"Can you try to negotiate it out? I'll starve if I can't sell art."

"I'm not going to ask them to take that clause out. It's a ridiculous request and they're not going to do it. You need to accept the fact that you can't sell on eBay anymore. You need to move on with your life. Aren't you doing software now? How's that going?"

"It's going great, but it'll probably be a while before I can get a job."

"Well, keep working at it. You're a smart guy. You'll be good at it."

"I hope so."

"Hey, by the way, are you still selling that eBay program you told me about?"

"FeeFinder? Yeah, It's still on my website. I've got a couple of other programs on there I give away for free."

"Do they have anything to do with eBay?"

"Just simple little tools for eBay users. I mainly built them to teach myself how to code."

"Listen, I think you should stop distributing the eBay software. You just need to get away from eBay altogether. Make other kinds of programs."

"But they don't have anything to do with me buying or selling."

"Yeah, but it just doesn't look good, and I don't like the fact that you're still lingering around eBay. Just drop them and make something else."

The prosecutors indicted us on March 8, 2001, ten months after the close of the Diebenkorn auction, and the announcement once again attracted national media coverage. The day before the indictment was released, I admitted to Katherine and my family that I'd forged the initials onto the Diebenkorn painting and explained why I hadn't been able to tell them sooner. After everything else I'd put them through, this one thing I'd withheld did not seem to matter to them very much. Matt and Keith both said they'd suspected it. My older brother James concurred. My mother said she feared it might be true but didn't want to believe it. Katherine was angry at first, and then sad, and said she'd thought Fetterman had probably signed it but had prepared herself for what I told her.

The prosecutors' press release did not mention that I'd cooperated, and it let everyone believe the charges had taken me by surprise, even though I'd been expecting them for months. People reading the article in the paper the next day may have

imagined me being dragged from my apartment in pajamas and handcuffs, but as Harold suspected, I was left alone. I stayed inside, avoided phone calls, and waited for my arraignment. Scott Beach was offered the same no-jail-time deal as me, and he took it.

The case was assigned to Judge Lawrence Karlton, and Harold was glad. "I've had a case come before him in the past," he said. "He's fair, and probably the most liberal judge in the district. He's very unlikely to go against the recommendation of the prosecutors."

Harold and I sat in the courtroom on April 17, the day of my arraignment, and waited our turn, watching other less fortunate defendants in tangerine jumpsuits drag and clink their shackled feet as they were escorted through a heavy door. Sonderby approached us and handed me a yellow piece of paper with instructions for reporting to be fingerprinted before I left the courthouse. He leaned in close to Harold and whispered something in his ear. Harold nodded. When Sonderby left us, Harold turned to me and said, "He wanted to make sure we didn't mention the fact that what you were promised seems different from the wording of the plea agreement—the no-jail-time deal."

My name was called, and I pushed through the swinging wooden half door and planted myself to the right of Harold. Judge Karlton glanced down at me from his wooden fortress and issued questions. His words were clipped and memorized, and he seemed to force an intonation to keep himself from sounding bored. He'd done this hundreds, probably thousands of times, and I was just one of many people appearing before him that day to enter a plea. He rushed through the script of questions the law required him to ask a person who was pleading guilty. Did I understand what a jury trial meant? Did I understand that I had

a right to one? Did I understand that he did not have to follow the recommendation the prosecutors made and was free to sentence me however he saw fit?

I stood in front of a chest-high podium next to Harold and issued short answers, most of them either "Yes, Your Honor," or "No, Your Honor." To the judge's left, a fat reporter sat in the press gallery, squinting through his glasses and scribbling things onto a notepad. Nearby, a bored federal marshal with a shiny badge stared at the carpet. Directly to my left, Sonderby and Malecek stood in front of their podium.

The judge looked at me and said, "Is there anything you were promised that is not in this agreement?" He held up a copy of my plea bargain.

I paused for just a moment, looked over at Sonderby and Malecek, and thought about what I might say: *Actually, Your Honor, the prosecutors promised to recommend a sentence of probation, but then they refused to express their promise this way in the plea agreement. As you can see, they would only say they'll recommend a sentence 'as low as' probation, even if I continue to cooperate fully. To me, this seems different.*

If I said this, I might hear low gasps from the audience. The court reporter would stop fluttering her fingers on her contraption and look up at me. The judge might raise his eyebrows and look at Sonderby, who would click his pen and clench his jaw and glare at me.

But I didn't say this. Instead I said, "No, Your Honor," and the judge moved on to the next question. What choice did I have?

In the turn of five minutes, I'd become a convicted felon. The speed and efficiency of it all reminded me of traffic court. Everyone stared at me as I walked out of the courtroom. Katherine and my mother met me in the hallway outside.

"This made it all seem so real," my mother said.

I hugged her. "There's no going back now."

Katherine had tears in her eyes. She embraced me tightly and put her hand on the back of my head. I held her and smelled her perfume and felt her sadness, and then I opened my eyes and saw the reporter from the courtroom standing twenty feet away, watching us.

"I have to go get fingerprinted," I said. "I'll meet you downstairs and we'll go out for lunch, okay?"

Harold had to return to San Francisco, so I took the elevator downstairs to the booking room alone, wrote my name on a list, and waited. With its scratchy chairs, aging magazines, and cheap framed prints, the place looked like the waiting room of a low-rent dentist's office. A man opened a door and called my name.

Behind the door, everything changed. Security cameras leered down at me. We walked down a concrete hall and buzzed our way through a massive steel portal. The man took digital scans of my fingerprints, and then I stood in front of a backdrop and posed for two photographs: one from the front, and one from the side. The man printed the mug shots and showed them to me.

I smiled faintly and asked, "Can I get a copy of these for my fridge?"

THE FOURTEENTH
PART.
One Sunday a few weeks later, I was sitting in the rocking chair on our porch when the driver of a blue Toyota pickup passing by tapped his brakes, slowed, and craned his neck to look at me through the passenger window. I dropped my cigarette and jumped to my feet.

It was Fetterman.

The Toyota continued down 33rd Street, then turned left on L. My whole body shuddered as I lurched into the apartment and drew the blinds.

"Katherine! Something bad." She turned off the kitchen faucet. I was taking deep breaths. "I think I saw Fetterman."

"What! Where?"

I grabbed two fistfuls of my hair. "Outside. He drove by in a truck and slowed down and looked right at me. I don't know how he found me."

"Are you sure it was him?"

"I'm not positive, but it was his profile, his hair, but maybe darker. He could have dyed it."

Katherine was frozen, her arms crossed tightly in front of her. "Okay, this is scary. This is not good," she said, her voice shaking.

I ran into the living room and slipped my fingers between the blinds. "There he goes again! He just passed by again." Fuck this! I wasn't going to let this guy terrorize us. "Lock the doors," I said. "Get ready to call 911." I grabbed the knob of the front door. "I'll be back in five minutes."

"Where are you going?"

"Lock the doors!"

I walked across the street to my car, trying to seem nonchalant. I was afraid to turn and look at the truck, but I did, and saw it turning left on L Street again. I cranked the car into a U-turn and accelerated after him. A couple of blocks away, he was circling around again, as if he were going to drive by our building for a third time. He was driving slowly. Was he waiting for me to catch up? Had he seen me walk out to the car? He didn't know this car, an old red Saab I'd bought from a friend when I had to sell the Mercedes to make rent. I was afraid to get too close, but I wanted to memorize the license plate number. The truck slowed to a stop at the intersection of 32nd and M, and I had no choice but to creep up behind him. Would he jump out with a gun? Had I left myself enough clearance to pull around him and speed away?

I was almost certain it was Fetterman. The thick neck, the T-shirt, the Adam's apple, the spiky hair. I waited with my hand on the stick shift, ready to slam my foot on the accelerator pedal, ready to hit him if he got out and tried anything. But he didn't

jump from the truck, and he didn't turn left and head back toward our apartment. He pulled forward and continued down 32nd Street. I watched as he made a right on Folsom Boulevard, and I realized he was leaving the neighborhood, at least for now.

Wait! The license plate number. I jerked my car into first gear and caught up with the truck out on Folsom Boulevard. I stared at the plate and recited the numbers over and over in my head.

"It wasn't him."

"Oh, God, that's such good news." Katherine had been terrified by the thought of Fetterman stalking our apartment, so we'd spent the night at my mother's house. I felt horrible for putting her through this. She softened her voice to a whisper and asked, "Do they know who it was?"

"Perry said it was a real estate appraiser checking the neighborhood for comps."

"That's almost funny. Have you told Harold?"

"Yeah, I just talked to him. He said my sentencing date is getting moved to August. They probably won't sentence me until they catch Fetterman."

"Why do you have to wait for him to get caught? It's not your fault he disappeared."

"They think if they sentence me before they catch him, I might not testify against him the way they want me to." The events of the previous day had made me realize how much Fetterman scared me. While part of me wanted him to be caught so I could move on with my life, the thought of actually taking the stand against him made my stomach churn.

"So if they don't catch him by August, it might get moved forward again?"

"Yeah."

She sighed. "It's not fair for them to keep you in limbo like this."

"Well, there's nothing we can do. We're cooperating, so we have to go along with whatever they want."

"But until you get sentenced, you don't really know—"

"I know. The judge could go south on me and decide he wants to put me in prison. It's a slim chance, but it's still out there." As I said that, I wondered how long Katherine would wait for all of this to be resolved, and what she would do if the outcome was not as planned. I knew I would lose her if I went to prison.

"It scares me," she said.

"Try not to worry about it. We don't have any control over it."

As much as the man who drove by my apartment resembled Fetterman, I should have known it wasn't him. He never would have risked coming around. I would come to find out much later that he and Terri Lee Galipeaux were on the run, driving from town to town around the southwest United States.

Terri had finally learned his real name when the two of them saw our indictment announced on television. Fetterman scrambled for the remote control and changed the channel. "What did you do that for?" she asked. He knew he couldn't hide the truth, or at least this part of the truth, any longer. The story would appear in the newspapers the next day. He told her about the Diebenkorn auction and the shill bidding and explained to her that he'd been framed by Beach and me and was innocent of the charges. We'd set him up. He told her he had an attorney in Sacramento working on the case.

"You need to go down there and straighten this out," she said.

He told her he would and went to the South Lake Tahoe bus station to catch a ride to Sacramento. A few hours later, he called her and said he'd changed his mind. "I'm going to turn myself in," he said. "I just need some time. I need to find a better attorney."

Galipeaux and Fetterman left his condominium, and for the next few nights she checked them into different hotels around Lake Tahoe using assumed names. Fetterman began growing out his beard, which sprouted leprechaun red. The FBI was in the area questioning people about the couple's whereabouts, so on March 21 they decided to leave town. Galipeaux called her mother before she left. "The FBI was here," her mother told her.

"Tell them we're going north," Galipeaux said.

But they weren't going north. They took the train to Salt Lake City and stayed in a motel while Fetterman read stories about himself on public Internet terminals. Within a week they'd bought a car and headed back to Tahoe, then to Santa Rosa to pick up paintings from Fetterman's storage unit. He unloaded the art at an auction house near San Francisco for several thousand dollars.

Fetterman continued to insist that he was Stone Gossard and a famous science fiction writer. "Everything I've told you is true," he said. It didn't make sense, but Terri wanted to believe him. He promised her that he would turn himself in when he managed to find the right attorney.

From San Francisco they headed south, through Arizona and New Mexico, and then into Texas, staying in cheap hotels in bad neighborhoods in small towns, always checking in under assumed names.

Galipeaux was growing weary of life on the run and began to wonder if Fetterman would ever turn himself in. But it was too

late for her to change her mind. On May 14, Sonderby and Malecek indicted her for harboring a fugitive. She and Fetterman were now both on the run from the law.

"Maybe you should get a job as a bartender or something," Katherine said. I looked over at her from the passenger seat and frowned. "There's no shame in it. It's just a job, a way to make money."

"Katherine, I'm going to be a software developer. I'm not going to work at a bar."

"Don't get defensive. You've been out of work for a long time, you know. The money you borrowed from your mom's not going to last forever."

"I know. I'm sorry. It's just—I don't want to tend bar, okay?"

She stopped her Honda at a red light and looked over at me. She'd just come from work and was dressed in a black pinstriped suit, and she looked clean and perfect and beautiful. I, on the other hand, had neither shaved nor bathed for three days. I was wearing a worn T-shirt emblazoned with a shocking image of Subcomandante Marcos, the leader of the Zapatista rebel army, and the same pair of jeans I'd had on all week. Katherine had recently gotten a raise and wanted to buy a house, and we were on our way to look at a two-bedroom brick Tudor at the edge of Oak Park. This was her endeavor, of course. Buying a house, or contributing in any meaningful way to buying a house, was unthinkable to me. I was just along for the ride, to point out dry rot and slanted floors and other potential renovation issues.

"It doesn't have to be bartending," she said. "I just thought it would be a way for you to get out of the house and make some money. You stay inside too much."

"I've got to focus on software. I'll be able to get a job soon." I paused. "I sold a copy of FeeFinder today."

She looked ahead and issued a sour smile. "So, how much did you make on that? Five dollars?"

Her words stung. "That's not the point. HammerTap is a way to learn. For the first time in so long I feel like I'm doing something worthwhile."

"I know, but Jesus, you're so obsessive about it. It's like you can't think about anything else." She shook her head. "I've seen that grocery sack of bills on your desk."

She was right. I hadn't kept up with my bills in a year. I never paid the last three months of rent on the office space I leased. I had $15,000 in credit card debt, and all of my accounts had been turned over to collection agents. I had $60,000 in student loans, and while I'd saved several of them from default by requesting a hardship forbearance, the interest-free loan I'd gotten directly from Hastings had been sent to a collection agent who was threatening to sue. I owed my father $30,000 and my mother $20,000, and from this pool of parental charity, only about $15,000 had gone unspent. On top of this, I'd agreed to pay $62,000 in restitution. This was $187,000 of debt that I had nothing to show for, other than a 1989 Saab, some Hal Runyon paintings in my garage, and a law school education I couldn't use anymore.

Every few weeks I traveled out to my mother's house in Orangevale and picked up a check, usually for about a thousand dollars or so, drawn from the special account she'd opened to store the money she'd borrowed on her house. The balance of this account was dwindling. I hadn't sent a payment to my father for many months, and he never mentioned it when we spoke, but the thought of the money I was not repaying sickened me. After my sentencing, I would be required to begin paying restitution in monthly installments. The amount of these

payments would be calculated by subtracting my monthly expenses from my income. Debt to family members was not an allowed expense, so even with an eventual job, any money I might have otherwise sent to my parents would have to go toward restitution instead. I wondered if I would ever be able to pay them back.

For the most part, I carried my weight in my domestic partnership with Katherine. I paid for half of all the basic expenses, but anything extra was usually up to her. When we went to a restaurant, she paid, unless it was very inexpensive. I never shopped for clothes, and now and then she'd bring home underwear or T-shirts for me. We'd stopped taking weekend trips. When she decided she needed a vacation, she went to Thailand with a friend while I stayed home.

My financial troubles put additional strain on our relationship, which was already stretched close to the breaking point. We couldn't do things that other couples in their thirties could do, and Katherine hungered for the type of normalcy and stability that I just couldn't provide.

To dwell on these thoughts for more than a moment was to trip into a crevasse in the already deep valley of depression where I dwelled. I couldn't focus on my bleak financial future. I buried my head in software instead. Programming was my way out, my messianic path, a way to redeem myself and make something of my life. I pursued it to the exclusion of nearly everything else, including my relationship with Katherine.

Both Matt and my father warned me of the dangers of letting my techno-obsession erode the integrity of my relationship. "Make rules for yourself," my father told me. "Tear yourself away from your computer when it's time for dinner, and when Katherine goes to bed, join her. No matter how much your mind may be wrapped

up in your work, it's unimportant compared to her. She needs your attention."

I tried following this advice, but it usually didn't work. I broke away from my computer during the dinner hour to eat with Katherine, but I could think of nothing other than my work and couldn't make normal conversation with her. On the nights when I joined her in bed at a decent hour, I often screwed up any chance for romance by smelling like cigarettes or failing to shave. I could feel her distancing herself from me emotionally, and I felt powerless to fix it.

Katherine and I were unimpressed with the Tudor we saw that day; its brick walls needed repair and its kitchen was rotting. A few days later, however, she found a place she loved, a three-bedroom house in the heart of Tahoe Park, a postwar subdivision that had, through the years, become leafy and charming. The place had hardwood floors and a big backyard with a redwood deck and grapevines, and it was on a nice street just a block from the park. One of the bedrooms had been converted into an office, and I envisioned it as the new center of my programming universe, the room where I would spend most of my time.

But when her offer on the house was accepted, Katherine pulled me into the living room and we sat on the couch. She looked sad. "This is not easy to say," she said, pausing and looking down for a moment before she continued. "I think it would be better if you don't move to the house with me."

"What do you mean?"

"I feel like nothing's going to change if we move together. You spend sixteen hours a day in front of your computer." Her voice trembled. "You're still smoking, even though you said you'd quit. You keep saying—" She paused and closed her eyes and breathed in deeply, holding back tears. "Listen, I know you're trying to

make progress, but I think—I feel like I'm holding you back by taking care of you. You need to move on with your life and you need to do it on your own."

"Do you mean you want to break up?"

"I just want us to live in different places and I want you to put your life back together. I want you to be happy and successful, and I want us to be happy together. And right now I'm not happy, and I haven't been for a while. We've talked about this a lot, and nothing's changed."

I swallowed her words like foul medicine. I knew she was right. I'd been taking our relationship for granted for months, so selfishly absorbed by my own problems that I hadn't given her the simple things she needed and deserved. But I was losing her not just because of things I'd done or not done over the previous six months. Her departure was yet another consequence of the choices I'd made over several years. I did not deserve to be loved and pampered and supported by her.

When Katherine moved into her house, I put most of my stuff in a rented garage and settled into the spare attic bedroom of a house my friend Michael was renovating. This was not the end of my relationship with Katherine, but it was the beginning of the end. When we moved, something broke between us, and over the next several months, our relationship collapsed in agonizing slow motion.

While my relationship faded slowly, Fetterman's ended abruptly. After many broken promises and weeks of life on the road, Terri Lee Galipeaux grew weary of him. She no longer believed he would turn himself in when he found a good attorney. They'd made it to Galveston, Texas, and were hiding out in yet another stinking motel room. One night she awoke, took one last look at

him lying in bed, and walked out the door. She hitchhiked all the way to northern California and called her mother on July 11 from a truck stop along Interstate 5 near Dunnigan, about forty miles north of Sacramento.

She knew she was in trouble. She'd seen the stories about her indictment and was ready to turn herself in. But after hitchhiking two thousand miles, she just wanted to spend the night in a clean bed. "I am hungry, I am tired, I am dirty," she said to her mother. "I will take care of this, but I need to come home and eat something and take a shower. Please don't call the FBI. I will turn myself in tomorrow morning."

Terri waited at the truck stop, but by the time her mother arrived, about an hour later, federal agents were lingering in the parking lot. Her mother's brother, when he heard that Terri had appeared, had called the FBI. Terri felt betrayed, but she accepted her fate. She walked across the lot and introduced herself to the agents, who escorted her to the Sacramento County jail.

Seven months later, it took a jury forty-five minutes to decide she was guilty of harboring a fugitive. Sonderby and Malecek called her mother, her daughter, and her best friend to testify against her, and argued for a twenty-seven-month prison sentence. Judge Karlton, believing that Galipeaux had been duped by Fetterman, sentenced her to ten months. As she finished her term in the spring of 2002, Fetterman's whereabouts were unknown. "They'll never catch him," she told a reporter.

Although I didn't think I could make my living with HammerTap, I didn't follow Harold's advice and abandon it. I kept distributing the software and built several other small applications, including more robust versions of BayMail and BayCheck. I created a program called Auction Informant that allowed obsessive eBay sellers

to receive updates by e-mail or pager when bids were placed on their auctions. I made an application called BidderBlock that allowed sellers to create and manage lists of bidders who were blocked from bidding on their items. I recognized the irony of my eBay-related pastime but believed I wasn't doing anything that violated my agreement with the prosecutors. By building the software, I did not "participate directly or indirectly" in online auctions. Or so I hoped.

Although the dust had now settled on the rubble of the dot-com boom, it was actually a good time to start an eBay software company. EBay grew explosively in 2001, and the hordes of new users buying and selling on the site were looking for software utilities to make it easier. Several companies such as Andale, AuctionWatch, and ChannelAdvisor offered web-based auction management systems that helped sellers control inventory, design and create auction ads, and keep track of who'd paid and what had been shipped. I wasn't skilled enough to build a tool this comprehensive, so I looked for opportunities to create niche programs that performed specific functions.

I was shy about running HammerTap, given my notorious recent past, and tried not to make it obvious that I was the wizard behind the curtain. I didn't put my name on the website. When I responded to customer support e-mail, I did so with my first name only. On a few occasions, when journalists e-mailed with questions about the programs, I used my middle name, Andrew. It wasn't that I was ashamed of what I was doing, but I didn't want to besmirch the software with my own misdeeds.

In addition to selling the HammerTap applications, I offered my services as a custom software programmer and built several small projects for eBay users. One was an inventory database for a woman who sold used clothing. Another, which I built for a

man who shopped in a tiny, close-knit collectibles market, allowed him to monitor the bidding activity of his competitors. These custom projects sometimes took many days to complete, and I typically made only a few hundred dollars on them, but they strengthened my skills.

In the summer of 2001, I started looking for real work as a programmer. After some searching, I was hired for a senior-level position with a software company called Revenue Solutions. I started at the end of July, a mere seven months after I wrote my first line of code. The company had been hired by the State of California to help build a huge software application to collect unpaid child support from deadbeat parents. I was in charge of the user interface team, a group of four programmers who would design the windows and buttons and text boxes, and connect them with the muscular code that would process the data.

I was lucky to have landed the job, not just because I lacked experience, but because the job market for programmers, so generous and forgiving just a year earlier, was tightening. Technical recruiters who once had begged anyone who could click a mouse to fill their vacancies now had little to offer. Somehow I got hired and was offered a starting salary of $62,000, more than I'd been making as an attorney when I left Kronick.

On my second day of work I met a state employee, an orange-haired man who was working on the same project. When he told me he'd once worked for a company called VSP, I said, "Oh, my brother used to work there. Do you know Matt Walton?"

After a moment, recognition flashed in his eyes. "Matt Walton? Did you hear what happened to his brother?"

Apparently he wasn't paying attention, as I'd just told him I *was* Matt's brother. But I didn't try to correct him, because I was terrified by where the conversation was leading.

"What do you mean?" I stammered.

"The whole eBay thing."

"Uh, yeah." I looked away and felt my face growing warm. "Oh, that's my cell," I lied, reaching for my pocket. "I'd better take this. See you around."

I fearfully avoided the guy for the next week or so. Eventually I concluded that he hadn't thought much of the conversation and had probably forgotten it. But he hadn't. Several weeks later my boss Jay called me into his office and shut the door. "What's this eBay thing?" he asked.

I froze for a moment, took a deep breath, and explained what had happened. Jay told me that the orange-haired programmer had read a story about me on the Internet and told his boss about it.

"They're concerned because all the state workers have to do a criminal background check before they can work here," he said. "I know we never asked you about a criminal record when we hired you, and since you're a contractor, it probably won't matter. They just have to run it by the legal office."

"I hope it'll be all right. I think I'm doing okay around here."

"You're doing great. That's not the concern. They've just got to follow protocol. For now, let's assume everything is fine. Come to work tomorrow morning as usual."

The next morning, after I'd worked several hours, Jay called me back into his office. "I've got to ask you to clean out your desk," he said. "I'll walk you back to your cubicle and let's try to take care of it quietly, so we don't create a disturbance." He looked me in the eye and sighed. "I'm really sorry we have to do this. If it was up to me, I'd keep you on."

Jay hovered near my cubicle and made small talk with other programmers as I cleaned out my desk. "I'm sorry this had to

happen," he said, lingering for a moment at the glass door I exited. Then he locked it behind me.

That night I met a coworker at a bar and got drunk. The next day I awoke and vowed to find another job. I was a good programmer and knew someone would give me a chance. Losing my job was a shock and a huge disappointment, and made it obvious that my path through life as a felon would be cluttered with obstacles. But I'd been hardened by what I'd gone through over the previous two years, and the loss of a job, while saddening, was not enough to destroy me.

Three days later my problems seemed meaningless. Nineteen men hijacked four airplanes and used them as weapons against the United States. They destroyed the World Trader Center towers, blew a hole through the Pentagon, and killed nearly three thousand innocent people. The destruction wrought by the terrorists extended far beyond the lives they took and the property they destroyed. The attacks tore into the psyche of the American people and wreaked havoc on the economy. The job market, already growing weak, withered and collapsed in an instant. I had nothing to do but sit in my attic bedroom and work on HammerTap.

THE FIFTEENTH PART.

My mother's father built his first house with his own hands. After serving in the army during World War II, he lived with his wife and two young children in a rented house in Southern California. Within a couple of years, they'd saved enough money to buy a small lot in Redondo Beach. My grandfather hauled concrete for a living by day, and in the evenings, and on weekends, constructed a sturdy two-bedroom house from supplies he bought with his weekly paychecks. During the final three months of construction, in the summer of 1947, his family moved into an army tent on the back of the lot while the house was completed. My grandmother stored food in an icebox, cooked on a camp stove, and kept the tent spotless.

Whenever I asked her about it, she laughed and shared funny stories about the tribulations of life lived beneath olive green canvas. "Well, that was how it was," she said matter-of-factly. "We

didn't have much money and your grandfather wanted to take care of his family, so he built a house."

What my grandfather did then probably couldn't have been done today, but this never made it any less heroic to me. The story of the built house and the tent behind it never failed to astonish me. I often wondered if the house was still there, or if it wasn't, what sat in its place.

The house in Redondo Beach was just the first of many things my grandfather built during his life. When he moved his family to Sacramento, he built their second home. He built churches from the ground up. He bought dilapidated houses, renovated them, and rented them out. In his mid-seventies, he installed central heating and air-conditioning in his house, by himself. Building was never his occupation, but when he needed to draw upon the skill, he could.

I've always hoped I inherited some of this fierce self-reliance, the quality that allowed my grandfather to look at a bare piece of land and envision something sturdy and useful, and then build it. Memories of my grandfather's accomplishments gave me hope, in that dark time of late 2001, that I possessed some of his ability to forge something from nothing under difficult circumstances.

I thought of my grandfather often as I sat at the little desk in my attic bedroom working on HammerTap. With nothing else to do and no jobs to be found, I spent my days toiling at software, building my website, and looking for people who would buy my programs.

I found my first big customer when I bundled my software into a suite and let a company called Online Auction Academy, which taught people how to sell on eBay, distribute it to students at a discounted price. With this new source of revenue, by the

end of 2001, a mere three months after losing my job with Revenue Solutions, I was making a few thousand dollars a month from HammerTap. This was enough to pay my rent and meet my basic expenses. I still hoped to find a job as a programmer, but I'd been able to turn my software hobby into something that could sustain me, at least for the time being.

In April 2002 I released DeepAnalysis, an eBay market research program that generated sales statistics for different items and categories. If a user wanted to know the average sale price for a particular Nokia phone, for instance, DeepAnalysis could scan eBay and provide this information. Among other things, the software also showed how many of the phones had been offered over the previous two weeks, what percentage of them had sold, and which sellers had sold the most. The software didn't use any kind of back door into eBay—it merely gathered information that was available on the website and analyzed it much more quickly than could be done by hand.

DeepAnalysis was the first program to lend transparency to the eBay marketplace. Although eBay pitched itself as a perfect market, it was anything but. A perfect market required complete information about what was being bought and sold at what price. For all the millions of dollars changing hands on eBay every day, very little could be readily discovered about what exactly was taking place. Unlike commodities markets and stock exchanges, which were open and subject to exhaustive analysis, eBay was essentially a black box. DeepAnalysis cracked its lid and shined light inside.

Before DeepAnalysis, professional eBay sellers relied on hunches and tips, or spent hours poring through auctions, scribbling figures onto notepads. I knew the program saved these sellers a lot of time and was far more valuable than my other software.

I set the price at $129 and sold thirty-five copies in the first month. Sales of this new product helped push HammerTap revenue to more than $8,000 in April 2002. I added more features to DeepAnalysis, raised the price to $179, and sold even more copies. I knew I was onto something, and I stopped sending out my résumé. I'd found my occupation.

DeepAnalysis attracted some press coverage, including a fawning review in the *Houston Chronicle*. More significantly, it captured the attention of Munjal Shah, the CEO of Andale, the largest of several companies offering web-based auction management services to eBay sellers. Shah called to express an interest in buying HammerTap and invited me to meet with him at Andale's office down in Mountain View, in the heart of Silicon Valley. I found out that the company was working on its own eBay market research tool, and they were interested in how mine worked. Shah seemed impressed that I'd thought up the idea on my own. "We think you're a product genius," he said. By the end of the day, after several hours of meetings with Andale executives, I left and wondered what they wanted from me. If they already had their own, presumably more sophisticated tool in the works, I didn't know what my software could offer them.

Shah called shortly after I departed and explained that they were more interested in hiring me to work for them than they were in buying my software. They would create a new position for me; I would work on their new line of research tools and focus on product development, rather than programming. Without being very specific, he said he thought he could convince me to abandon HammerTap by offering me a handsome salary and a healthy portion of stock options. I would have to move to the Bay Area and work at the Andale headquarters. Shah could tell I was hesitant, but he didn't

know why. He was not aware of my notorious relationship with eBay.

He didn't let my trepidation dissuade him from trying to recruit me, though. "I want you to come back down and meet some more people before we make an offer," he said. I drove down again the following week for lengthy meetings with several more company executives. It turned out that the position they wanted to create for me would require me to spend up to two days a week at the eBay headquarters, working with its programmers. When I learned this I became glum. I knew I couldn't accept this job, as flattering as it was to be courted.

"Everyone gave me the thumbs-up after they met you," Shah said with a smile at the end of the day.

"I need to tell you something," I said.

"Let's take a walk." He led me out of the building and down a path through the tree-shaded lawns that surrounded the suburban office complex.

"There's something you should know before you consider hiring me," I said as we strolled.

He chuckled. "What, are you a felon or something?"

"Well, as a matter of fact . . ." My voice trailed off, and Shah raised his eyebrows. I told him the story.

He said he had no more than a vague recollection of the forged painting that had been auctioned for so much money. "So much happens on eBay. It's hard to keep track of it all," he said. "I really appreciate your honesty. I know it wasn't easy for you to tell me this." I assumed our relationship would be over, but for some reason, he said, "This doesn't necessarily mean you can't come on board. Maybe there's a way we can still make it work."

Within the next two minutes, as we walked back to the office, I watched the glimmer in his eyes fade and the corners of

his mouth sink. I knew, as he said good-bye, that I would not hear from him again. And I didn't. Andale released its research tool within a couple of months and, while it was good, it didn't seem to cut into sales of DeepAnalysis.

In April of 2002, I moved out of Michael's house, which he was getting ready to sell, and into an apartment in an old Edwardian building in downtown Sacramento. I ran HammerTap from a desk in the living room and was drowning in work, flooded by e-mail from customers. I spent a hundred hours a week in front of my computer. In May, HammerTap brought in nearly $10,000, and I decided that with this much revenue, I could hire an employee.

I created a corporation for the business and rented space on the unfinished second floor of a 1920s-vintage building near the corner of 7th and J Streets. The floor had been unoccupied for years and was as big as a warehouse, empty, and undivided. I rented the rear portion of it, a five-hundred-square-foot slice next to the huge windows that overlooked a park. I scraped the carpet glue from the floor and stained it, painted the walls dark green, laid down a couple of Persian rugs, and brought in the desk I had once used at my law office. The place was airy and sunny and reminded me of one of the converted industrial buildings in the South of Market district of San Francisco. It was the type of office a budding dot-com venture would have coveted in the late 1990s. The neighborhood surrounding it was filled with shops and restaurants, and my gym was across the street. Sometimes I took breaks and rode my bike in figure eights around the huge part of the floor that hadn't been transformed into HammerTap headquarters.

As soon as I opened the office, I hired Daniel Buki, an out-of-work programmer, to answer customer support e-mail.

Within weeks it was clear that Daniel was too talented to be limited to that job, and he began taking on any task I assigned him—coding, marketing, website updates. Things seemed so real now, with both of us toiling in our loft office. I was doing things the right way—paying taxes, providing health insurance for Daniel, and building and selling useful software. I was making my living doing something I loved, succeeding in the most improbable of ways, and I relished every moment of it.

I also seemed to be getting my personal life back in order, even if I wasn't doing so pursuant to any kind of calculated campaign. Things were just falling into place. I quit smoking and drinking coffee. I almost never drank alcohol, too focused on work to need any kind of distraction. I was paying my bills again, catching up on overdue debt. If anything was out of balance, it was the inordinate amount of time I spent at the office, but this didn't feel like a problem. Running HammerTap was as natural as breathing, as pleasurable as human touch, and it felt like what I was supposed to be doing.

In October 2002 we brought in $15,000. My sentencing date had already been postponed three times, and I began to wonder if I might be able to earn enough money from HammerTap to pay my restitution before I faced the judge. Just a year earlier I'd been fired from my first programming job and my debt had seemed unconquerable, and now I began to envision a battle plan. If I could continue to build HammerTap and Fetterman could evade the FBI a bit longer, I would be able to walk into the courtroom for my sentencing hearing with a check for $62,000.

At this point, though, I was putting most of the money I made from HammerTap into paying back my parents and investing everything else back into the business. In early 2003 a large European software publisher asked us to develop German-

language versions of our products for distribution in retail stores. We spent several months putting this together, translating our programs into German and modifying them to work with the German eBay site. These packages would appear on shelves in Germany, Austria, and Switzerland in the summer of 2003.

I found new ways to distribute our programs by packaging them into a suite that other companies could resell. Bright Builders, a Utah-based software company that sold a "build your own website" package, bought hundreds of copies of the HammerTap suite every month at a deeply discounted rate that was still profitable for us, because of the volume.

We also formed a partnership with ChannelAdvisor, a large auction management service that competed with Andale. We approached ChannelAdvisor and asked it to build a branded version of its site for us, which we called HammerTap Manager. Less than nine months after I was shunned by Munjal Shah, HammerTap now offered an auction management service every bit as good as anything offered by Andale.

In early 2003 our revenue bobbed above $20,000 per month, and I hired several new employees. Juba, a computer science student at Sacramento City College, took over customer support so Dan could focus on programming. Kim, who had an MBA and worked in Silicon Valley during the dot-com boom, joined us part-time to help with marketing strategy. I contracted my friend Michael to assist with business development and website design. My brother Keith, who had recently been laid off from his job, came in to help us build a new version of DeepAnalysis. At times we'd all be in the office at once, perhaps watching Kim lead a strategy session at the white board, and I would pause to take it all

in, to gaze at the bustle I'd created in this little office, to revel in my own astonishment at what I'd built in such a short amount of time. I felt unstoppable.

While I was building HammerTap, Fetterman was hiding out in Wichita, Kansas, living in a small rented house on South Athenian Street, in a quiet residential neighborhood east of downtown. He had arrived there shortly after Terri Lee Galipeaux left him in Galveston. He settled in, befriended a group of young men who played Frisbee golf, and called himself Flood Peters. His friends in Wichita said Flood was gregarious and happy-go-lucky, in an outspoken way that struck them as insincere. "Man, it's a great day!" he was fond of saying. "It's good to be free." No one was sure how he made his living, but he always seemed to have plenty of money and showed up at parties with enough beer for everyone. When asked why he'd chosen to settle in Wichita, he said, "It's right in the middle of the country! How good is that?"

He also started smoking marijuana. This was something I'd never seen him do. He had always, during the time I knew him, expressed disdain for drug use. Perhaps he did it to fit in with his new friends, or maybe it helped soothe the stress of being a fugitive living under an assumed name, on the run from the FBI.

Flood couldn't live indefinitely on the money he'd brought to Wichita. Eventually, he gained the trust of a friend with an eBay account and, very cautiously, once again began selling art on the world's largest online auction. No one was sure whether any of it was fake.

In early January 2003, Flood and a friend were on their way to the Saturday league, a weekly Frisbee golf tournament held at a park in Derby, Kansas, just outside Wichita. Flood was

driving his black 1984 BMW. A sheriff's deputy stopped him because his windshield was cracked. Flood had no driver's license and told the deputy his name was Kenneth Wilson. He must have reeked of fear. The deputy searched the car, found a plastic baggie filled with joints, and arrested him. After he was fingerprinted, Flood Peters was discovered to be Kenneth Fetterman. Within days he was extradited, transported to Sacramento, and put up in the county jail. From the front of my office building I could look down 7th Street and see his new home. I sometimes walked by it on my way to work.

Had it not been for this improbable traffic stop, Fetterman might have been able to evade the authorities for decades. He couldn't have anticipated that a minor flaw in his car would be the cause of his downfall.

I had begun to believe, after nearly two full years, that he would never be caught. At the very least, I thought the FBI would not find him until long after it gave up hope, and Scott and I were sentenced. Now I would have to wait until his case was resolved and would need to testify against him if he went to trial. I dreaded this. I was terrified by the thought of taking the stand, looking down at him in his orange jumpsuit, and being berated by his defense attorney. I wasn't sure I could remember everything I'd told the prosecutors at those meetings that now seemed so long ago. The details of our eBay activities were fading in my memory. I was afraid of saying something wrong on the stand, or simply speaking in an incorrect tone or manner, or doing anything that would jeopardize the prosecution's case against Fetterman and therefore put my deal with them at risk.

I also wondered, though, if his capture would give me the extra time I needed to save enough money to make restitution. If he went to trial it would take months to prepare. If he lost, it

would be several more months before he would be sentenced. And then, finally, after all of this, I'd face my day in court. This might give me enough time.

"You need counseling," Harold said. "You seriously need help."

I'd pulled my car off the freeway to take his call, and I sat in the parking lot of a Denny's overlooking Interstate 80. I raised the volume on my phone so I could hear Harold over the drone of diesel engines and the hiss of tires.

"Why didn't you tell me you were still running this Hammer-Tap thing? I told you it wasn't a good idea."

"Harold, back then I didn't intend to make my living at it. I got that job, but they fired me because of my record, and I didn't have anything else to do. Then HammerTap got big. If I can keep it going, I can pay off my restitution."

"Yeah, but it's eBay software, and eBay's pissed off. They called the prosecutor, and he wants us to come in and talk to him about it."

"Was it Sonderby or Malecek?"

"They're both gone now. Another guy has taken over the case."

"Really? He knows about our deal, right?"

"Of course. But now I find out you're going around behind my back selling eBay software. What the hell were you thinking? You're dangerously close to screwing up your deal, Ken. It's as if you're unable to recognize the risks you take. Why did it have to be eBay software?"

"I've been really careful. I've haven't bought or sold anything on eBay since I signed that plea agreement."

"Okay, so maybe you haven't violated the precise language, but you're thinking like a lawyer. I'm a lawyer, so I get it. The

prosecutor's a lawyer, so he'll probably get it also. The judge might agree with you too. But the fact is that this doesn't look good. You're still making your living off eBay, even if you're not doing auctions. Can you imagine what the press would do if this got out?"

"Harold, I've been trying to do the right thing. Everything about HammerTap is legit."

"That's not the point. If you really thought you needed to run this company you should have told me, and we could have approached them early on and maybe gotten their consent. But now, all bets are off."

"You don't think this will jeopardize my deal, do you?"

"I can't say, Ken. You got yourself into this, and now we have to deal with it. The prosecutor wants to talk to us next week. I'll call you."

The phone went silent. I balled my fist around it and pressed it into my forehead. I knew this would happen eventually—I couldn't hide that I was running HammerTap forever—but I'd hoped I would be sentenced before this information percolated out into the world. I couldn't fathom how the prosecutors would find my operation of HammerTap a violation of my plea agreement, but I'd been wrong about them before.

I should have guessed that something like this might be happening. EBay had started sniffing around HammerTap a few weeks earlier, beginning with a voice-mail message from someone named Tucker Smith. We did some sleuthing and discovered that Smith was in charge of the new eBay data licensing program. DeepAnalysis surfed the eBay website to collect data about auctions. EBay had recognized that this data was valuable and created the licensing program to sell direct access to its database of auction information. I assumed Smith was calling with a sales

pitch, perhaps hoping to sell us licensed data for DeepAnalysis.

I was afraid of eBay, worried that someone there would recognize my name if I entered into negotiations. But I knew I couldn't avoid them completely, so I left Smith a voice mail several days after he called. He didn't call back; eBay had already realized that I, the notorious shill bidder, was running HammerTap, and someone from its legal department had called the federal prosecutor and complained, hoping the government would put a stop to it.

The U.S. attorney called Harold and asked for a meeting, and now I faced the very real possibility that when I met with this new prosecutor, a man I didn't know, he might be furious about what I was doing.

Over the next two weeks I prepared myself for the worst. I halted development of the new version of DeepAnalysis and cut back my employees' hours. I remembered Harold's admonition and wondered if there was something wrong with me, some huge hole in my character that spurred profound lapses in judgment and prompted me to take gross risks. Perhaps building HammerTap had been a giant mistake. But I couldn't embrace this idea. Everything about HammerTap seemed too right. I couldn't believe that my time on eBay as a shill bidder made my company any less worthy of existence. If I had to go to prison for HammerTap, I would accept my fate, but I could not believe that by running it I had done anything wrong.

On March 26, 2003, I put on a suit and met Harold at the federal courthouse. The prosecutor, Patrick Hanly, escorted us to his office, which was just down the hall from the room where I'd spilled my guts to Sonderby and Malecek two years earlier. Hanly seemed busy, and eager to get our meeting out of the way. "What's this software you're selling?" he asked.

I explained HammerTap and described DeepAnalysis.

"So the question is whether this violates your plea agreement," he said. He tilted his head back thoughtfully for a moment, then said, "I don't think so. As for any dispute between you and eBay, that's a civil matter, and I don't want to get involved. They've been bugging me about it, but you guys are going to have to work it out on your own."

I stared at him in silence. Every muscle in my body relaxed. He took a moment to scan the pages of my plea agreement. "This is a good deal you got," he said. "We're going to be depending on you to help convict Fetterman if he goes to trial. I don't want you to do anything to screw it up, so I need you to keep your nose clean out there. If you're doing anything that could cast you in a negative light, you need to stop."

I nodded. "I understand."

"As for this software venture of yours, I couldn't really care less. Just don't do anything that'll embarrass us if we put you on the stand."

"Do you think Fetterman is really going to take this to trial?" Harold asked.

Hanly stretched his mouth into a smirk and shrugged. "I have no idea. He just might be crazy enough to think he can get off. The guy seems pretty unpredictable."

Hanly stood and walked us to the door. He'd just given me, on behalf of the United States government, permission to run HammerTap, and I wanted to flee the building before he changed his mind.

"Well, that was easier than I thought it would be," I said to Harold in the elevator. I reached up to loosen my tie.

"Yeah, he seems like a good guy. We're on solid ground. But you need to take what he said to heart and keep me informed about whatever you're doing."

On our way back to my office we walked by the county jail. Sometimes when I walked down 7th Street, I looked up and saw the inmates gazing southward through the chain-link fence on the sixth floor, the open-air recreation area. I sometimes wondered if Fetterman was one of the sullen figures up there, clutching the fence and glaring down at the street. I wondered if he ever saw me walking to work, going about my day in freedom while he languished in a cell.

I said good-bye to Harold and returned to my office in triumph, realizing what a burden it had been to run HammerTap without the prosecutors knowing about it. What I perceived as the single biggest threat to my company had just disappeared. I felt energized. I called Keith and told him he could rejoin us and continue building the new version of DeepAnalysis. I told Dan his job was secure. I would continue to repay my parents and sock away money for restitution. HammerTap would get bigger and better and I would navigate its course without hesitation.

My bubble of elation expanded for several weeks, and then was burst by an April 30 letter from Allyson Willoughby, an attorney for eBay, demanding that we stop selling DeepAnalysis. The letter made no mention of my conviction. Instead, in dry legalese, it claimed that DeepAnalysis was harmful to eBay because it allowed users to "trespass" on the website.

Willoughby referred to an ancient legal doctrine called "trespass to chattel," which meant trespassing on a piece of personal property, rather than land. Historically, a person could sue for trespass to chattel when he loaned something to someone who overused it in a damaging way. Willoughby claimed that by selling DeepAnalysis, and giving people a way to "spider" the eBay website—surf it automatically with software, rather than manually—we helped them trespass.

It was a dubious legal argument. Many legal scholars questioned whether website spidering was really a form of trespass, and the courts had not yet conclusively decided the issue. But eBay was big, and by sending out letters like the one it sent to me, it was usually able to frighten small companies into doing what it wanted. I was indeed frightened, but the notion of being sued by eBay wasn't nearly as terrifying as what I'd already been through. I wasn't going to shut down HammerTap without a fight. DeepAnalysis caused eBay no harm, and it was wrong for the company to try to eliminate the software by claiming it did.

Based on a recommendation from a law school friend, I hired Judy Jennison, an Internet law expert and a partner in the San Francisco office of the firm Perkins Coie. Judy drove to Sacramento to meet me, and I told her the story of HammerTap and my own personal legal troubles. "You could fight this," she said. "I'd estimate you have about a fifty-fifty chance of winning. But it'll cost you at least a hundred fifty thousand dollars before you even get to trial, and I don't recommend it for a company of your size. The best solution is to come to some kind of agreement with eBay. Maybe you can purchase their data."

I knew our sales would increase if we bought the data, as it would make DeepAnalysis much faster. And since I'd been given permission to run HammerTap from the assistant U.S. attorney, I could see no reason why eBay wouldn't allow us to purchase a license.

Judy scheduled a teleconference with eBay in mid-May to discuss a licensing agreement. She sat in on the call from her office in San Francisco. On eBay's end, Tucker Smith, Allyson Willoughby, and Jay Monahan, eBay's assistant general counsel, were on the line. After we were all introduced, I launched my pitch. "I'm glad we're all finally able to get on the line and talk,"

I said. "We're eager to discuss eBay's concerns about Deep-Analysis and find out more about your data licensing program. I hope—"

Monahan cut me off. "Just a minute," he said. "Before we start talking about this, I want to get one thing straight. You're the same Ken Walton who was involved in the shill bidding scandal back in 2000, right?"

I closed my eyes and replied. "That's correct."

"Well, let me say this. That incident was the second most embarrassing public relations event in the history of this company, after the website outage of 1999, and under no circumstances will we ever enter into any kind of business relationship with any company even remotely affiliated with you, or any member of your family." His voice was deep and oily, laced with well-mannered contempt. "What we should be talking about here is collecting damages for the harm you caused us."

No one said anything for a moment. I was frozen, like a soldier in a bunker looking at a grenade that had just dropped from the sky.

"Now," he continued, "if you want to talk about the legal merits of the letter we sent, we're happy to do that, but we won't discuss any kind of licensing agreement with you."

Judy took over. "I think we're done here. Your letter didn't mention that it was motivated by Ken's personal legal problems, and we came to you in good faith to discuss business."

"Well, that's not going to happen," Monahan said.

We all hung up, and I leaned forward in my chair and buried my face in my palms. So this was personal. It wasn't about trespass to chattel or harm to the eBay website. The company simply didn't want me anywhere near it.

Judy called.

"What do we do now?" I asked. "How can I just shut down and abandon all my customers?"

"Well, maybe you could sell HammerTap to another company that eBay *would* be willing to do business with. Have you considered this?"

I sighed. "I wouldn't be opposed to it. I don't know how much we could get for a company that's about to get sued."

"You never know. Let me give them a day to cool off, and I'll call Allyson and see if they'd be willing to sell the data license to someone who purchases HammerTap. It seems like your only option at this point."

Judy talked to Allyson Willoughby and Tucker Smith the next day. Willoughby said that eBay was not opposed to the software itself and thought DeepAnalysis was an innovative product. If I continued to sell it, eBay would sue me, but it was not opposed to me selling HammerTap to another company. Tucker Smith said he would prefer that I sell HammerTap to one of eBay's existing business partners.

Willoughby promised to give us some time to find a buyer. I had no idea what HammerTap was worth, or if anyone would want to pay anything for it, regardless of its worth, but we had no other choice. I contacted our larger business partners and told them the company was for sale. Scot Wingo, the CEO of ChannelAdvisor, said they'd looked into buying a data license and decided it was too expensive. Our European software publisher was interested only if I could continue to run the company, which wasn't possible. Greg Cole, the president of Bright Builders, the company to which we sold our software in bulk, also expressed interest. But because his company had no experience developing eBay software, I wasn't sure if it was a good candidate.

The CEO of Vendio, one of Andale's competitors, said he was

interested in finding out more about HammerTap, so Judy set up a meeting. Keith, Daniel, and I drove to the Vendio headquarters in San Bruno and gave a demonstration of the new version of DeepAnalysis. The company's executives seemed intrigued, and they indicated that any type of buyout would probably involve stock options rather than cash. Displaying a remarkable lack of bargaining savvy, I said, "I'm open to offers. I don't have a lot of options or time."

Judy also scheduled a meeting with an AuctionWorks executive while he was in San Jose to meet with eBay. He too seemed interested and took a copy of the software back to Atlanta to show his colleagues.

For the next couple of months, we labored to sell HammerTap while trying to keep eBay off our backs. Its lawyers kept sending threatening letters, and Judy kept buying more time. Meanwhile, HammerTap was making more money than ever. In June 2003 it brought in nearly $28,000. I cut costs by laying off everyone except Daniel. If I could hold on for a couple more months, I would be able to save enough money to pay my restitution in full when I got sentenced. I no longer cared about long-term growth or creating new partnerships—I just wanted to generate cash as quickly as I could.

Ironically, as eBay's attorneys threatened us, others within the company admired our software. At least six eBay employees were registered users of DeepAnalysis, and our records showed that the software was used on eBay computers nearly every day. One of the company's marketing executives told me he loved DeepAnalysis and preferred to use it for research because it was simpler than running ad hoc queries on the eBay database. In mid-August I discovered that eBay was recommending our software on its website.

Use HammerTap tools to calculate fee estimates, determine optimal pricing strategies, and check bidder feedback.

HammerTap offers three products that can increase the effectiveness of your TA services. Determine listing fees before posting with FeeFinder by HammerTap.com, which allows you to calculate everything offline, including PayPal fee calculations. Complete details on FeeFinder are available here (link http://www.hammertap.com/FeeFinder.html). DeepAnalysis determines optimal pricing for your client items—click here for more information. Check bidder feedback using BayCheckPro—minimize the odds of an NPB affecting your account on behalf of your client.

In early September, I received an e-mail message from a representative of the eBay Trust and Safety department, the division of the company that enforced its rules. Apparently a high-volume eBay seller had been sending DeepAnalysis reports to the department to demonstrate how some of his competitors had been breaking eBay selling rules. This prompted interest in the software within the department, which led to this message:

> I have looked through the free trial version at home, and wanted to review it further with a supervisor contact. We would like to see if it is something that eBay can use to help with internal reports, or possibly offer as an additional tool like Turbo Lister.
>
> Let me know if it is possible to receive an evaluation copy, and I would be happy to review it with the supervisor and eBay management. I would also like to know any

background on the tool itself, so I can present the information to the other eBay supervisors and the legal department in the event that we are permitted to use this wonderful tool.

Thanks so much, and I look forward to working with you.

DaNeen Vance
eBay Customer Service Enhancement Specialist

Despite this enthusiasm among some eBay employees, the company's legal department dutifully kept the pressure on us, and as the summer of 2003 waned, things were looking bleak. Vendio and AuctionWorks both decided they didn't want to buy HammerTap.

As these companies dropped out, my talks with Bright Builders grew more serious. Its CEO, Greg Cole, spoke with Tucker Smith extensively, and had to convince him that his company was not an extension of mine, but a thriving software venture in Utah with fifty employees and no relation to me other than a resale agreement. Over the course of many weeks, Greg came to an agreement with eBay for the purchase of a data license. Then he and I finally began speaking in real numbers and discovered that our ideas about the value of HammerTap were very different. After a week of negotiations, however, we finally agreed on a purchase price and payment terms. The official transfer took place on October 31, 2003.

I didn't get rich. The total value of the sale and long-term royalties, which I'm forbidden to reveal due to a nondisclosure agreement, was less than a million dollars. But considering how destitute I'd been just two years earlier, I was happy with the

terms, and I felt relieved to have found a buyer. I spared the life of the little software start-up I had built out of a good idea and countless hours of hard work, and I felt like I'd done the right thing.

For the first time since late 1998, I had nothing whatsoever to do with eBay. In December I paid off my parents and wrote a huge check to Harold and told him to put it in his trust account and set it aside for restitution.

THE LAST PART. I frowned at

myself in the bathroom mirror, twisting my tie with shaky fingers. I used to wear a tie every day and could whip up a perfect knot without effort. Now it had taken me three tries before I could tie it properly, so the end of it didn't dangle over my crotch or too far above my belt buckle. It still didn't look quite right.

I never imagined, when I walked into that stark white conference room to cooperate with the prosecutors, that it would take three and a half years to arrive at this day. My sentencing date had been scheduled and rescheduled at least five times. I assumed that by now it would all be over, a part of my past that would be fading. I didn't resent the long delay—I'd accomplished a lot while out on my own—but there was something unsettled about my life that I hoped would now pass. I wondered if this sentencing would mark a turning

point, or whether too much time had passed for it to have any dramatic effect.

I stared at my sallow face in the mirror. I'd been a youngish thirty-two when I tried to auction off that fake painting and the world took notice. Now I was thirty-six, but I felt like my body had aged a decade in the interim. I'd felt like a kid when I dashed those initials onto that painting, and now I looked in the mirror at a middle-aged man. The events of the last several years had exacted a toll, and I wondered if the things that had wreaked havoc on my body had changed my character in any significant way. I wanted this to be true, but I knew it might take years for me to fully appreciate how what I had gone through had shaped who I'd become.

My life was markedly different from what it had been just a year earlier, when I was fighting eBay and scrambling to find a buyer for HammerTap. I'd settled into a routine of shorter work-days, dividing my time between consulting with Bright Builders and managing other custom software projects, most of which I farmed out to contract programmers. I kept an office downtown, upstairs in a smaller space on the sixth floor of our building, mainly to give me an excuse to get out of the house.

For the first time in several years, I really didn't have much to do, and I made the most of it. I shopped around and bought a two-bedroom bungalow in an old, tree-shaded neighborhood near downtown Sacramento. I traveled to southern Mexico and Spain. I started reading books again. I rekindled relationships with old friends. It was as if I'd returned from a long journey and was becoming reacquainted with my surroundings. The things I'd learned about myself—good and bad—affected the way I saw everything around me.

Fetterman finally pled guilty, after spending nearly a year in

the Sacramento County jail while he wrangled with the prosecutors. He switched lawyers, which led to delays. A trial was scheduled that was then postponed. At one point Fetterman wrote a private letter to his attorney, only to find it returned several days later, errantly opened by a guard. The jail had mistakenly failed to add postage to the letter, and when it was returned, a guard opened it, even though it was clearly marked as confidential attorney-client correspondence. Fetterman's attorney asked for the charges to be dismissed, claiming that his client's rights had been violated by this breach of confidentiality. This took several months to sort out, and the judge concluded that the letter was not a good enough reason for him to be set free. Finally, in March 2004, only weeks from trial, Fetterman pled guilty to money-laundering charges, based on his long-ago request for me to break his earnings from the C. Still sale into several payments. In doing so, he spared me from having to testify against him. I was greatly relieved by this.

On May 26 Fetterman was sentenced. The guidelines called for a prison term of between forty-one and fifty-one months, and the prosecutor argued that Fetterman deserved the maximum penalty. "I detest the person I was," Fetterman said at his hearing. Judge Karlton then sentenced him to a term of forty-six months.

I gave up on my tie, put on my jacket, and drove downtown to meet Harold and Theresa across from my office building. I helped Theresa carry her bulky leather briefcase and realized that I hadn't seen her since our first meeting with the prosecutors. She was a full-fledged partner of Harold's now, their firm called Rosenthal & Gibbons.

As we walked to the courthouse, Harold showed me a cashier's check for $74,232 that he'd drawn to pay my restitution. This was more than the $62,000 I'd originally agreed to pay,

and more than I'd earned on eBay during the entire time I worked with Fetterman. To determine how much I owed, the federal probation office sent a letter to every person who'd ever bought a painting from Fetterman, Beach, or me in an auction with at least one shill bid, and offered each of them an unconditional refund. Out of hundreds of customers, only about twenty asked for their money back. Many of the auctions for which I was held responsible were sales from which I never received any money, and the rest were sales from which the profits had been shared. The total amount owed by all three of us was $94,683, and most of the debt was "joint and several." This meant that by paying my restitution in full at my sentencing, I was covering debt that should have been shared by Fetterman and Beach. But I had the money, so I paid it, relieved to finally put all of this behind me.

I'd always been fearful that when I reached this day, the judge wouldn't follow the recommendation of the prosecutors. But now it had been so long, and I didn't feel the same apprehension. Harold had told me many times that I had nothing to worry about, and I'd finally taken his words to heart. I knew the hearing would go as planned.

My mother, her brother, my brothers, and several of my friends were waiting for me in the courtroom. I sat with them and waited for my turn in front of the judge. I noticed Scott Beach sitting across the aisle, his dark hair cropped short. He looked younger than his thirty-three years, no older than the last time I'd seen him, in San Francisco, more than seven years earlier. I wondered what he'd experienced, how the charges and the conviction had affected him and his family financially and emotionally. I didn't really even know him, but I felt some sort of kinship between us, as if we were strangers who'd survive the same earthquake.

After several other defendants appeared before Judge Karlton, our names were called. As we approached, the judge glowered down at us. He'd gone about the business of the morning with efficient indifference, and now, for the first time, looked genuinely perturbed. I hadn't seen him react this way to anyone else. He turned to the prosecutor, held up a copy of the sentencing recommendation, shook his head, and spoke. "I think what I hear you saying, Mr. Hanly, is the case really may not have been made, or would have been extremely difficult to be made, without the cooperation of these defendants. Is that where we are?"

Patrick Hanly concurred, and he explained how the sentencing recommendation was warranted, given that our case was the first shill bidding prosecution in the country and was very complicated.

"Mr. Fetterman got forty-six months," the judge said, "which he *richly* deserved."

I felt dizzy and thought I might collapse. I looked to my right and saw Theresa frowning with concern.

The judge continued. "And I feel comfortable with that. I must confess, I'm less comfortable with this."

This was it. My sense of entitlement to the agreement I'd made was unwarranted. This judge did not have to go along with any bargain I'd made with the prosecutors. He thought I deserved to go to prison, just like Fetterman. My cooperation? The check for $74,232? The years I'd waited? None of this meant anything.

Eighteen months. This is what I would get if the judge ignored the request of the prosecutors. If I behaved while I was in, I could get a 15 percent reduction in my sentence, which would leave me with 15.3 months. One year, three months, and ten days.

I would have time to prepare before I went away. The judge would give me several weeks to get my affairs in order before I would have to report to prison. I'd have time to clean my house, forward my mail, and make arrangements. I could have someone—maybe my sister-in-law—pay my bills while I was away. I could pay Keith to help Bright Builders with the HammerTap software—he knew how it all worked. Maybe I could rent out my house, but then again, maybe I didn't need to. I wouldn't be spending any money in prison, and I had enough to cover my mortgage while I was locked up.

I'd make the best of it. I was much stronger now than when this had all started. I could read a lot of books and perhaps learn an instrument. Maybe they would give me a job working with computers and I could learn some new skills. I would save money while I was in and have it waiting for me when I got out.

The judge spoke again, and it took all of my effort to clear my head of thoughts and listen. "I'm going to go along with it because I accept the government's representation of the great difficulty that would have been faced had these folks not cooperated. But it is troubling."

He turned to Scott and asked if he had anything to say, and I felt my entire body loosen. Scott's attorney said a couple of things, and then Scott made a statement I didn't hear. When it was my turn, I mouthed the five or six lines of apology I'd memorized. The judge tapped his gavel and sentenced me to a term of nine months of probation. The whole thing was over in five minutes.

I turned and walked down the aisle on my weakened legs. I saw nothing but the huge doors at the back of the courtroom, and when I made it outside and into the hallway, everyone was hugging me and patting my head and asking me questions. I

turned to Theresa and said, "I thought he was going to send me to prison."

"He was just trying to get that on the record," she said. "He was going to go along with the recommendation. He just wanted everyone to know it wasn't his idea."

Maybe she was right. But I was nevertheless grateful for Hanly's defense of us and the statements he made on our behalf.

Harold and Theresa returned to San Francisco, and I took my family out to lunch. As I sat at the table I grew sullen. I realized that the four-minute stint in front of the judge was not the climax I'd hoped it would be. I felt no great sense of joy or relief. It was, if anything, overdue closure that took place long after closure was necessary. I realized I had already moved on with my life, and this event was no more than a footnote to the story.

After lunch I went back to my office and sat by myself in the conditioned air and stared out the window at the pale, empty sky. I'd often pondered, over the previous four years, how things might have turned out differently. I thought of things I could have done, or not done, that might have spared me from being prosecuted. If I'd never painted those initials on that cheap painting, there would never have been an auction for a fake Diebenkorn to shock the world. If I hadn't made up that asinine story to go along with it, I wouldn't have brought ridicule upon myself, and the press might not have deemed the whole thing worthy of reporting. If I'd never spoken to a reporter after the auction, the story might never have caught fire. But a life is shaped by a series of small decisions, and the choices that led me to where I was began long before I spotted the orange and green painting in that shop in Pearblossom. My path was paved by the

time Fetterman and I went on that expedition to Vegas, and had I not attracted attention to myself when I did, I might have taken a much bigger fall later on. And even if I hadn't, I might have continued living a life laced with deceit, a life of compromise and shortcuts.

Or maybe not. Perhaps I would have stopped working with Fetterman and never sold a fake painting again. Maybe I would have built my law practice and eBay would have become a hobby, something I did to relax, something that provided amusing anecdotes and a few dark secrets. But it didn't matter now.

Everything I did and what happened as a result is an indelible part of me. I am forever a shill bidder and an art forger and a felon. I tricked people out of sizable sums of money in exchange for worthless works of art. When I meet someone new, I am acutely aware that eventually, I will have to explain the part of my life of which I am most ashamed. No matter what I do the rest of my days, there will always be people who will judge me or shun me for what I did on eBay. I know I've filled my life with unexpected obstacles, and that this will be painful and limiting in ways I cannot yet fathom. Worse than this, perhaps, is the doubt I carry inside myself. I've met my inner con man, and I can never again pretend I don't know him.

But just as much as these shameful things are now a permanent part of my story, so too are the good things I discovered—the strength of my family bonds, the resiliency of my friendships, and my ability to endure hardship and thrive under severe circumstances. I discovered what it means to have true passion for work. I learned what it is like to do something for the sheer joy of it, as well as for financial security. I might have lived my

life on autopilot, never pausing to reflect on what was truly important to me, were it not for what happened. Being stripped to the bone and shaken apart gave me the opportunity to piece things back together in a better way. I can only hope the things I've discovered, lessons I will carry with me for the rest of my life, may someday outweigh the price I paid.

ACKNOWLEDGMENTS

I'd always wanted to write a book but never thought I had an exceptional story. And then I did. Have a story, that is. But having a good story didn't make this book easy to write. Had it not been for the people around me who helped, I might never have finished. Or, for that matter, started.

Foremost among them are my agent, Eileen Cope, who believed in this story, and my ability to tell it, enough to take me on as a client; and my editor, Tricia Boczkowski, who let me write this book the way I wanted, and then gave it the extraordinary editorial treatment everyone said I shouldn't expect from my publisher. These women not only excel at what they do, but are also, quite simply, very nice people. They return e-mail.

I must also thank Susan Brown for her valuable assistance with my book proposal, and the many people who supported and inspired me while I hunkered in a dim room for months and wrote. This includes Susie Kramer, who cast her novelist's eye on my manuscript and made innumerable valuable suggestions; Nicolette Dalpino, who eagerly read the first draft of each chapter as I finished it (and was blunt and outspoken about the bad parts, and kept bugging me about that one *really* bad part until I fixed it); and of course Tina Kuenneth, who made extensive comments on my enormous first draft, and was the first to tell me to

cut out all the postmodern stuff (which I, and apparently no one else, actually liked).

My father, Jim Walton, and my brothers, Matt and Keith, all read early drafts and made helpful comments. Michael Rolph's early recommendations got me headed in the right direction. Julie Cortez read my manuscript on a road trip from Portland to Sacramento and made several valuable suggestions. Po Bronson and Tom Bissell gave me helpful pointers at a writer's workshop at 826 Valencia. Angela Scarlett, Dave Grecu, Matt Youell, Lori Grecu, Nina Davis, Shannon Jackson, Sarah and Josh Bruck, Heather Hannold, and Trista Macaulay were all kind enough to read and comment on early drafts.

I must also thank R. V. Scheide for his article "Prisoner of Love," which appeared in the April 4, 2002, issue of *Sacramento News and Review*, and from which I gleaned information about Fetterman's time on the lam. More information about this time was gathered from Fetterman's friends in Wichita (who asked not to be named), to whom I am equally grateful.

And finally, I must also thank Coffee Works, for being within walking distance, and its staff, for keeping me awake while I wrote.